PRENTIS ROLLINS

THE MAKING OF A GRAPHIC NOVEL

Watson-Guptill Publications/New York

For Scotia

A note from the author: Any occurrence of "he" in the text is intended to refer indifferently to male and female readers and artists.

Executive Editor: Candace Raney
Editor: Holly Jennings
Designer: Kapo Ng@A-Men Project
Production Manager: Hector Campbell

First published in 2006 by Watson-Guptill Publications, a division of VNU Business Media, Inc., 770 Broadway, New York, NY 10003
www.wgpub.com

Library of Congress Control Number: 2005929012
ISBN: 0-8230-3053-9

Text set in Rotis Serif

Printed in the United States of America

First printing 2006

1 2 3 4 5 6 7 8 9/14 13 12 11 10 09 08 07 06

CONTENTS

PREFACE

In *20,000 Leagues Under the Sea*, the last thing Professor Arronax hears as he's fleeing the sinking *Nautilus* is the crew crying out "The Maelstrom! The Maelstrom!" That pretty much sums up how I feel when I walk into a comic bookstore these days. There's so much material—and so much of it is great, and so much of it is mediocre or worse—it seems the only way to tell which is which is to read it all. It's all spinning around you, and you feel like you're being pulled under.

Lately I've noticed books that allegedly tell "how to make a graphic novel." The problem is that there is no one recipe for making a graphic novel, any more than there's one recipe for making a novel or a film. There are just as many genres and styles of graphic novels as there are of novels and movies. And the number of artists out there right now, and the diversity of their creative voices, is staggering. But there are common practices and principles that almost all graphic novelists, and comics creators at large, would deem essential and universally applicable.

The purpose of this book is twofold. First, it's simply to provide what I hope is an entertaining graphic novel. Second, it's to provide a sort of blow-by-blow account of the steps I went through in putting it together, along the way discussing and illustrating some of the aforementioned basic principles and practices. My hope is that by "looking over my shoulder," the reader can get an idea of one way of constructing a graphic novel. And it truly is an act of construction—of taking a gigantic task, breaking it down into manageable subtasks, and methodically carrying out those tasks. Again, there are myriad ways of doing this, and I don't pretend that my approach does or will work for everyone. But it worked for me—I got the job done, and in any creative endeavor that in itself is more that half the battle.

I recommend that you flip the book over and read *The Resonator* first. If you give it an initial read-through, unbiased by any talk of method or technique, I think you'll appreciate the "making of" chapters all the more. I very much hope that this book is of some assistance to aspiring creators, or that it at least helps give some insight into the mechanics of this unique art form.

ACKNOWLEDGMENTS

Special thanks to Executive Editor Candice Raney, for letting me do this book, to my wife, Jacqueline Ching, whose idea this book was, and to my editor, Holly Jennings, whose many great ideas—not least of which was the "flip book" concept—made this book a far better thing than it might otherwise have been. Kapo Ng, the designer of this book, also deserves a word of thanks for his beautiful work.

Regular ole thanks to Poder, Pliny, and Thrasymachus.

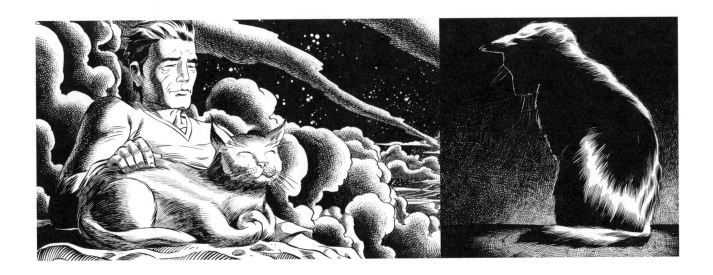

INTRODUCTION

ON GRAPHIC NOVELS

BROWNISH-GRAY FORMS SOARED UPWARDS. THEY WERE TOPPED WITH RIOTOUS GREEN FLUFF THAT BOBBED AND SWAYED IN A COOL WIND.

THOSE MUST BE TREES, I REALIZED. AND THE STARS BURNING IN AN EXPANSE OF DEEP BLUE.

ENDLESS, ENDLESS SPACE.

Comics—sequential art, storytelling via sequential visual images—are as old as human history itself. The hieroglyphics in ancient Egyptian temples are comics, in this broad sense. But comics as we know them today—colorful little rags detailing the lives of outlandishly dressed superheroes and villains—are a relatively new phenomenon. The comics industries in America, Europe, and Asia are all less than a century old. And graphic novels are newer still—Will Eisner's *A Contract with God*, commonly hailed as the first proper graphic novel, was published in 1978. (The late Eisner might have differed; he counted Lynd Ward's novels done in woodcut as among his major influences.)

Despite their relative youth as an art form, comic books are the "sick man" of the visual arts. I've been working in mainstream comics—that is, superhero comics, the type of material published by Marvel and DC Comics—since 1993, and of those twelve years, two of them have been good for the industry: 1993 and 1994. Then the industry went into a withering recession, caused by:

- rising paper prices
- the sudden end of a boom of speculative collecting
- competition from too many other entertainment outlets
- the increasingly apparent limitations of the direct market (the system by which most comics in the United States are distributed and sold)

These are just some of the reasons for the industry's woes. As to the third item on the above list, it's no surprise that kids today would rather spend twenty bucks on one new Playstation game than on four or five comic books. I spent more time playing *Grand Theft Auto: Vice City* than it took me to read *War and Peace*, much less five twenty-two-page comics. The only way I could stop compulsively thumbing *Vice City* was to physically destroy the disk. Okay, I haven't actually read *War and Peace*, but you get the point. (The part about destroying the *Vice City* disk is true.)

When I was a kid in the '70s, kids read comics because there were no video games, cell phones, palm pilots, PCs, Macs, or Game Cubes. Movies were mostly boring, television was mostly crap (nothing new there, but at least you didn't have nine hundred channels of crap), and kids were allowed to be bored and idle—they weren't constantly being shunted from ballet to baseball to debate team like little assembly-line workers on a perpetual speed-up. We always had lots of unstructured, unmonitored time after school, so we read and drew comics.

Am I sounding like an old man yet? Well, the fact is, compared to the comic book target demographic of yore, today's comics audience is old. I have four nephews, ages nine through thirteen. They have Gameboys welded to their hands. They stare, and stare, and stare at them, like scholars poring over the Rosetta Stone. When mention is made of what I do, they shrug with uncomprehending indifference. When I was twelve, I'd have freaked to meet someone who did art for DC Comics. What are you gonna do? More on the aging of the comics-buying public soon enough.

As to the fourth item on the above list of challenges, the "direct market" just means that comics retailers buy their comics *outright* from the publishers (via a few distribution companies). Whatever they can't sell, they're stuck with. This is also known as a no-return policy. This unusual method of getting comics to the buying public helped save the industry in the late '70s when it was in a slump, but it has become a hindrance to the growth and health of the business—retailers are encouraged to give ever more shelf space to just a few guaranteed good sellers (like the Spiderman and X-men titles) and less space to more innovative, risky stuff. And the very fact of there *being* specialty stores that you have to go to to get your comics is itself problematic. I mean, it's a good thing they exist, but only if one of them is near you and if you have some way to get to it. This can be a real problem if you're ten years old. You don't see comics for sale in every 7-11 convenience store the way you did twenty-five years ago. Maybe, in

time, the Internet will change things, and swapping comics online will be as easy as swapping songs is now. But that's the future. The fact right now is that it's perhaps harder than ever to get comics into young hands. Which brings us back to the question I left dangling above . . .

What in God's name are forty-year-olds doing reading comics?

Enjoying them immensely, from everything I've observed. Readers of graphic novels, in particular, are exposed to some of the most beautiful and compelling artwork being produced by illustrators today. For some, graphic novels provide the only real literary experiences of their lives. Some readers of graphic novels are enjoying the closest thing they'll ever have to the kind of transformative, mind-changing epiphany that great novels and books can give. A lot of the material being published today is *that good*, I think. Art Spiegelman's *Maus* is that good. Will Eisner's *A Contract with God*, Chris Ware's *Jimmy Corrigan*, Joe Sacco's *Palestine*, Alan Moore's *Watchmen* and *From Hell*, Jason Lute's *Berlin*, Max Allan Collins's *Road to Perdition*, Craig Thompson's *Blankets*, Daniel Clowes's *Ghost World*, and Seth's *Clyde Fans* are all that good. The titles just mentioned—the merest smattering of goodies available out there—are as different one from another as can be. Fiction, nonfiction, history, biography, autobiography, fantasy, crime drama, on-the-spot journalism, comedy, horror—all of that and much more is to be found in this short list of titles. What do they all have in common? They're all graphic novels.

What are graphic novels?

Well, they're not porn, so just calm down.

There can be no one definition of graphic novels, any more than there can be a definition of graphic art or of novels. Alan Moore, writer of the above-mentioned *Watchmen* and *From Hell*, prefers the term "big expensive comic book," and Art Spiegelman, creator of *Maus*, likes "a comic book that needs a bookmark."[1] How about this?

> *Graphic novel, df. Big, fat, expensive, hoity-toity comic book that wants to soar with Hemingway and Faulkner, but can't get the mud of its Super-Friends-and-Wonder-Woman birthplace off its wings.*

But seriously, a few generalities can be ventured.

First, graphic novels are comics—a form of sequential, visual storytelling. They exploit and expand on the armory of comic book techniques and conventions that thousands of comics artists with no literary pretensions whatsoever have been building up for decades. As in all the arts, we stand on the shoulders of giants.

Second, they are indeed long. *The Resonator* is short for a graphic novel. Anything shorter than seventy or so pages is seldom graced with the title "graphic novel"—it is usually called an "extra-long one shot," for example. Craig Thompson's *Blankets* is 582 pages—probably the longest comic ever published in one piece. But physical bulk doesn't necessarily entail a huge time investment—I plowed through *Blankets* in 3 hours and 20 minutes because of the compelling story and lucid storytelling.

Third, they're for big boys and girls. Even though *Maus* is drawn in a charmingly simple style, *don't* give it to your eight-year-old. Graphic novelists tend to be far darker and more inward-looking than their mainstream counterparts. Mature themes, often autobiographical in nature, abound in the pages of graphic novels. Even when superheroes are given their own graphic novels, as in *Watchmen*, or Frank Miller's *The Dark Knight Returns,* the intention is typically to somehow debunk the superhero mythos, or to expand and reinvigorate it in some new and very dark way. Again, all of this reflects and is reflected by the aging of the comics audience. Comics and their readers have indeed matured.

Fourth, graphic novels *tend* to deal with real world problems. And their protagonists *tend* to be lonely people who don't fit in. I know the exceptions to this are legion, and I'm not saying this is how it

ought to be—I'm simply noting a curious fact. If you look at some of the best graphic novels—*Blankets,* Debbie Drechsler's *The Summer of Love,* Adrian Tomine's *Summer Blonde, Ghost World,* Marjane Satrapi's *Persepolis,* Harvey Pekar and Joyce Brabner's *Our Cancer Year* (not to mention everything else by Harvey Pekar) and arguably the works of Joe Sacco—you'll see what I'm talking about. This is a consequence of the fact that graphic novelists often tend to be odd, unemployable, solitary types, not to put too fine a point on it (plenty of exceptions here, too).

Fifth, as noted by comics expert Charles McGrath, "Most of the better graphic novelists consciously strive for a simple, pared-down style and avoid tricky angles and perspectives."[2] This is true of all of the titles I mention in this book. The tendency in the mainstream superhero comics community, by contrast, is towards ever more detailed artwork and ever more splashy imagery—readers of superhero comics expect them to keep pace with effects-laden movies and computer games. The differing aesthetics of graphic novelists and mainstream creators is partly due to those whom they count as their respective influences. Graphic novelists tend to count films, European comic artists, and icons like Will Eisner, Harvey Kurtzman, and Robert Crumb (all of whom have cartoonish styles) among their influences. Mainstream artists will more often cite other mainstream artists, living or dead. Countless mainstream artists learned most everything they know by emulating the work of Jack Kirby and John Byrne, two of the most prolific and brilliant superhero comics artists ever.

This deliberate paring down of styles among graphic novelists isn't just due to an attempt to put story and storytelling first. They are also trying to distance themselves from the popular association of comics with juvenile literature—children's eye-candy. The process at work here has played itself out many times in the history of art. You have an art form—think of photography, or film, or all of popular music—that has lowly, impoverished origins, and which tries, and if it tries strenuously enough, succeeds in making itself into a *high* art form. I think that's what comics in general, and graphic novels in particular, are going through right now. A negative consequence of this striving-for-the-high ground among graphic novelists is that it tends to make some of them contemptuously dismissive of their mainstream/superhero forebears and colleagues. I have never known a mainstream artist to be dismissive of graphic novels. Though their influences may be fewer, they're open-minded and take quality wherever they find it. I wish the independent comics community would try to return the favor more often.

Sixth, graphic novels tend to have an authorial integrity—a unique vision—that is often absent from mainstream comics. Most of the comics from DC and Marvel are produced assembly-line style: writer, penciller, inker, colorist, letterer, and production designer are typically all different people. This is an artifact of the way the industry evolved, with its need to put out books on a monthly basis. No one—except maybe the legendarily prolific John Byrne—could do *all* the jobs listed above and turn out twenty-two pages every month. Because graphic novelists don't really *have* deadlines—except of the self-imposed sort—they can sink one year, or two, or five, into a single project and create something substantial and still uniquely theirs.

What kind of maniac do you have to be to go into this line of "work"?

That's a tough one. Part of the answer starts in childhood. Everyone draws as a kid. *Everyone.* The psychological underpinnings of this universal need to express oneself on paper, the walls, Dad's new car, whatever, are beginning to be understood. What's also clear is that most people *stop* drawing around age twelve. Whatever need fueled their artistic endeavors has somehow been fulfilled, and they just stop.

A very few *don't* stop. A very few of those become comic book illustrators. Most comic book illustrators are just obsessive knuckleheads who never stopped drawing, have no idea why, and were lucky enough to be prodded by circumstance into a fascinating if low-paying line of work where their skills can be put to use.

But producing a full-length graphic novel is something else—it calls for a level of obsessiveness that goes above and beyond. Most graphic novel publishers won't risk committing to publish a graphic novel until they've seen a lot, if not all, of the work. Doing mainstream comics requires discipline, but at least the issues are only twenty-two pages, you know you're getting paid a fee as you work, you're in more or less constant contact with your editor, and you know you'll soon see your babies in print. You get in your little skiff, you row out a-ways, but you never lose sight of the shore. When you do a graphic novel, you get in the skiff, start rowing, lose sight of the shore, and hope to God you've got enough energy to get you to the other side of the ocean.

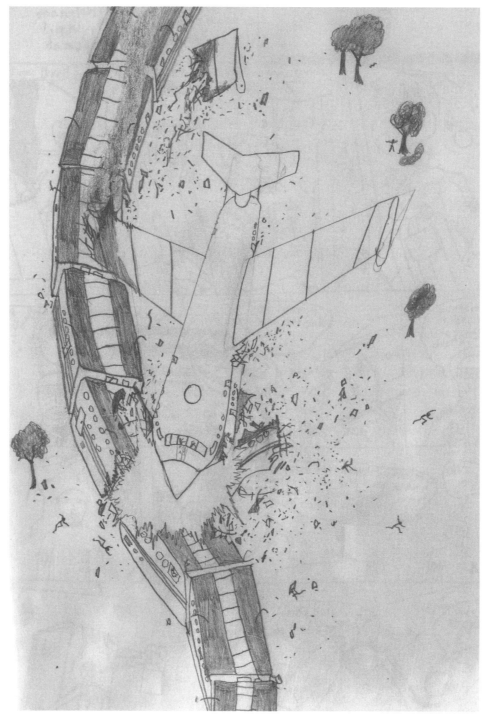

I am one of those knuckleheads who never stopped drawing. I've always loved things crashing. This is from "Disaster on the Oriental Express," my first comics story at age 11. (Can you guess what the disaster is? Compare with the shuttle crash in *The Resonator*, page 80).

It is an ocean of work, and it's often performed in solitary confinement. It's somewhat comparable to being the writer, producer, director, costume designer, set designer, star, and editor of your own film. But the payoff lies in seeing the thing grow and shape itself into something complex, multilayered, and definitively your own. And there's a unique kind of fulfillment that comes from simultaneously exercising several skills—writing, pencilling, inking, pacing your action, timing your revelations. I can't answer the question of who should or shouldn't try it. Ideally, if you do decide to write, illustrate, and letter a graphic novel, it should be because you feel utterly compelled to—there's really no better reason to do anything at all.

Why are graphic novels important?

Well, they might just end up saving the comics industry in this country, or at least being the next big permutation of it. The mainstream comic book publishers themselves are devoting more and more resources to putting out high-quality, book length compilations of their superhero material. Why? Because these giftable, archive-quality books are carried by *book*sellers like Barnes and Noble, not just by comic book shops. They're basically graphic novels. A lot of people might say that the comics industry doesn't need to be saved, that the thirty-page superhero comic will take care of itself, as it always has, thank you very much. I hope so, because I love superhero comics, and I know that if they ever stop being published, the world will be impoverished for it, no matter what anyone says.

Still, there's no denying that the comics audience is older, more sophisticated, more affluent. I don't think this is going to change; the writing is on the wall in that regard. And this is a wonderful thing, because it means that artists and writers can be more experimental, more daring, more profound than ever—they no longer *have* to appeal to kids.

There's never been a more exciting time to be in comics. The critical mass of talent in play right now—independent graphic novelists and mainstream artists alike—makes the talent pool of twenty years ago pale by comparison. Back then, in 1985, graphic novels were having their birth pangs, and mainstream stuff was still relatively yoked to the tastes of adolescents. Now, even though the industry as a whole is quite small—a "glorified flea circus," as the late comics artist Gil Kane aptly put it—everything is flowering, growing, in flux.

Charles McGrath speculates that eventually, graphic novels might supplant novels themselves altogether. "Comic books are what novels used to be—an accessible, vernacular form with mass appeal—and if the highbrows are right, they're a form perfectly suited to our dumbed-down culture and collective attention deficit."[3] We tend to forget that novels are a relatively recent innovation; prior to the nineteenth century, people read poetry and history instead. The prospect of a bookstore filled with graphic novels is a little mind-boggling, but appealing—I do like job security.

1. Charles McGrath, "Not Funnies," *The New York Times Magazine* (July 11, 2004): 44.
2. Ibid., 30.
3. Ibid., 24.

ON WRITING

[handwritten dialogue, upper left:]
"When did you sleep last, Mr. Bronsen?"
"Oh... when I was a kid, of course, but I
can't remember that. Not since."
"So it's been how long?"
"About 35 years, I guess. I'm 38 now."
"And how long are you going to be at
Sleep Station?"
"36 hours. Then I'm leaving for the McHenry
Mining colony on IO."
"You're on the Arctipode 7? drill
Yeah, that's right. I'm a mining technician.
Freelance."
"Hmmm. We get a lot of you guys in here these
days, shuttling back & forth between Mars & IO,
looking for a new ride."
"I been on Mars 18 months, pal. I
want to take a nap. I understand people used
to do it every day. That'll be my first
time ever -- not too much to ask."
"Sorry, I didn't say it was," the sleep merchant
said in a tone of deliberate amelioration.
He was a squat, elderly man with
a wheezy, lulling voice and a face that
struck Bronsen as ... well, sweet was the
word that popped into his head. Why that
word? His grandmother had used that word
... back when he was a kid. Course, a sweet boy.

[printed column, right:]
...y as she walked with studied intentness down the corridor.
...only the blood roaring in her ears and the muffled rush of
...'s ancient ventilation system. At the end of the corridor,
...ayish masses flanked a single closed pressure door. They
...en meters away now. The woman smoothed the blue fabric
...ase, pretended to look for something, pretended to find it.
...ndred times before--no problem. Ten meters away. *Click*
...e woman suddenly suspected that there might be a booger
...do anything about it now...
...am," the blob on the right said uncerimoniously, hoisting it

[handwritten note, right:]
Nightmare industrial mayhem, extending to horizon.
Splash page. Text hovers in the sky.

At a certain point, after the War Famine
after the ravaging of the Solar system for raw mate...
had begun, after the Probe Corporation had seized total
political power over the Earth -- humans stopped sleeping
The scientists never agreed on why it happe...
Some [crossed out] result of information overload --
pitch of cognitive stimulation had reached a threshold
beyond which sleep was simply impossible. Some,
[crossed out], suggested that the Probe Corporation
found a way to secretly alter people genetically, &
them to eliminate sleep in the interests of increasin...
productivity. Still others thought it was simply a
new evolutionary adaptation -- a saltation, or leap. The
productivity demands on the common run of men
made anyone more likely to survive and reproduce
than sleepers.
Whatever the case, sleep left the realm of
common life & acquired the status of a
decadent indulgence. Over the generations, the

[manuscript / script notes, lower left:]

ZONE

[margin note:] I think there used to be shuttle cars that took...
life nodes. Now there's just rusted-out...
tunnels you pull yourself through. It took all the...

Huggert: Get out of here, Bronsen. I can handle things till this shift ends. Go to a ...
lounge and pull your head together.

Bronsen: ...Okay. Thanks, Huggert.

Narr: I took the shuttle car to the concourse of life node 1. (we see Bronsen in a
cramped shuttle car.) Scores of miners milled about the endless patchwork of gunm...
gray. There were no windows outside of drive control and the officers' quarters. T...
officers were the only ones who had quarters at all.
I slumped against a bulkhead and rubbed my burning eyes. People were bru...
past and bumping into me, going to and from work details in the galleys, the central
maintenance shaft, one of the drive piles. Some cursed me under their breath.

[margin note, left:] THE TRANSITION FROM ZERO TO FULL-GRAVITY HAD ITS USUAL GUT-CHURNING, JOINT-WRENCHING EFFECT.

Page 38

[note:] HAVING WEIGH... TREMBLING IN [note:] AND THEN I REM... HAPPENING. I WAS F...

Narr: Full gravity only increased the weight of my limbs and the webbing in my m...
The only thing that stayed in my mental focus was the slowly gathering disgust I fel...
the voices and smells bombarding me. I struggled along the concourse for a while, ...
the rec lounges, the galley, auxiliary drive control, the infirmary. Then I saw a
ventilation control access door. I entered it and climbed the narrow staircase befor...

Page 39

[note:] TRANS IN BEST TO LOOK LIKE I WAS ON A REGULAR MAINT-ENANCE RUN. TWO OF

Narr: I was now in a network of catwalks separating the life node's two levels. (Bro
has to crouch in this area—it's a bit like the half level John Cusack discovers in the
building in 'Being John Malkovitch'.) I had no idea any of this was here. I continu...
a bit and entered a storage hall off the primary corridor.
The voices were gone. I removed my work belt and laid my flight jacket on
grill. As I laid down on this makeshift bed, I realized I could hear it again—the sam...
muffled echo deep in my ears that I'd first detected in the bed on Sleep Station.
After a while I closed my eyes, breathed deeply, and listened to the distant p...
of the drive ears. PILES MOST OF MY GEAR AND COLLAPSED.
[note:] AND THEN AN

Page 40

(We're back in the wilderness dreamscape. The resonator is perched on its branch,
Bronsen stands nearby.)

Bronsen: (smiling) Hello.

Resonator: Hello.

The origins of *The Resonator* reach back to early 1996, when I read James Blish's remarkable short story "Common Time." Blish's story concerns an astronaut testing the world's first spaceship with light-speed capability. He arrives at Alpha Centauri only to find that the ship's engines have died. There transpires a series of hazily remembered, dreamlike encounters with a benevolent alien who repairs the ship, allowing the astronaut to return to Earth. He is crushed to learn that he won't be allowed to return to Alpha Centauri to revisit the alien, that he will be trapped in the common time of ordinary life for the remainder of his days. The story impacted me tremendously, for a number of reasons. First of all, it was a fine specimen of *hard* science fiction—it was scientifically informed, and dealt with technological possibilities that really could come to pass. Second, it simultaneously managed to tell a simple, sweet, and deeply emotional story about two radically different beings, unified only by mutual curiosity and the desire to help each other. And third, it said something we all feel from time to time, consciously or not—that the everyday doings and trappings of our lives (work, status, clothes, politics) are not what really matter. What ultimately matters is love, transcendence, insight, knowledge. I guess it was the way the story drove this point home that stuck in my craw.

Then in the summer of 1996 I served on a grand jury here in New York City. That's 3 hours a day for 1 month of mostly just sitting around, waiting for the DA to come in with a case. After jury duty I would come home and usually take a nap for about a half an hour before getting to work. Our cat, Poder, was of assistance here—he'd snuggle up against me, and his purring would often lull me to sleep.

Guilt-ridden sleep.

I've always been bemused by the way people, myself included, feel guilty about sleeping too much, like they're somehow shirking their duty. Americans engage in the goofiest one-upmanship when it comes to how little rest they get. "I only sleep about six hours a night." "Dude, I can't remember the last time I slept six hours. Five's enough for me." After weight loss and pharmaceutically enhanced sexual prowess, sleep deprivation seems to be our main national aspiration. There's lots of reasons for this. We're a hard-working, materialistic lot, not given to reflection. We all know that idle hands are the devil's workshop. The term *workaholic* is due to be retired from the national lexicon—we're *all* workaholics. Only the Japanese outdo us in this regard.

I suspect that this need to be awake and constantly busy very much serves the interests of the status quo and our political masters—idleness is a precondition for creativity and reflection—including reflection on the myriad ways in which we're all being screwed over, all the time. In George Orwell's novel *1984*, the citizens of Oceania are kept in a constant state of war hysteria, and they are manipulated in such a way that all of their fear and hatred is focused on one despised, shadowy man—the real world parallels of all this are too obvious to mention. This theme of the government and the organs of commerce keeping citizens constantly awake and busy as a means of suppression was absent in the original, written version of *The Resonator,* but very much informed the text of the final graphic novel—in it, the government *is* the sole organ of commerce, and sleep is a rare, tightly regulated activity; the government knows the potential threat to itself posed by its citizens resting.

Anyway, all these musings about sleep deprivation, purring cats as sleep inducers, and "Common Time" were going on in the radiant abyss of jury duty. One day the tumblers just lined up and I started writing a short story on ruled paper. At the end of the month, I had done my civic duty AND I had a twelve-page story called "Resonator Dreams." In it, Bronsen, a space-going miner in an unspecified future where humans no longer sleep, has a dreamlike encounter with a resonator, a creature *we* know to be a cat but which, in this particular future, is basically used as a tool for inducing sleep. The creature does

Opposite (clockwise, from top left): Page 1 of the original short story (Thank you, New York Municipal Courts); page 1 of the expanded short story; page 1 of the first draft of the comic script; a typical page from the final script (Additions and deletions were made right up until the end. The numbers in the margins refer to panel breakdowns.)

something to him, reawakens his ability to sleep (as it were), and the story ends with an indication that Bronsen and the resonator are able to reestablish their dream connection at any time, no matter how far away they might be from each other. I showed the story to four or five friends (who said they liked it), and tucked it away.

The thing I liked most about the story was its central conceit—or joke—that the ominous-sounding resonator is just a fluffy kitty cat. *We* know this, but the work-addled denizens of Bronsen's world don't. We're in on something they can never be in on, and that gives the reader a connection to this future world, a foothold in it, no matter how bizarre it might otherwise be.

The other thing I liked was that "Resonator Dreams," like "Common Time," smacked of being hard science fiction, which is wonderful, considering how little I know about science. Again, hard science fiction is rooted in real science—it usually proceeds by postulating something strange but possible, and then extrapolates to see what the consequences are. In the case of "Resonator Dreams," the postulation was that humans might evolve in such a way that they no longer sleep. The idea was that we, now, are only beginning to feel the environmental pressures that could cause this—not natural environmental pressures, mind you, but pressures from the social environment, the pressure to work more, be a good producer, and so on. And the extrapolation was that maybe another species might evolve in such a way that it could give sleep back to us.

The problem with the story at that point was that it was *just* an exercise in hard science fiction. It was at bottom a story about sleep and cats, and honestly—

—who cares?

The plot thickens

In 1997 I took a writing seminar at the Gotham Writer's Workshop. I needed to submit a short story. "Resonator Dreams" was rechristened "The Resonator," and I tripled its length, so that its plot basically matches that of the current graphic novel. It was pretty heavily criticized by the class, and changes were made. The critical improvement was that, although the hard science fiction elements were retained, the story was now about Bronsen, and the resonator was demoted to being the macguffin. More on that anon.

From 1998 on I knew I wanted to turn "The Resonator" into a graphic novel, but until the prospect of writing *The Making of a Graphic Novel* came along, I never had a reason to get serious about it. When this book was OK'd, the first thing I did was translate the short story into a comic script—initially as a long-hand version and then as a typed manuscript with changes and improvements. This was a fairly easy, mechanical process. Most of the dialogue in the short story was carried over directly into the script, and any thought about what the characters or their environments would look like was deferred to the pre-production process that would follow (see the next chapter). So the script, in both of its forms, was almost entirely dialogue, peppered with minimal descriptions of actions. I did it this way because I didn't want to bias myself (at this early stage) as to how the world of *The Resonator* would look—I just wanted to get the dialogue and scene structure on paper, as a necessary prelude to the hard choices to be made during preproduction.

Changes and improvements to the script were made throughout the entire period I was drawing the graphic novel. I drew the graphic novel ten pages or so at a time—that is, I would pencil and ink the first ten, then the next ten, and so on, instead of pencilling the whole thing and then inking the whole thing. This was just to allow for new ideas. By the time I'd finished my current chunk of ten pages, I'd have ideas on how to make the next ten better. Changes and additions kept occurring to me right up until the end. I didn't have the idea for the last dream sequence, in which Bronsen spurns and then symbolically ingests the resonator (pages 85–90) until I was nearly done drawing and inking the pages leading right up to it. It wasn't there in the original short story. I now consider it the most important scene in the whole thing. I can't recommend enough the strategy of drawing in piecemeal; the key is to allow some

means whereby your novel can naturally evolve and dictate its own development. If I had gone with the strategy of first pencilling, and then inking, the entire graphic novel, I would have been hamstrung in the presence of the aforementioned new ideas that presented themselves along the way. If a new scene occurred to me as belonging after page 50, for example, I would not have been able to insert it at all, unless it had absolutely no bearing on anything that happened after it, which is unlikely. And if I had second thoughts about a scene, I wouldn't have been able to delete it.

The Resonator's voyage from short story to script to graphic novel is not typical—but then there is no typical route whereby graphic novels are conceived and created. Usually when a graphic novel has an earlier incarnation as a piece of writing it's because an artist has made an *adaptation* of a written work by someone else (the old "Classics Illustrated" line of comics, in which classics like *Beowulf* and *Last of the Mohicans* were given comics treatments, are an instance of this). More often graphic novels are conceived originally *as* graphic novels, and as such they are written first in script form. But they can also be adaptations of films (all the *Star Wars* films got comics treatments), and it's even possible for a graphic novel to emerge from what was originally planned to be nothing but an ongoing comic strip. All I can recommend is that you use whatever writing process you're comfortable with—there is no rule to be followed here.

The structure of *The Resonator*

The Resonator has a traditional three-act structure. I gave it this shape because solid, traditional storytelling demands it—stories necessarily unfold in a certain rule-governed way. If you want to write the next *Ulysses,* you needn't bother with acts or structure. But I assume that you are more interested in the rules of traditional storytelling (you should know them if you intend to break them). Acts must not be confused with chapters. *The Resonator* has three acts but five chapters. Chapter breaks are chosen arbitrarily, usually at the end of an important scene. They allow the story to "breathe," giving the reader chances to pause or stop, put in a bookmark, go to bed. Chapter breaks also serve to "punctuate" a scene, to add a little metaphorical exclamation point ("That scene you just finished is so important I'm gonna start a whole new chapter after it!"). Acts are units of dramatic structure, and they are not arbitrary. In *The Resonator,* act one corresponds to Chapter 1, act two to Chapters 2 and 3, and act three to Chapters 4 and 5.

Stories proceed by **beats, scenes,** and **acts.**

A **beat** is simply an exchange between characters, either of dialogue or action. Drama lives and dies by *conflict,* and ideally beats themselves should be mini-conflicts, where your characters' values—their goals and desires—are either being furthered or thwarted. Someone asking a question and having it answered would constitute a beat. But someone asking a question and getting slapped in the face for having asked it would be a more dramatic, and thus better, one.

Several beats make a **scene,** and scenes should culminate with an even bigger reversal for your protagonist. Bear in mind that reversals can be both negative and positive—if things are going really badly for your protagonist, as they often do in second acts, the reversal in the act's final scene will most likely be something good. (The term *protagonist,* incidentally, is Greek in origin; it means "the one who struggles/endures the most." It's a mistake to think that the protagonist has to be good; Oscar Mannheim is the protagonist in the film *Runaway Train,* but a more vile man couldn't be imagined.)

An example of a scene from *The Resonator* is when Bronsen first meets the Sleep Merchant (pages 10–15). The scene slowly escalates as each character hedges around the other, each trying to get what he wants. Bronsen wants to use the resonator, but he's suspicious of the Sleep Merchant's (and Huggert's) motives, and he's afraid of breaking the law. The Sleep Merchant wants money, but he's suspicious of Bronsen's credentials. The scene culminates with Bronsen agreeing to the Merchant's terms—and quickly realizing that he's just made a bargain with the devil. A small, but significant reversal.

Another example of a scene is the entirety of Chapter 2 of *The Resonator* (pages 27–34). This is the sort of scene that mainstream comics writers hate to write, and that most mainstream artists dearly hate to draw—two guys sitting around talking for seven pages. I did feel uncomfortable writing it, precisely because there's *so much* talking, and telling, and as a comic book artist, every fiber of my being cries out against this! There should be action, characters *doing* things, showing us, not telling. But there was no clear way around it; the scene was necessary, for several reasons. First, I needed to flesh out the characters of Bronsen and Huggert a bit, and clarify the relationship between them. Second, there was a lot of exposition that needed to be put on the table.

Exposition is just backstory (stuff that happened in the past) or any other information the reader has to know for the story to make sense. The problem with exposition is precisely that it is information, information that has to be told somehow—and, as I indicated above, as a general rule you never want to *tell* the reader anything; you want to *show* them, through action. In order to show the exposition in *The Resonator* I would have to do another graphic novel, set in the past. Not having that option, I settled on having the exposition unfold as a conversation between Huggert and Bronsen, peppered with flashback imagery (to Huggert's boyhood, for example), quasi-abstract imagery (the X-ray of a resonator standing on a person), and cut-aways (to the lonely resonator sitting in the dark). I could have put the exposition at the very beginning (as part of the narration on the first three pages of the story), but I would have lost the reader (too much information too soon equals eyes glazing over), and spoiled the surprise that the resonator is really a cat.

I tried to make the give-and-take between Huggert and Bronsen subtle yet palpable in this scene, by slowly revealing aspects of their personalities as the exposition unfolded. Huggert emerges as a cynical, pompous know-it-all, friendly one moment and vindictive the next. And Bronsen emerges as a slightly craven but still basically good man, who is intrigued with the resonator and who wants to help it, but who can't risk looking *too* concerned about it. That was what I was going for, anyway. The scene climaxes with the conversation abruptly becoming personal and quite uncomfortable for both men.

Huggert fancies himself an ambitious man, yet Bronsen insinuates that Huggert has no idea what it really means to want something, and Huggert *knows* that Bronsen is right—a reversal for Huggert. Huggert retaliates by telling Bronsen that the resonator will soon be dead, that he'll never see it again—a reversal for Bronsen. Huggert becomes conciliatory but is silenced by a look of barely contained anger from Bronsen—a reversal for Huggert. The power of the emotional exchange escalates—from coy insinuation to crass revelation to a glance that practically threatens violence. And there the scene, and chapter, ends. So in seven short pages we got the backstory of resonators, part of Huggert's backstory, and a look at the precarious emotional relationship between Huggert and Bronsen.

Several scenes make an **act**, and an act always culminates with a major reversal for the protagonist—this is sometimes called a "plot point." George Lucas has characterized dramatic structure thus: in act one you introduce your characters; in act two you put them in the worst situation they could possibly get into; in act three you get them out of it. That's a pretty good way to remember it.

Act one of *The Resonator* ends with Bronsen waking up from his first dream encounter with the resonator and realizing that he's just experienced something that has changed his mind, his life, or both (page 26). Act two ends with Bronsen killing Huggert and fleeing Polarprobe 7 (page 58)—obviously a huge reversal; this man who at the start was afraid of breaking *any* laws has willy-nilly become a criminal in the worst way possible. Act three ends with Bronsen waking up from his third and final dream encounter with the resonator—a major reversal, since he now knows that he has lost the resonator forever (page 91). This is followed by a **denouement**, a final scene in which plot intricacies come together and are resolved, and in which we are given an indication that although Bronsen has in fact lost the resonator, the resonator may have given him something even more important. Note that with each successive scene, and act, the conflicts and stakes escalate—the protagonist's decisions become harder, more momentous.

And this is reflected in the growing extremity of the actions taken by the characters—each of Bronsen's criminal actions outdoes the one before in its daring—he goes from using a resonator to killing a fellow miner to sabotaging a starship to stealing said resonator from a very dangerous man to defying a top government agent . . . and so on.

There are three fundamental types of dramatic conflict: man versus self, man versus man, and man versus nature. The more of these types of conflict you can work into your story, the better. *Star Wars* beautifully embodies all three types: Luke Skywalker is conflicted—he wants adventure and yet is unable to abandon his adoptive parents (man versus self); he has to fight off hordes of imperial troopers (man versus man); and he has to attack and destroy the gargantuan Death Star (man versus nature).

In *Raiders of the Lost Ark,* Indiana Jones is a singularly *un*conflicted character, as unconflicted as Odysseus or Robin Hood or any of the other pure, archetypal heroes. He's a studly, brilliant adventurer, and he loves himself, and everyone loves him, and he knows it, and they know it, and he knows they know it, etc., etc. But the film is a smashing success because what it lacks in the man-versus-self variety of conflict is more than made up for with the other two kinds—man versus man and man versus nature. The conflict in *The Resonator* is mainly of the man-versus-self variety: Bronsen has to overcome certain fears to accomplish something he realizes is more important. More on this shortly.

The Resonator employs what's called a **framing device**—that is, the story itself is a flashback framed by a scene at the beginning and end that takes place in the present. A framing device is a good way to hook your readers—you show them something interesting (in this case a hideously injured man talking to a beautiful young woman), and then you basically promise to show them how this situation came to be—*if* they read on. I tried to put multiple hooks in *The Resonator.* The first three pages of splashy visuals are accompanied by the message that humans have stopped sleeping, which is bound to make people scratch their heads. Then Fenright reveals that Bronsen has a rap sheet as long as his arm, and on the very next page we see him whispering to Huggert that he's never broken the law. What gives with this guy?

Your goal is to keep your readers hooked until you can get to your **inciting** incident. The inciting incident is the event that starts your protagonist on his journey, the thing that changes his life and throws it out of balance. It often coincides with the first plot point—for example, in *Star Wars*, the inciting incident is Luke's discovery that his adoptive parents have been murdered. There are several mini-inciting incidents leading up to that, but that's the incident that changes Luke's life irreversibly. The inciting incident in *The Resonator* is Bronsen's first dream encounter with the resonator, which turns his conception of reality upside down.

As I said before, the resonator is the story's **macguffin**, a term coined by Alfred Hitchcock. This is an invaluable concept. The macguffin is what your story is *ostensibly* about, but not *really*. All the characters want the macguffin—either to save it, possess it, or destroy it—but the reader doesn't really care about it, he just cares about the protagonist. In *Star Wars* the macguffin is the stolen Death Star plans. In *Jaws*, it's the shark. In *E.T.*, it's E.T. *Citizen Kane*: Rosebud. *Bladerunner*: the replicants. *Titanic*: the big diamond. And so on. Anytime there's traditional storytelling, there's a macguffin that acts as a vortex around which the story turns.

Wanna send a message? I recommend Western Union

Well of course you want to send a message in your writing, everyone does. The problem is that if your reader thinks for a moment that he's being preached to, you'll lose him, and serves you right!

I fantasize about hearing two people talking about *The Resonator* in the café at a Barnes and Noble store:

> **Person A:** I'm reading this absolutely fabulous graphic novel!
> **Person B:** What's it about?

On Writing

And then Person A gives one of several possible answers:

Answer #1: It's sci-fi, spaceships and whatnot. It's the future, people never sleep, they just work work work. This miner kinda' like falls in love with this cat that makes him sleep, and then he chucks his whole career just to allow the poor thing to have a dignified death or whatever. There's a cool crash scene. Burp.

Answer #2: Well, it's about THE HERO'S QUEST. Bronsen, the hero, is a miner—he embodies that drive in all of us that is seeking after riches. He lives in a world without sleep, a world in which the tyranny of labor has driven all magic, all *dreams*, from life, and reduced us to the status of machines—or servants of machines. He encounters a resonator, which opens the doorway to blah blah blah.

Answer #3: Well, it's about how we can lose sight of the important things. In the story, sleep symbolizes something fragile and distinctly human that can be (and has been) lost. The resonator symbolizes that animal *je'ne sais quoi* that can put us back in touch with our true selves. Bronsen is a cipher, a stand-in for humanity, and Huggert is blah blah blah.

Answer #1 is the one I'd want to hear. Here's why: I want the story to be enjoyed first and foremost as a story. If your story has a further point, slip it quietly under the back door, so that your reader discovers it later, and gets a little added treat. I very much like answers two and three, and I certainly had their main points in mind when I was putting *The Resonator* together. It's just that if they're the first things that come to mind when someone is asked about *The Resonator,* then I've succeeded as a preacher, but I've failed in my primary purpose as an entertaining storyteller. You want your reader to put down your graphic novel and say, "Wow, that was a hell of a story."

As an object lesson, consider the following story:

A girl, full of self-doubt and on the cusp of womanhood, lives in a circumscribed world that she thinks is the only world she'll ever know. Suddenly, she finds herself thrown into a dangerous situation she can neither understand nor control. An impoverished yet wily young man, from a world totally foreign to her own, comes to her aid. They fall in love over the course of 48 hours. They make love only once, and then the young man gives his life to save her. In doing so, he pulls her from the confines of her tiny world and shoves her into one that is bigger, more dangerous, and more thrilling. From him she learns that she has strength she never knew of and that she must believe in herself.

That's the plot backbone of two films, *The Terminator* and *Titanic.* The only other thing those two movies have in common is their writer/director. They are as different as night and day, and the only reason you never really realize that they tell basically the same story (convey the same message) is that they are such rip-roaringly good yarns that you don't actually *care* about the message. You're too entertained.

That's as it should be.

A note on character

The famous comics writer Dennis O'Neil has pointed out that it's vital to know what your characters are afraid of, not just what they want. Quite true—when you know what they want and what they fear, their actions become much more comprehensible.

And characters become much more interesting when there's a difference between what they *think* they're afraid of and what they're *really* afraid of. For example: in *Jaws,* what is Sheriff Brody afraid of?

He claims to be afraid of water—which is interesting, since he left a New York City police job to live on an island surrounded by it. What he's really afraid of is being tested—that's why he fled to the island in the first place. The shark is his test.

What is Darth Vader afraid of? He *seems* to be afraid of the Emperor, and I'm sure he thinks he is. But he's really afraid of failure. In the end, when he realizes that letting his son die will be his greatest failure in a career composed mainly of failures, he overcomes his apparent fear and destroys the Emperor. George Lucas has taken great pains in the recent trio of *Star Wars* prequels to make clear the origin of this fear.

Bronsen thinks he's afraid of getting into trouble with the authorities. What he's really afraid of is that there's no magic in the world. There's this recurring question about whether or not the resonator actually thinks and communicates with us in dreams, or rather whether it's just a dumb animal, a placebo. This was my way of phrasing the question: Is there magic in the world? Or is it all just matter and physical mechanism in the end. There's a million ways of asking this question, and each of us has to answer it one way or the other, and the answer we give will always be a leap of faith. Bronsen doesn't just want there to be magic in the world—he needs there to be. The contrast of his beautiful dream encounters with the resonator with the ugliness of his waking world is such that he can't accept the idea that the dreams are *just* dreams. For him, that would make life not worth living. Everything that happens in *The Resonator* is consistent with whatever answer the reader prefers—that's why the story ends without a pat resolution. The reader can supply it him- or herself.

The dichotomy between appearance and reality carries over to your characters' desires. Bronsen thinks he wants to save the resonator; what he really wants is to save himself. Brody thinks he wants to protect his town from the shark; what he really wants is to know that he's not a coward. Darth Vader thinks he wants to destroy the rebellion; what he really wants is to save his son, and himself. In each of these cases, the protagonist's actions appear to us, and to them, to be motivated by their concern for their respective macguffins. But their actions have deeper sources, and ultimately spring from ulterior desires and fears that they themselves may not be aware of. Characters, like real humans, are complicated, multilayered entities. Know your characters intimately, especially when they don't know themselves.

CHAPTER TWO

ON PREPRODUCTION

9/5/03

The term *preproduction* comes from the film industry—it refers to all the work that has to be done in order for production (shooting the film) to begin. In film and television, preproduction involves designing and building sets and costumes, hiring actors, finding suitable locations, and many other things. In the world of comics and graphic novels, preproduction amounts entirely to designing settings and characters (and to whatever research, if any, this entails). Mercifully, there are no actors to hire, and there is also no budget—the size and sumptuousness of your sets is limited only by your own imagination.

Working in science fiction creates a unique preproduction challenge since you have to create an entire world with visual and conceptual integrity. I never thought about how the world of *The Resonator* would look until I had to start designing it. And the designs I settled on led to changes in plot and dialogue—story and design shaped each other.

More than anything, I wanted the visuals to convey that everything is old. The story is set over a millennium in the future, and I wanted it to look like technological advance had ended centuries before—like humanity had entered a dark age, and that this dark age was somehow connected to the fact that no one sleeps. Everything, with the exception of the Sleep Merchant's quarters, is dented, rusted-out, cobbled together. I wanted to convey a feeling that humanity was lost inside these ancient machines and vehicles that they had inherited from a forgotten age, and that it was all they could do to just keep them running, and that keeping them running was its own justification in this crazy world.

All comics artists rely to a greater or lesser degree on photo reference. Time was when they were required to keep reference files with photographs of everything imaginable clipped from magazines and newspapers, all arranged by topic and tucked in folders. Some still do. The Internet, however, has lessened the need for extensive art files. If you need photo reference for the Taj Mahal, or an M-16 rifle, or a harp seal, you just Google it and in seconds you've got all the photo reference you need. Still, having a reference file is a good idea, especially if you come across a really unique photograph that catches your eye.

Given that *The Resonator* is science fiction, and that so many of its visuals had to be made up out of whole cloth, I didn't rely on photo reference nearly as much as I did on my personal taste and influences. The only photo reference I relied on pertained to Stander's face, the design of the outfits for Stander and Fenright, and the interior of Sleep Station. Up until 1992 there existed in Kowloon (a city near Hong Kong) something called the "Walled City"—a rectangular mass of urban growth about six acres in area. This area was in British territory but, for historical reasons, it was not under British jurisdiction, and so it became, in the 1960s–'80s, a haven for people fleeing communist China. It looked *grown* rather than built, a chaotic, tumorlike mass of unzoned, unregulated urban growth (see photographs on page 22 in this chapter). I wandered through the organic, labyrinthine interior of this thing for a couple of hours in 1991, and never forgot it. I wanted the interior of Sleep Station to have the same feel as the "Walled City"—like it once had a purpose but that squatters had taken over, built it up willy-nilly, and given the thing a look and culture of its own.

I spent several weeks working on the preproduction phase. Sleep Station interiors and exterior were the most challenging, but the other spacecraft presented challenges of their own. I wanted Polarprobe 7 to look beautiful in its own way, but to also approximate what a fusion-powered interplanetary vehicle might look like (it would of necessity consist mainly of engine and fuel dumps, with smaller, ancillary living areas). The miners' costumes were designed to look consistent with the spacecraft interiors and exteriors—lots of bolts and dents, everything old and re-used. Huggert's helmet is ridiculously retro—I know it's not particularly believable as a futuristic mining helmet—but it suited my goal of creating a sense of oldness and decay. The resonator itself looks decrepit and diseased—only its dream-

Opposite: In this early drawing I'm playing around, trying to settle on the "tech" look for *The Resonator*. It's pretty "steam punk," which I like.

On Preproduction

double is huge, young, and beautiful. The only things of significance that I did not do preproduction designs of were the resonator and its dream environment—I had pretty much settled in my head what they would look like during the initial writing stage.

I'm glad I devoted the weeks I did to preproduction work; I relied on the design drawings that resulted from it right up till the end. Spending a certain amount of time sketching and designing is also important because it enables you to settle on a drawing style that is appropriate to the story you're telling. *The Resonator* has a very detailed, realistic style for a reason: I had a very specific idea about how I wanted this world to look. A simplified style—like that of Marjane Satrapi in *Persepolis*—would have been inappropriate. It would have left the reader with too much work to do, too much imaginative filling-in of backgrounds and settings. Again, science fiction typically entails creating a whole world, often one that has little or no points of reference in the real world (think of the films *Star Wars, Logan's Run,* and *Metropolis*). It isn't enough in this type of undertaking to just indicate or hint at what things look like—you have to explicitly *show* the reader what they look like. On the other hand, if *Persepolis* had been drawn with a spot-on realistic style, that also wouldn't have worked—the story would have been gutted of the child's-eye point of view that it embodies. Your story should dictate its style—and as I said, you'll find that the style you've adopted, and the designs you've settled on, will in turn dictate changes in your story.

Preproduction Work for *The Resonator*

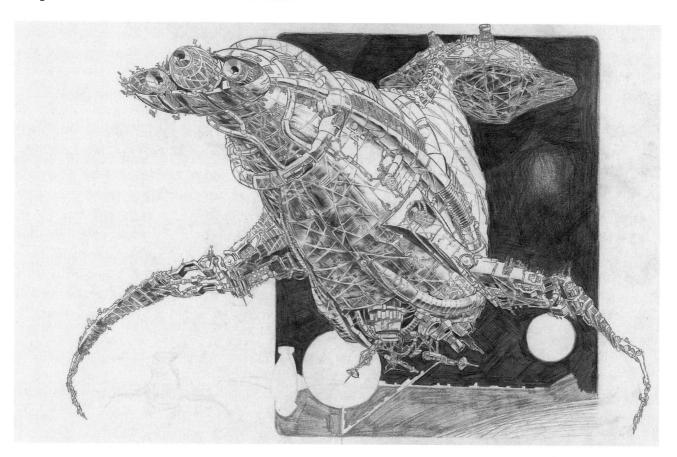

An early pass of Sleep Station. At this point I knew that I wanted a biomechanical look—vaguely organic, and in a constant state of being repaired and rebuilt due to its great age. The painter H. R. Giger, who designed the alien spaceship and the monster in the film *Alien*, exercised a great influence on me when I was a kid, and I think it shows here. I wanted the spaceships in *The Resonator* to be very intricate and detailed, but at the same time to be instantly recognizable due to their simple, organic-looking forms.

Chapter Two

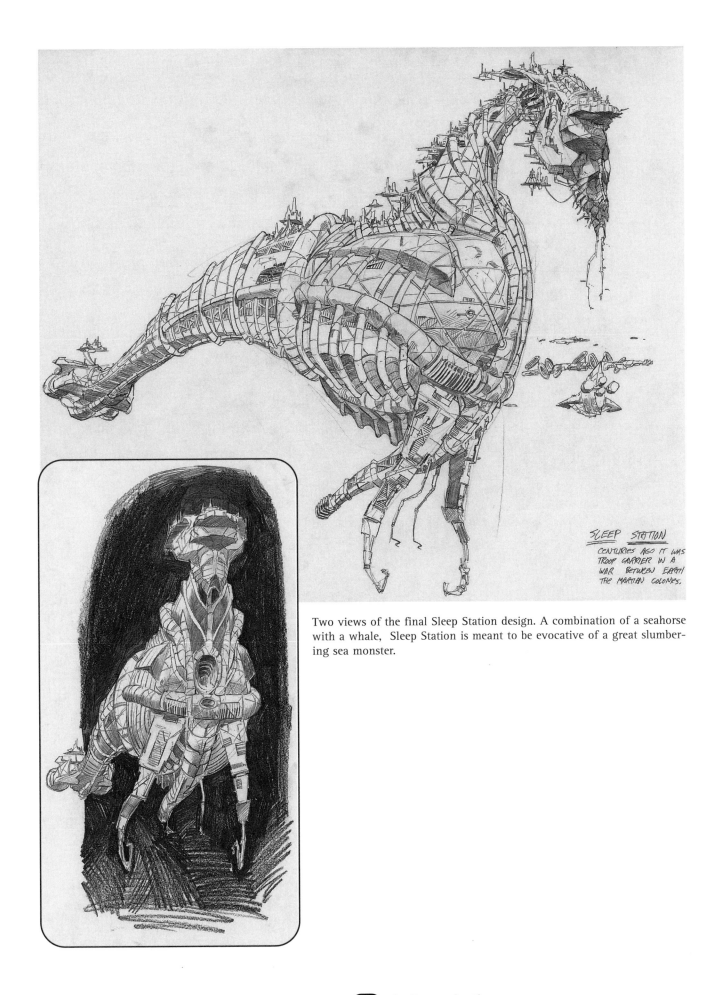

SLEEP STATION
CENTURIES AGO IT WAS
TROOP CARRIER IN A
WAR BETWEEN EARTH
THE MARTIAN COLONIES.

Two views of the final Sleep Station design. A combination of a seahorse with a whale, Sleep Station is meant to be evocative of a great slumbering sea monster.

Sleep Station interior. The look of the interior was inspired by some of the older architecture in Hong Kong and Kowloon, which seemed not to have been built as much as *grown*. I mainly wanted to convey an ancient, squalid, yet thriving community, with a unique culture all its own.

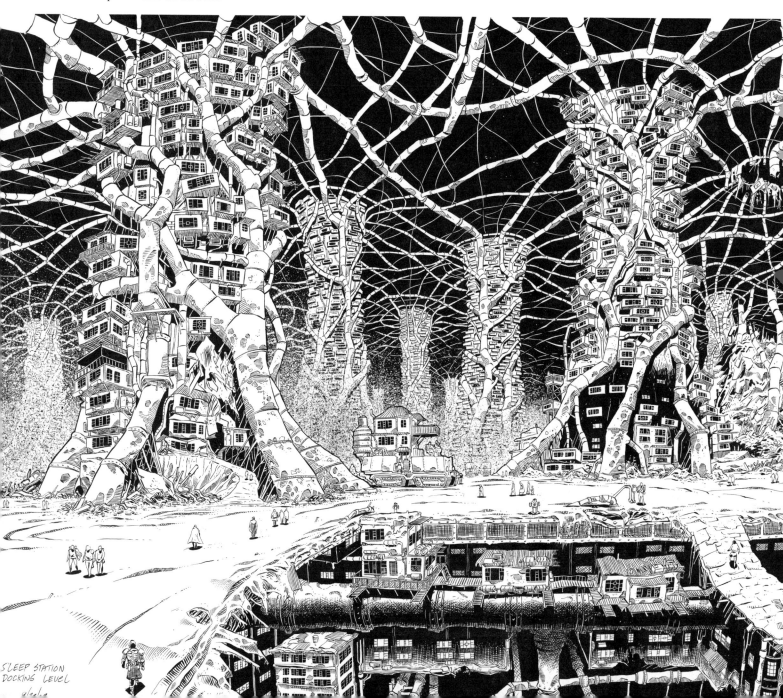

SLEEP STATION
DOCKING LEVEL

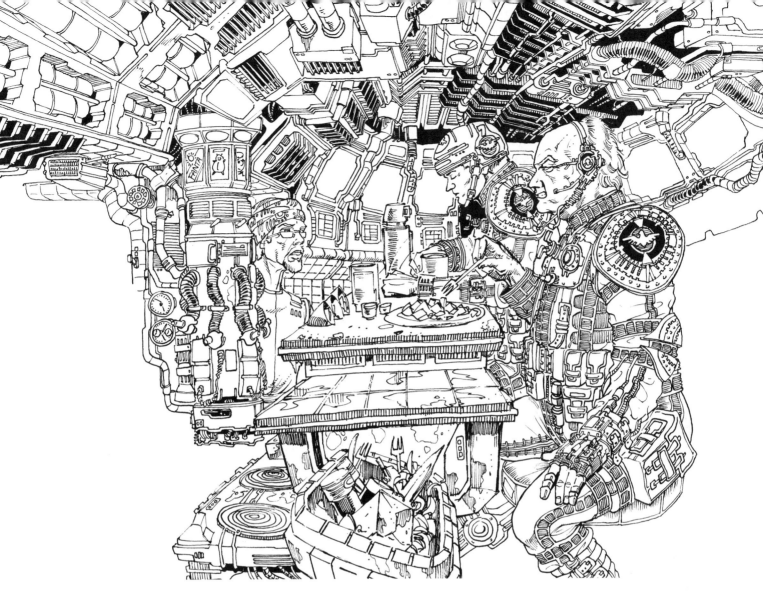

An early shot of Bronsen and Huggert eating at Sleep Station. This is the only preproduction drawing I did of an actual scene. At this early stage, I was still thinking of Sleep Station as having cramped interiors, very unlike the vast inner spaces it has in the final graphic novel. The costumes also had not been finalized at this stage. I was mainly trying to settle on an overall look, an "atmosphere."

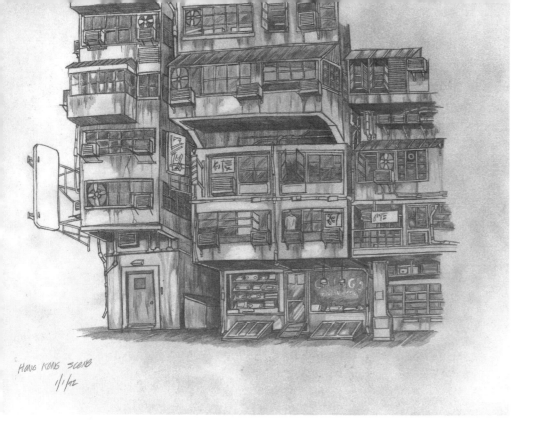

HONG KONG SCENE
1/1/92

Above: An architectural sketch I did in Hong Kong. This would later shape how I envisioned Sleep Station's interior.

Two views of the Kowloon Walled City, the inspiration for Sleep Station's interior.
Photographs courtesy of Ian Lambot

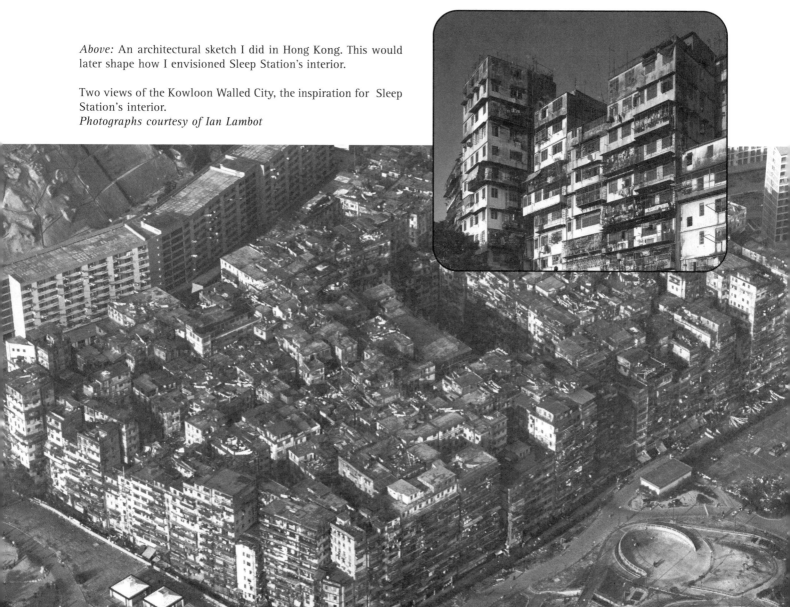

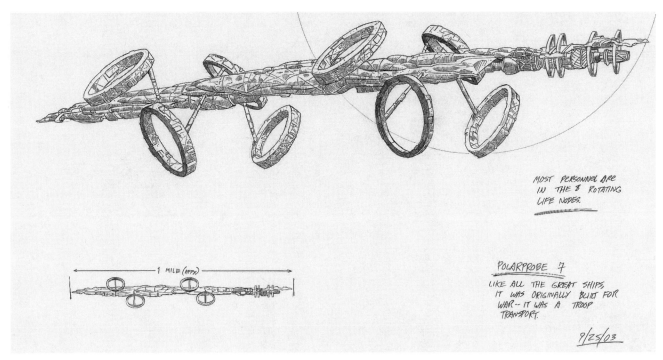

1 MILE (APPX)

POLARPROBE 7

LIKE ALL THE GREAT SHIPS,
IT WAS ORIGINALLY BUILT FOR
WAR -- IT WAS A TROOP
TRANSPORT.

9/25/03

Polarprobe 7, one of the "surviving war vessels" mentioned on page 2 of the novel and in which some of the action later occurs. I conceived of it as being essentially a vast fuel depot; it's mostly just engine and fuel pods. The uranium being sought by the miners is mainly used to keep these ships in service, and the purpose of the ships is to find more uranium.

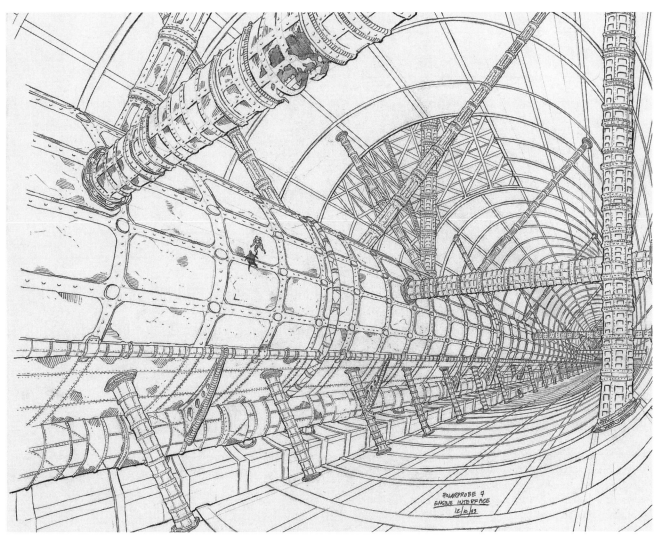

POLARPROBE 7
ENGINE INTERFACE
12/10/03

Polarprobe 7 interior. It is inspired by a Victorian train station. Most of all, I wanted it to look old.

LOGO WILL BE EVERYWHERE. IT SHOULD CONVEY THE FUSION OF CAPITALISM (THE SCRAWNY TAG LINE) & MILITARISTIC TOTALITARIAN GOVT. (THE EAGLE.)

BRONSEN'S CHEST EMBLEM

SIMPLIFIED VERSION ON CHEST/ARMPLATES.

FULL PROBECORP CORPORATE LOGO.

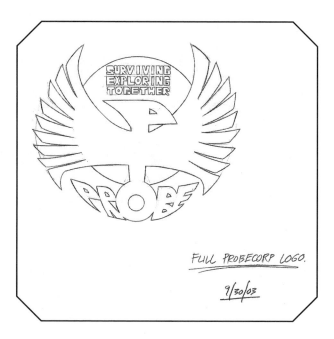

FULL PROBECORP LOGO.

9/30/03

Experiments with the Probe Corporation logo, including the final version (bottom, right). The logo was important because it was going to be seen a lot, and it's meant to be an indication of the type of government running things—a totalitarian, monopolistic corporation. Hence the militaristic eagle motif combined with the cheesy slogan. The name *Probe* was chosen because it connotes both exploration and violation of an intimate nature.

Chapter Two

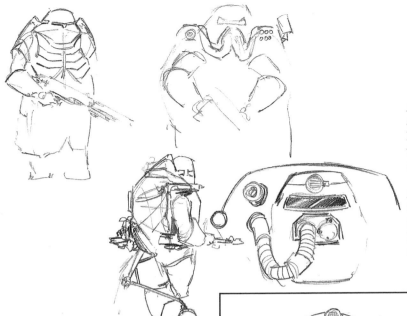

Left: Early "turtle" designs. Just playing around at this point, I knew only that they had to be big and dangerous. On the basis of these sketches, I decided to push them more in an organic direction.

Below: The final "turtle" designs. I was going for huge, scary, weird, and a little disconcerting. It was only after doing these designs that I dubbed them "turtles"—originally they were simply referred to as "guards."

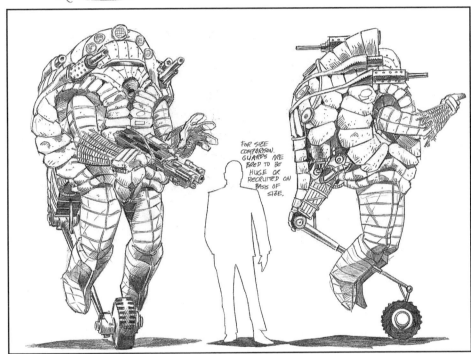

FOR SIZE COMPARISON. GUARDS ARE BRED TO BE HUGE OR RECRUITED ON BASIS OF SIZE.

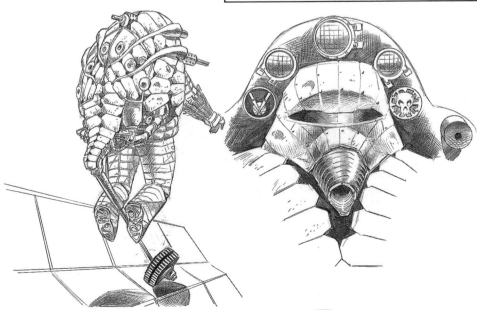

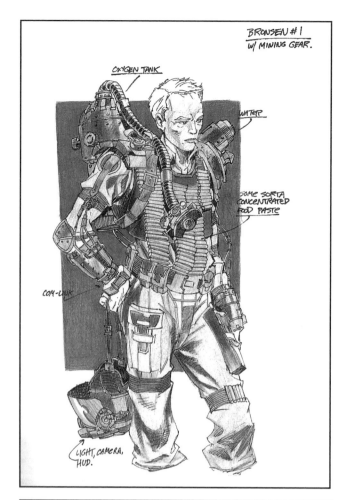

BRONSEN #1
w/ MINING GEAR.

OXYGEN TANK

WATER

SOME SORTA
CONCENTRATED
FOOD PASTE

COM-LINK

LIGHT, CAMERA,
HUD.

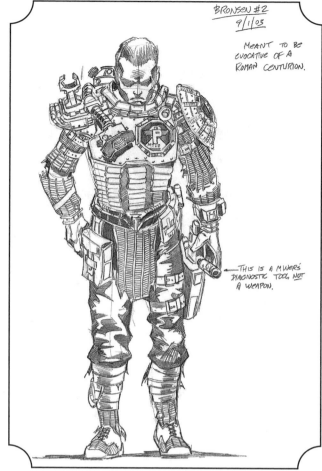

BRONSEN #2
9/1/03

MEANT TO BE
EVOCATIVE OF A
ROMAN CENTURION.

THIS IS A MINER'S
DIAGNOSTIC TOOL NOT
A WEAPON.

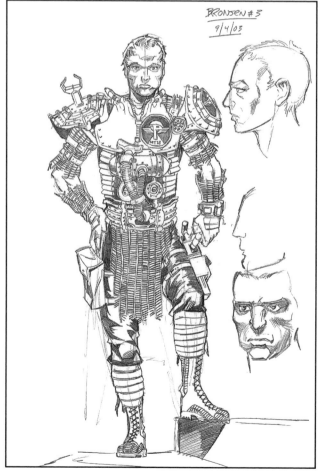

BRONSEN #3
9/4/03

Three early drawings of Bronsen. I wanted him to look handsome and sympathetic, but a little victimized and nebbishy.

Opposite: Final ink drawings of Bronsen—front, back, and profile. The young John Hurt influenced his final look. I inked the final character design shots just to nail down the inking style that would be used in the final graphic novel.

Chapter Two

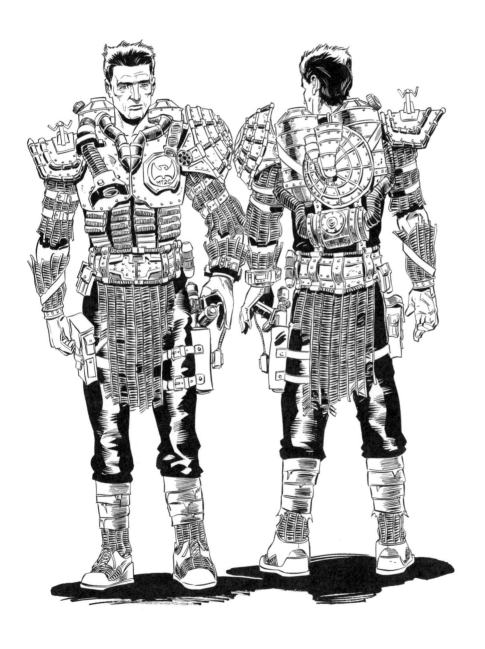
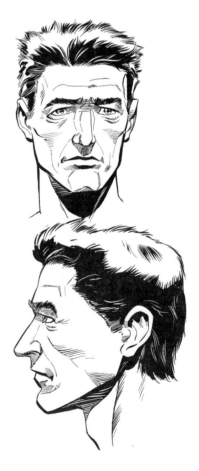

BRONSEN
10|2|03

On Preproduction

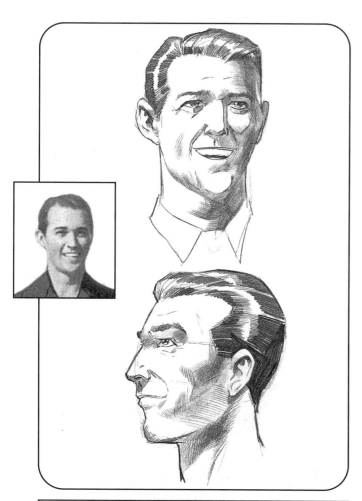

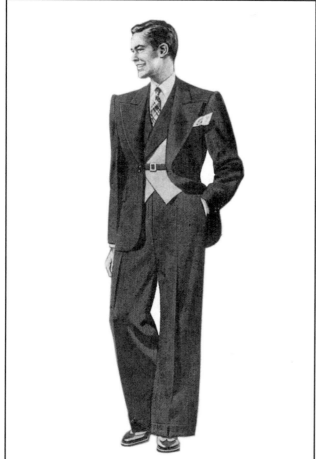

Above, left and right: Head and full-figure drawings of Stander, an ambitious, prim little dandy. I designed him thus because he was always meant to be flanked by two gigantic "turtles." I hoped that the overall effect would be a bit disconcerting. The photo inset is a guy from a 1940 Sears catalog, which provided the inspiration for Stander's face. I zeroed in on this guy because he just looks SO obnoxious to me for some reason and it seemed appropriate for Stander.

Left: This fashion plate, from a reprint of a 1941 Sears catalog, was the basis for Stander's outfit.

Opposite (top, left): An early drawing of Fenright, before I'd settled on her clothing. I had yet to develop her face.

Opposite (top, right): Final front and side views of Fenright's face

Opposite (bottom, left): Final partially inked drawing of Fenright. I know that only on *Law and Order* do lawyers look like this. What can I say? Readers like a pretty girl to rest their eyes on now and then, and I needed a break from drawing gruff-looking men.

Opposite (bottom, right): This lovely lass, from a reprint of a 1947 Sears catalog, provided Fenright's suit. I culled Stander's and Fenright's outfits from 1940s fashions to help create the visual impression that they belong to a totally different social stratum.

Chapter Two

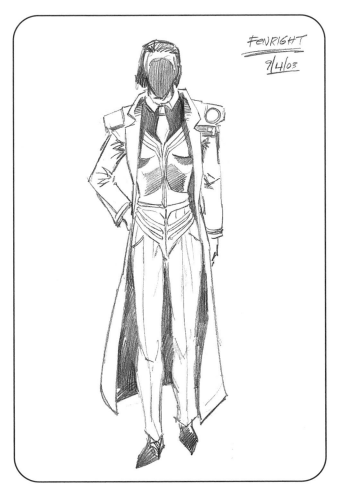

FENRIGHT
9/4/03

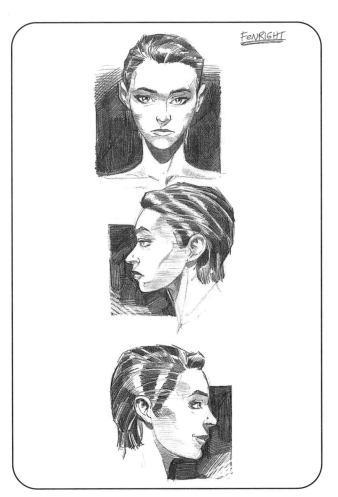

FENRIGHT

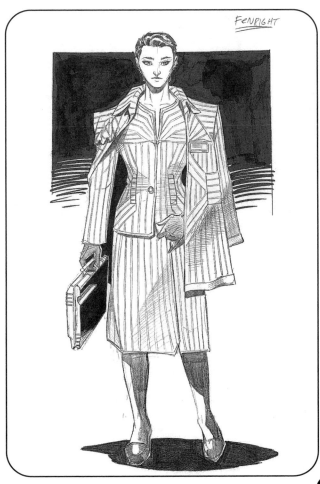

FENRIGHT

On Preproduction

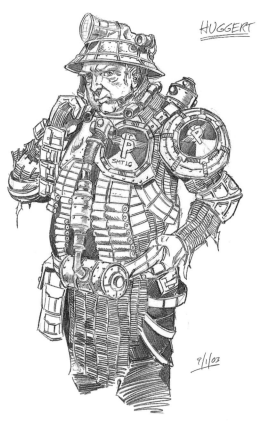

HUGGERT

9/1/03

A pencil drawing of Huggert, one of the miners

Below: Final ink drawings of Huggert as seen from the front, back, and side. I wanted the miners to be evocative of Roman centurions—rugged hombres out on the frontier, living off just what they can carry. A weird side note: The villainous Huggert is a dead ringer for William Gull (a.k.a. Jack the Ripper) as drawn by Eddie Campbell in *From Hell* (which I hadn't yet read when doing these designs).

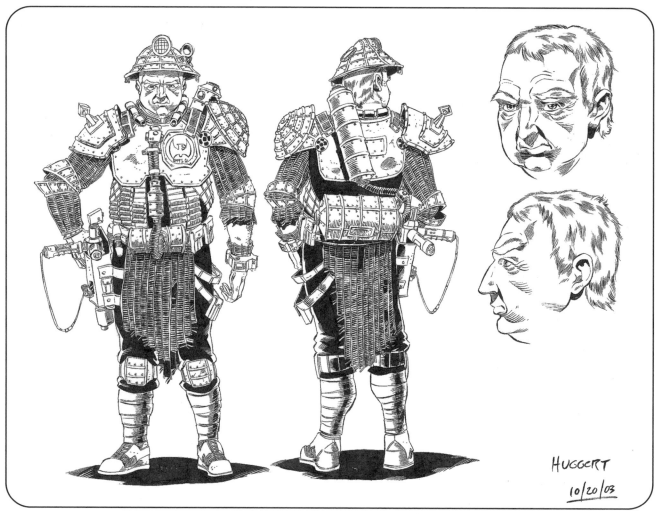

HUGGERT
10/20/03

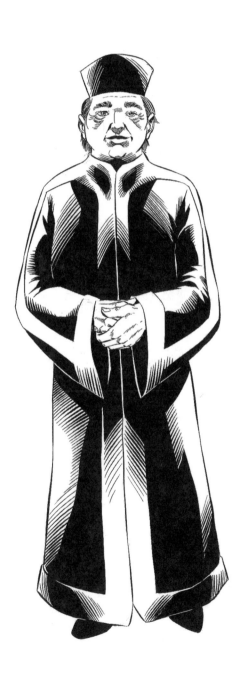
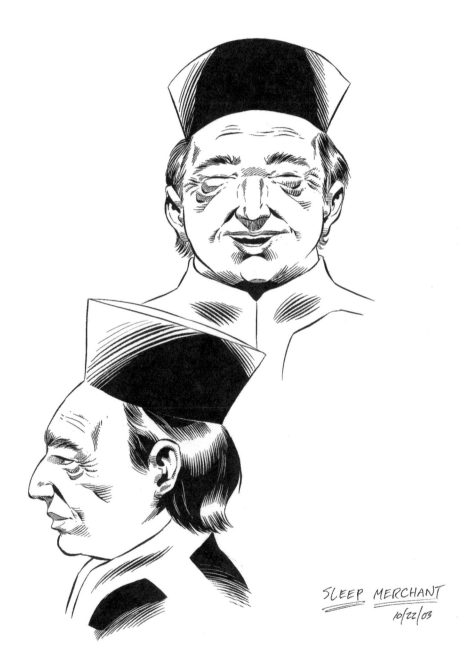

SLEEP MERCHANT
10/22/03

Final ink drawings of the Sleep Merchant. I nailed this guy on the first go—I'd always had a pretty clear idea of what this guy would look like, so after pencilling this design shot I inked it straightaway, and that was that.

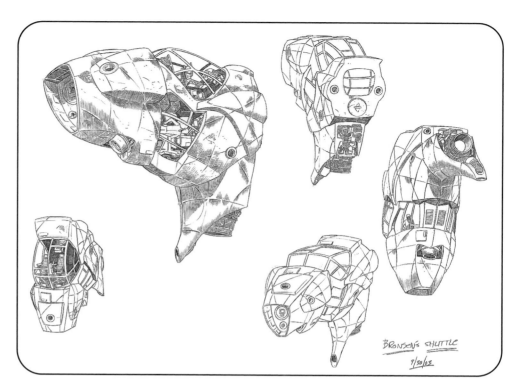

BRONSEN'S SHUTTLE
9/30/03

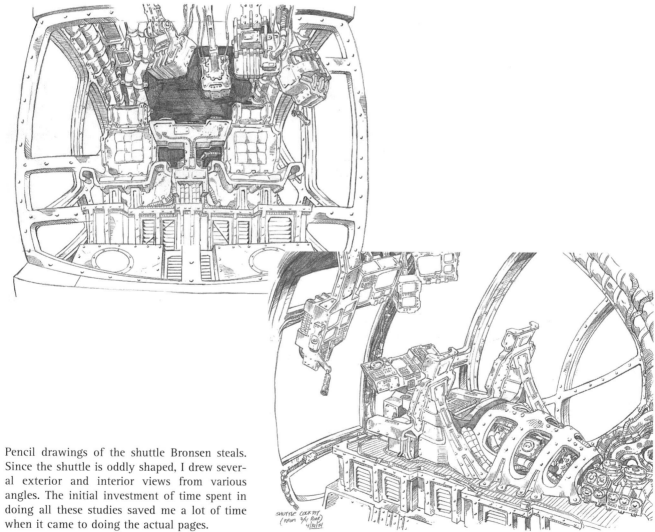

SHUTTLE COCKPIT
(FROM 3/4 REAR) 4/1/01

Pencil drawings of the shuttle Bronsen steals. Since the shuttle is oddly shaped, I drew several exterior and interior views from various angles. The initial investment of time spent in doing all these studies saved me a lot of time when it came to doing the actual pages.

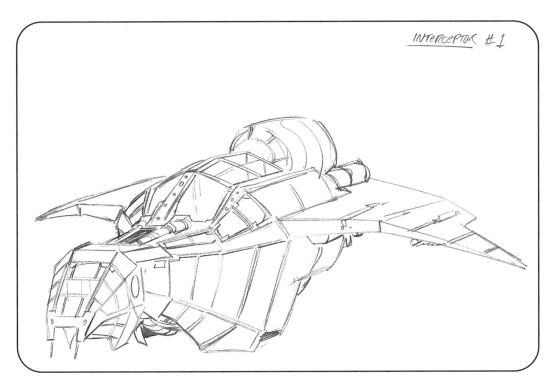

An early drawing of an interceptor, the transport taking Bronsen and Huggert to Sleep Station

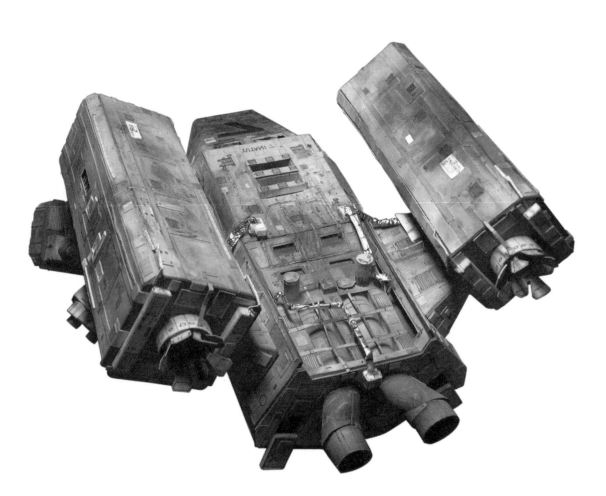

A paper and cardboard model of Stander's interceptor that I built years ago. I'm delighted I finally found a use for it.

CHAPTER THREE

IT WAS MASK-LIKE, FROZEN, LIKE AN OLD PHOTO.

ON PENCILLING

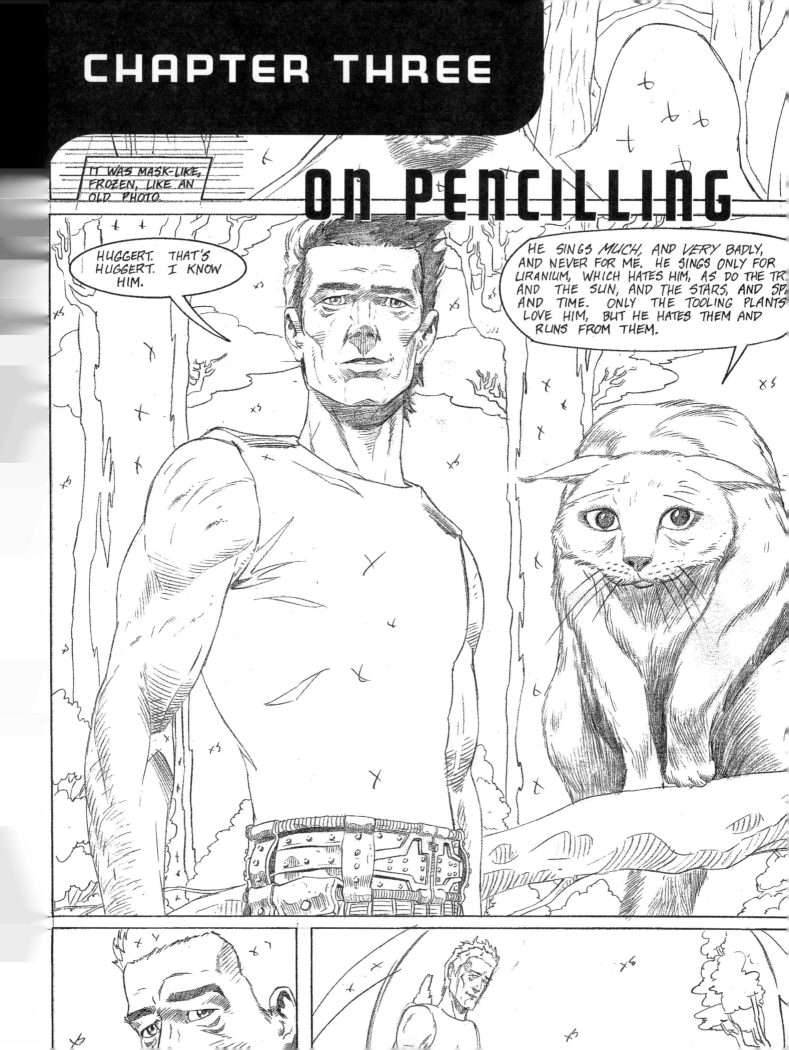

Given that comics is a visual art, and that comics are, even in this age of computer-generated art, still overwhelmingly often hand-drawn, one might think that the pencilling stage is the most enjoyable stage in the creation of a graphic novel. No doubt for some it is. For me it is not.

By pencilling I mean two things: the creation of thumbnail sketches that will serve as guides to the creation of final pencilled pages, and the creation of the final pencilled pages, which will then be inked and turned into your finished art. I very much love doing thumbnails—I consider this the most challenging part of the pencilling process. After I've laid out the page I'm working on in a thumbnail—after, that is, I've determined the page and panel compositions—what's left is, in a certain sense, drudgery. Don't get me wrong—I love to draw; you have to love it to finish a project the size of *The Resonator*. But I definitely consider thumbnailing the most fun part of pencilling.

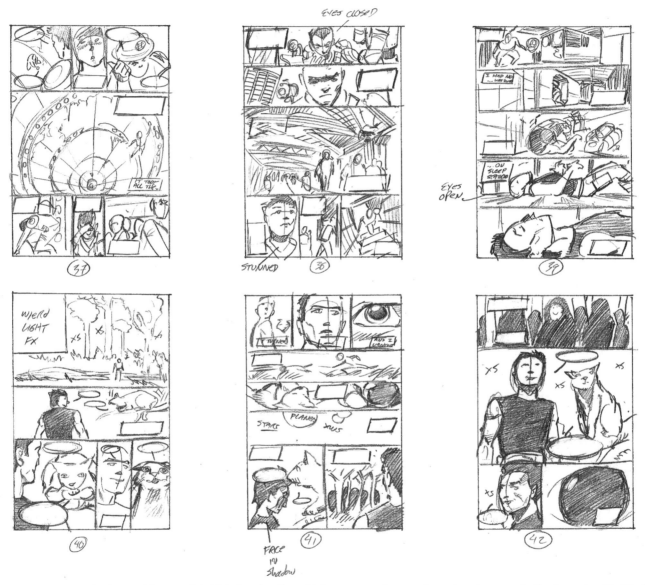

Example of a single sheet with several initial thumbnails, which correspond, some in part and some wholly, to pages 40–46 of *The Resonator*. The size of the individual thumbnails will dictate how many you can fit on an 8-1/2-x-11-inch piece of paper (the actual size of these are 2-x-3-inches each). Since the size of thumbnailed pages allows you to fit several pages on a single sheet of paper, you are more easily able to think in spreads and to plan the sequence of a chapter (keeping in mind that new chapters always start on an odd page, which are always right-hand-facing pages in an open book). These preliminary thumbnails were done quickly, with a minimum of detail (for me, anyway)—I was concerned just with settling on panel size and arrangement, camera angles, character poses, and placement of dialogue balloons and boxes. Note that on most of the pages one panel has been singled out as dominant and given more space than the rest—other things being equal, I always try to give each page a dominant image, a center of visual gravity, to grab the reader's attention.

Opposite: A final pencilled page ready for inking. The initial thumbnail for this page can be seen on the sheet of thumbnailed pages above (lower right corner).

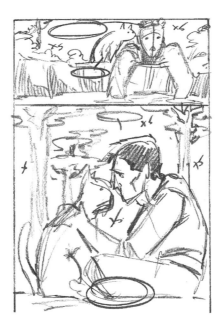

Four preliminary thumbnails, actual size. These small thumbnails are then used as a guide for making larger, more detailed thumbnails.

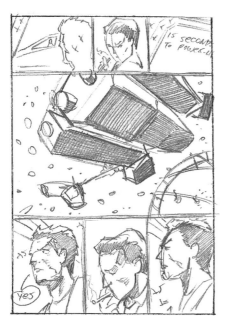

Why should this be the case? Simply because it's at this early stage that your design, composition, and storytelling skills are most called into play. It's during the thumbnailing stage that you decide how to arrange your panels on the page and how to depict the actions in those panels so as to maximize dramatic and emotional impact. The subsequent drawing of the full-sized pages can have an almost anti-climactic feel.

I do at least two thumbnails for each page—a very small one (about 2-x-3 inches) and a larger, much more detailed one (about 2-1/2-x-4 inches). Sometimes I'll do two or three of the smaller thumbnails until I'm satisfied. The vital thing about doing thumbnails is that working small gives you synoptic oversight—you see more clearly how the elements fit and work together, and at this stage that's *all* you should be thinking about. And it also forces you to deal just with large forms and groups of elements, enabling you to see the strengths and weaknesses of your compositions. You should deal with the small stuff, the details, when you do the final pencils and inks.

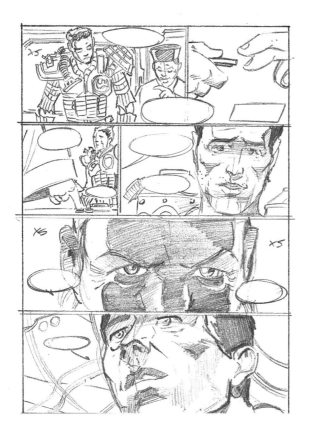

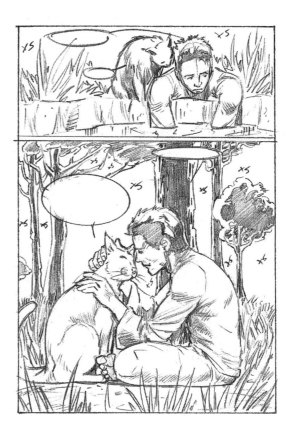

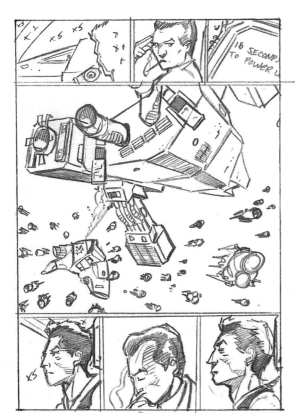

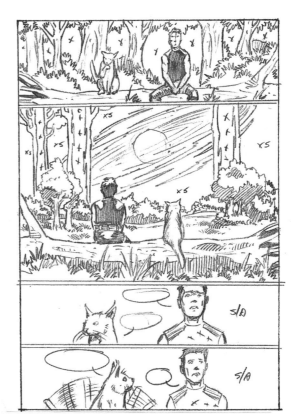

Four final thumbnails, actual size

Working from thumbnails can save you the frustration of having to scrap a half-pencilled page because you suddenly realize you don't have nearly enough space for the action that needs to happen on the rest of the page. Conversely, it can save you the embarrassment of finding out that you've left yourself an entire half page to devote to a single panel showing someone blowing his or her nose. These issues of panel number, composition, size, and organization should all be worked out at the thumbnail stage. A comic book artist working without thumbnails is like a novelist working without an outline (some do, but at their own risk!), or a house builder working without a blueprint (he could try it, and discover too late that he's put the toilet plumbing where the stove needs to be). Save yourself time and aggravation—do thumbnails.

At this point, most pencillers simply start laying out and drawing the final pages, using their thumbnails as guides. I put my final thumbnails to further use. I blow them up on a Xerox machine to 10-x-15 inches (this is the industry standard for final art size, although independent publishers obviously vary their size requirements), then tape them to the backs of 10-x-15-inch Bristol boards with the thumbnail drawing positioned toward the paper. I then place the Bristol board, top- or blank-side up, on my drawing board, which has a light box built into it. This enables me to shine a light through the attached thumbnail, creating a ghost image of it, which I use as a guide for the final pencils.

An enlarged thumbnail taped to the back of a sheet of Bristol board, with the light box on. Using the light box speeds things up for me somewhat, but it's clearly not necessary to have a light box built into your drawing table. The essential thing is that you make and use thumbnails.

Materials

You want to use sturdy (minimum 2-ply), high-quality Bristol board for your final pencils. Bristol boards are usually lighter weight than illustration boards, and the better quality brands are archival. The thickness or weight of Bristol boards is indicated by the number of layers, or "ply," of the boards. I used Borden & Riley's #120 Bristol Vellum for *The Resonator*. Bristol board comes in a rough or smooth finish, also known as vellum or plate. I use the rough (a.k.a. vellum), but it's purely a matter of taste. With smooth board, your pencil tends to dig into the page. With rough, it doesn't dig in so much, but the graphite tends to smear more easily on the page. So there are pros and cons either way you go. I do my thumbnails on cheap bond paper—there's no need to use high-quality paper for anything that won't be inked.

I use .2 mm and .5 mm mechanical pencils (because I hate sharpening) with hb leads, which are soft enough for shading work but hard enough that you can bear down on them when doing fine detail. And I use kneaded erasers. You'll also need a pretty good set of rulers, straightedges, and templates for doing circles, ovals, etc. And that's pretty much it. All of these tools are produced by numerous companies, and I find that they're all pretty much equally good.

BASIC PENCILLING SUPPLIES

Extra leads for your pencils
Kneaded eraser
Mechanical pencils
Pad of Bristol board
Rulers
Straightedges
Variety of templates

Circle templates

French curve

Triangle with beveled inking edge

Some standard templates

Borden & Riley's #120 Bristol Vellum

Extra .2 mm leads

Kneaded eraser

Staedtler® Mars® technico 780C (with .2 mm leads)

Berol mechanical pencil (with .5 mm leads)

Extra .5 mm leads

Some basic drawing tools

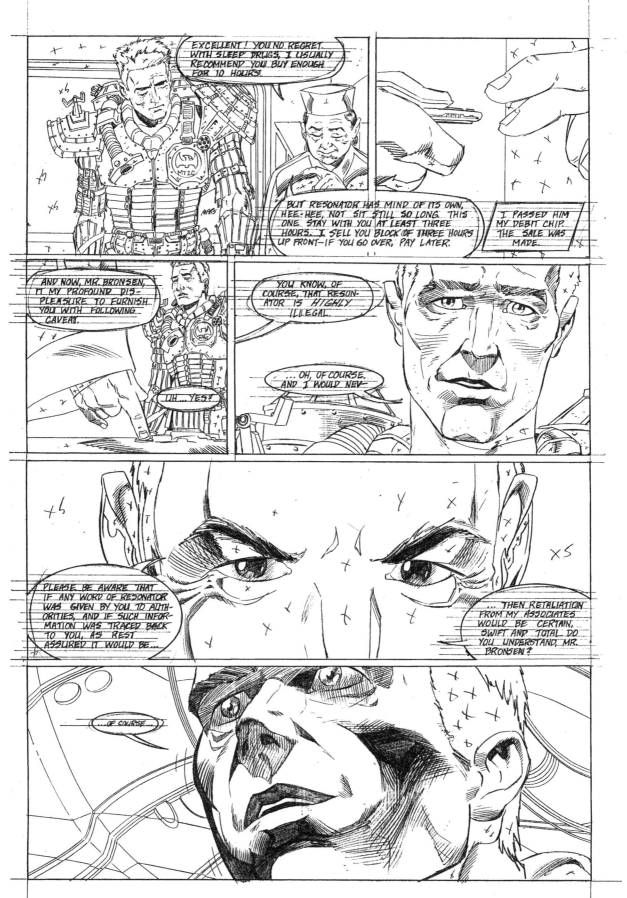

This and the following three pages show the final pencils, after lettering has been added, for the pages we've been examining in thumbnail stage on pages 36–37. "X" means "add black here." "XS" means "add black with stars here." They are shown here smaller than actual size.

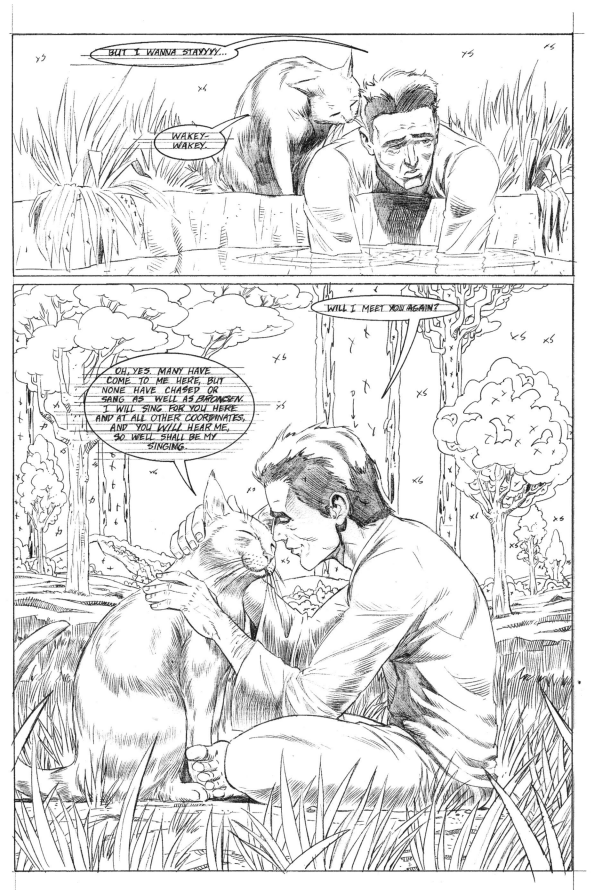

At this stage, the background is done diagrammatically—I knew I'd be doing a lot of enhancing at the inking stage. I was mainly concerned at this point to get the faces right, to nail the emotional rapport between Bronsen and the resonator. The pyramidal composition in the lower panel was meant to convey a sense of stability and permanence.

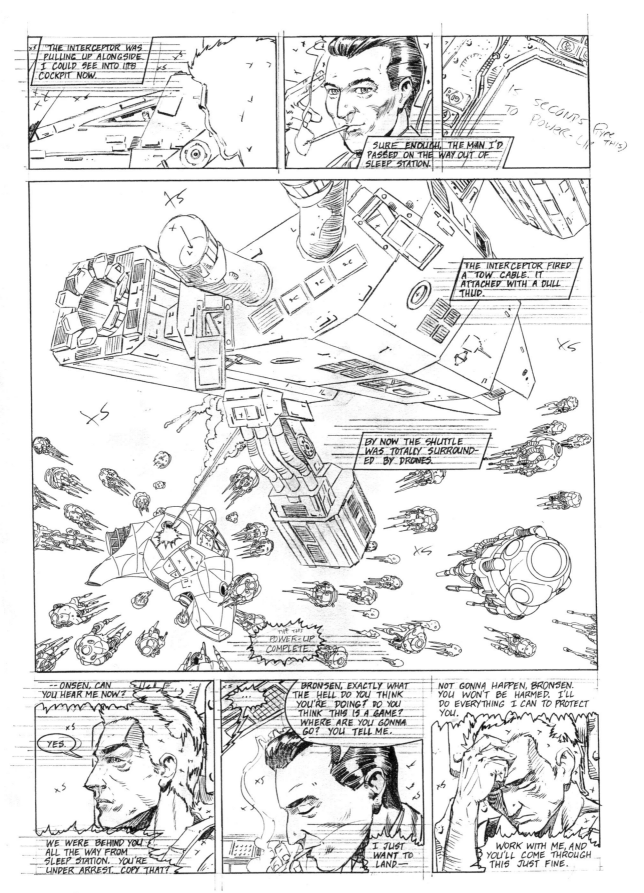

Stander's ship is drawn diagrammatically—again, I knew I'd be putting in all the shading and effects at the inking stage. In the crucial central panel, Stander's ship is above, to the right of, and vastly larger than Bronsen's ship—all deliberate choices, meant to visually convey the sense of threat posed by Stander. In the second panel, Stander's gesture is both a salute and the ole gun-to-the-head sign.

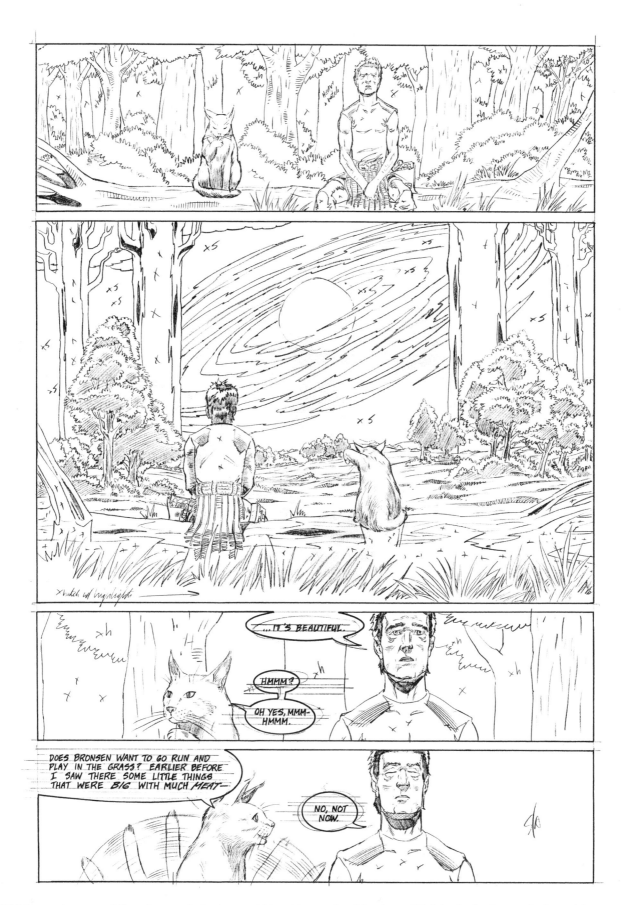

"Xh" in panels one and three is a reminder to myself to add cross-hatching later. "S/a" in the background of panel four means "same as"—that is, make a Xerox of the inked background from panel three and drop it in here. As with the other final pencils, the main concern here was with nailing basic forms and facial expressions, leaving rendering and special effects until the inking stage.

On Pencilling

Technique

My pencils are pretty tight—that is, finished and detailed—especially considering that I'm the one who's going to be inking them. How much detail you go into at the pencilling stage is purely a matter of personal method. I just don't feel comfortable putting my pencil down until I've got a really solid idea of how the finished page will look.

Drawing itself is too vast a topic to be dealt with in the confines of this book. My only advice is, regardless of your style, always make storytelling your top priority. This gets back to working small in thumbnails at the start. Comics is a visual medium, so your drawing skills have to be good—but, like film, comics essentially involves successive images that lead the reader through a continuous story. And, as in film, your top concern as creator is with arranging and composing those images in such a way as to maximize dramatic impact. By working small, by doing six or so thumbnails on a single page, you'll enable yourself to get a sense of the dramatic flow of your story before you make the much larger investment of time and effort in pencilling and inking.

When I set a comic book aside, 90 percent of the time it's not because the story or art is bad—it's because it's too much work trying to follow the bad storytelling. I just don't have the patience to reread panels and pages, trying to figure out what's going on. And no one should be asked to. Your goal should be to guide readers effortlessly through your story, so that they forget they're even reading. And for that you need to have a *filmic* sense—a sense for what camera angles to choose, when to use close-ups and long shots, how to pace the action (by adding or removing panels). Likewise, the best films are often the ones in which the directorial style is submerged, in which the director sought to make his or her imprint on the final product invisible, so that the viewers come close to forgetting that they're watching a film (the opposite of this is films where you are constantly reminded, by fancy camera angles, slow-motion shots, and other tricks, that you're watching a film). Furthermore, it's a laudable goal for the comics creator to showboat as little as possible and to concentrate on good storytelling.

Two thumbnails (actual size) and the final pencils (opposite) for page 34 of *The Resonator*. The page was intended to do two things. First, the upper tier of three panels was meant to draw the reader into a moment of intense intimacy. This was done by varying the "camera angles"; panel one is a medium two-shot, panel two is a medium close-up of Huggert over Bronsen's shoulder, panel three is a close-up of Bronsen—we pull in closer, get more intimate, as the emotional stakes rise (note the dialogue). Second, the large long-shot occupying the bottom of the page bookends the chapter by re-creating panel one on page 27 of the graphic novel, only from a reverse angle. And the juxtaposition of Bronsen's close-up in panel three and the long-shot in panel four was quite striking, and added to the sense of Bronsen's insignificance and helplessness.

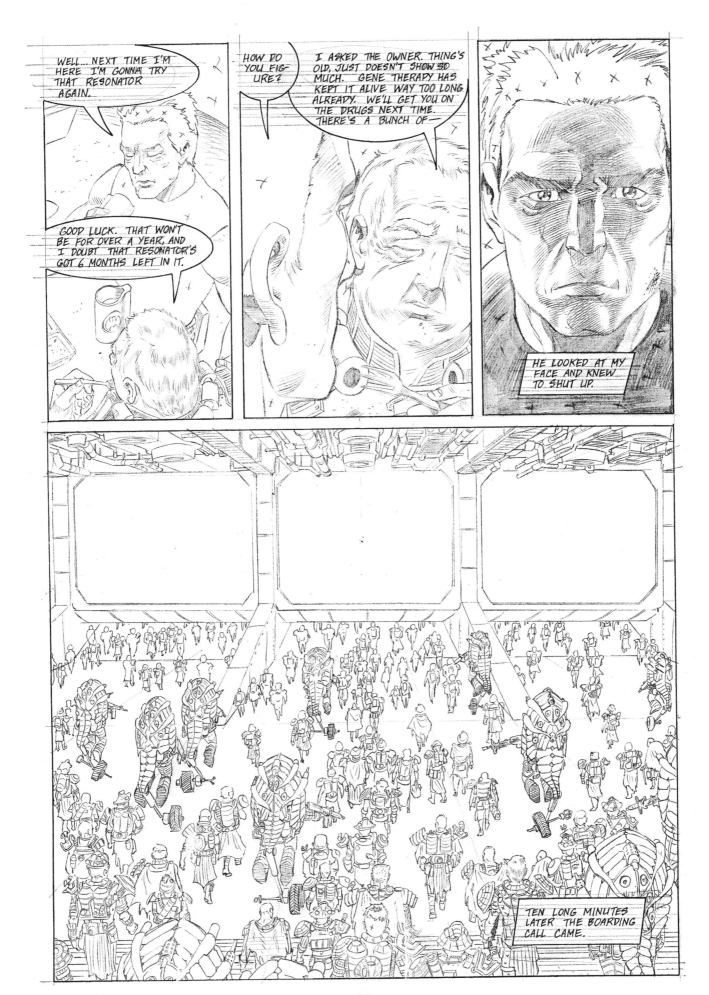

On Pencilling

CHAPTER FOUR

ON INKING

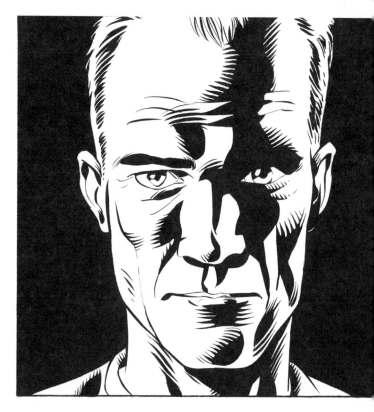

The story is told that Pablo Picasso was painting a woman's portrait in his studio one day. The cleaning woman who happened to be present looked over his shoulder, crinkled her nose, and said, "That woman's arm is too long." Without missing a beat, Picasso replied, "Madame, that is not a woman. It is a *picture.*"

To expect a visual representation to look just like the thing it's a representation of is a curious demand, and that was Picasso's point. Pictures—paintings, drawings, photos, woodcuts, movies, what have you—are produced in accordance with artistic conventions. Conventions are just techniques that artists have agreed over the years to use and that viewers have agreed over the years to accept as representations of reality. And nowhere are the conventions of comic art more in evidence than when it comes to inking.

Inking is the part of the process during which you produce the finalized, camera-ready artwork. It requires mastery of a distinctive set of professional tools, and mastery of a certain set of techniques or conventions.

Materials

You should have a set of technical pens for doing ruled work (for example, anything requiring rulers or templates). Rapidographs® (made by Koh-I-noor®) are good—I rely quite heavily on the .25, .35, and .60 mm pens. Some inkers use mostly brush—Winsor & Newton Series 7™ Kolinsky Sable Brushes are industry standards, as are Raphaels. I prefer using a #102 crow quill dip pen (with Hunt #102 pen nib) since my drawing style tends to be quite dense, with a lot of fine detail and crosshatch shading. I find that linework gets done more quickly and easily with pen than with brush. This is a matter of taste, however—there are inkers who do fine linework working only with a brush. My use of brushes is restricted mainly to laying down large patches of ink.

Though I mainly rely on the crow quill dip pen, I also use pens with "bowl" tips, one of which I use with white ink for corrections. The bowl tips are more durable than the crow quills, but are not nearly as flexible. You will also need a bottle of quality black India ink (I prefer Pelikan Drawing Ink A.) You should use India ink because it's archival—it stays dark over time—and it won't run when you sneeze on your page. And believe me, you will sneeze on your page. You should have a pretty big set of plastic templates for doing circles, ovals, and so on, and a bottle of white ink for corrections (I use FW Acrylic® Artist Ink for this). Like black India ink, correction inks thicken with time and exposure to air and need to be periodically diluted with water. I also rely on liquid frisket for achieving outer space effects, and it's also good to have paper frisket (masking film) for reasons on the following pages.

The dip pens I use most—a Hunt #102 crow quill (left) and a Hunt extra fine "bowl" tip (right).

Opposite (clockwise, from top left): A self-portrait done in my style, à la Gerry Shamray, à la Dave Gibbons, in a pointillist style, in an ink wash, and à la Frank Miller

Some tips for using dip pens:

1. Every time you start with a new pen nib, hold a lit match under it for a second or so to burn away the protective coating it comes with (this coating will hinder ink flow if you leave it).
2. You may have to make a lot of practice strokes to "prime" a new nib—that is, to get it to the point where it's cooperating with you, putting down smooth and clear lines, consistently.
3. If a nib isn't making fine enough lines, you can sharpen it with a whetstone—two or three gentle strokes on each side of the tip are usually enough.

Some tips for using brushes:

1. To get a fine point, after you dip the brush in ink, twirl it on a sheet of scrap paper.
2. Clean brushes often, and make sure to get soap (liquid dish detergent is also good) into the brush's ferrule, where old ink can collect and hinder the brush's performance.
3. After cleaning, dip your brushes in conditioner (they are hair, after all), rinse, and bring them to a point.

BASIC INKING SUPPLIES

A good quality fine-art brush
Crow quill dip pen and nibs
Good quality black India ink
Liquid frisket
Paper frisket
Rapidographs
Variety of basic templates
White ink for corrections
X-Acto® knife
Ziptone (optional)

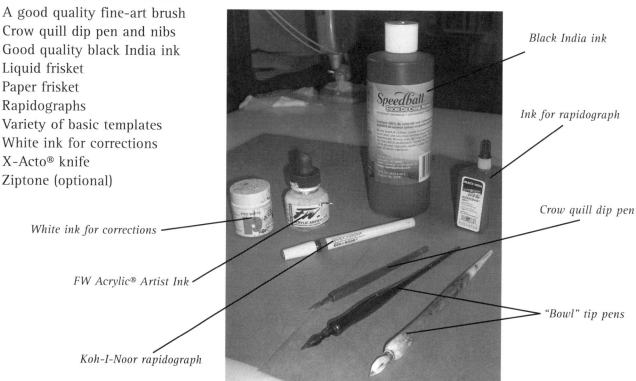

Black India ink

Ink for rapidograph

Crow quill dip pen

"Bowl" tip pens

White ink for corrections

FW Acrylic® Artist Ink

Koh-I-Noor rapidograph

Some common inking supples

Technique

There are scads of different inking styles—compare Frank Miller's work in *Sin City* to Klaus Janson's inking of Frank Miller's pencils in *The Dark Knight Returns*. But there's a certain core of basic conventions that are used by all, and I'll just touch on some of them.

Comic art is line art—objects in comics have outlines. Things in the real world *don't* have outlines; they have edges. When you ink, things that are closer to the "camera" should have fatter outlines, and things that are farther away should have thinner outlines. Why? Well, *if* things in the real world had outlines, that's how they'd look. Again, it's just a convention—readers agree to interpret things with fatter outlines as being closer, and this creates an illusion of depth. And the creation of depth is one of your primary goals as an inker.

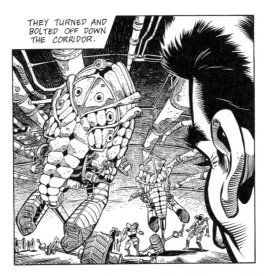

Foreground elements are heavily outlined. Linework lightens as objects recede into the distance, creating an illusion of depth.

Another goal is to convincingly portray light. As a general rule, the side of an object facing the light source should have a thinner outline than the side facing away from the light source.

Bronsen being hit with a strong light. I actually eliminated the outline of the lighted side of his face with white ink to accentuate the sense of a strong light source.

A lot of the graphic novels coming out now are done with a dead line—that is, the thickness of lines doesn't vary. If you ink only with Rapidographs or felt-tip markers, you'll automatically have a dead line, as these pens have rigid tips that don't allow for varying line weight. Mainstream artists are taught to always use dynamic linework, to keep varying the thickness of lines as a way of indicating mass and just creating visual interest. This is definitely the camp I'm in. Part of the point of using brushes and dip pens is that with these you can vary your line weight quickly and easily, and once you've gotten good at it through practice, you can create some really beautiful effects. This is what people mean when they talk about the "personality" of your line—the way you draw lines is as distinctive as your fingerprints, and mastering the creation of graceful linework is the very heart and soul of comic art.

I tried to pack *The Resonator* with a pretty broad assortment of inking techniques. I'll mention just a few here.

I used both dip pen and brush for this tight shot of Huggert. I wanted some of the lines around and under Huggert's eyes to have a softer look to them than I could get with pen alone. For the background, I laid down a flat layer of black, did a spatter of white ink, then covered it with a layer of shading film, also called Ziptone. It comes in sheets with various patterns of uniform dots that you can cut out with an X-Acto knife and paste directly onto your artwork. Ziptone isn't used nearly as much as it used to be, due to the proliferation of software for shading (Photoshop, for example), and is getting harder and harder to find in art stores. (I have a stockpile of it from the '90s that I'm still using up, so I haven't even tried to shop for it lately.)

The shadow on Fenright's face was done with Ziptone. Again, there is software that can give Ziptone effects, but I like the process of actually applying it.

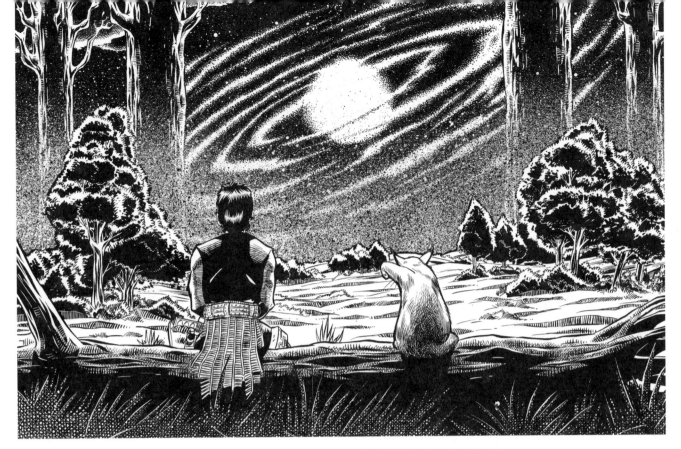

I use liquid frisket for outer space. The fog effect was done by spattering both black and white ink.

1

2

3

4

5

Liquid frisket

Creating a night sky effect with liquid frisket:
1. Use a toothbrush to spatter liquid frisket over a selected area.
 Don't worry if some gets on other areas—it rubs right off when dry.
2. Let it dry—about 1 minute.
3. Lay down a flat layer of black ink.
4. Let it dry—about 5 minutes.
5. Use your fingers or an eraser to rub away remaining frisket.
 Presto! A convincing night sky!

ALMOST FORGOT TO DO THIS.

The spattered texture used in a lot of the backgrounds was achieved with an old toothbrush. The areas that I didn't want spattered—the hand, knife, and narration box—were covered with paper frisket (a clear film).

1

2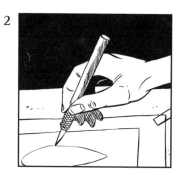

3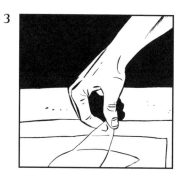

4

5

Creating a spatter effect in a confined area with paper frisket:
1. Lay a sheet of clear paper frisket over a preselected area.
2. Use an X-Acto knife to cut out the corresponding area you want to spatter.
3. Remove the cutaway area, leaving the rest.
4. Dip a toothbrush in black ink; drag your thumb along the toothbrush to spatter ink.
5. Remove remaining frisket.

Chapter Four

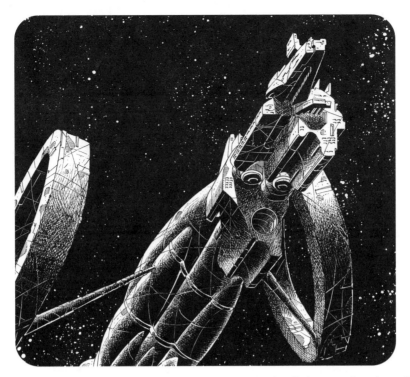

The dense cross-hatching you see throughout *The Resonator* takes little more than dogged patience. I just lay down successive layers of black and white cross-hatching until it looks sufficiently lush.

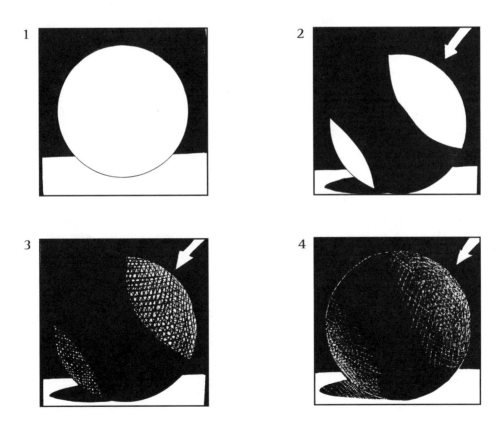

Using cross-hatching to achieve lighting effects:
1. Start with an initial outline.
2. Select a light source (here it's from the upper right). Lay down initial layer of black. The light area on the lower left side of the sphere is *reflected* light—it adds to the illusion of dimensionality.
3. Lay down first layer of cross-hatching.
4. You can soften up the effect with more cross-hatching using successive layers of black and white ink.

On Inking

Here is a page in various stages of completion:

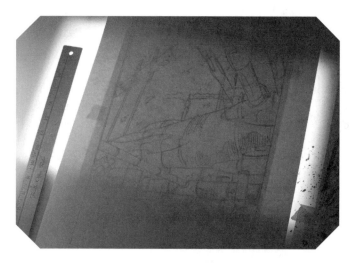

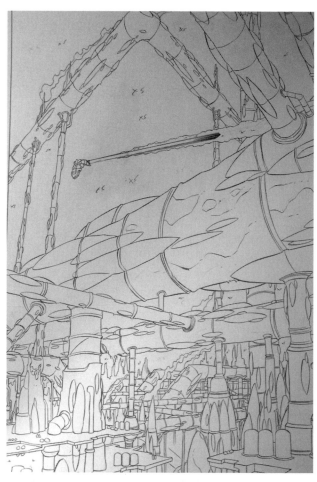

In preparation for doing the final pencils, an enlarged copy of the thumbnail is attached to the underside of the Bristol board, which is then placed on the light box built into my drawing table. Once the pencil work for this page is done, I'm ready to start inking.

Step 1 (top, right): Initial linework. This is the first step of inking. At this point I'm not concerned with cross-hatching or any other shading, but only with inking the lines that indicate objects. After I'm done with this, I can erase any remaining pencil lines.

Step 2 (bottom, right): Add night sky background. With an old toothbrush, I lay down a spatter of liquid frisket. After it dries, I put down a uniform layer of black ink. After that dries, I rub away the frisket with my fingers, and the result is a very convincing night sky—more convincing (and less time-consuming) than the alternate method of putting down black first and then dotting in the individual stars with white ink and a dip pen. (See also the liquid frisket demonstration.)

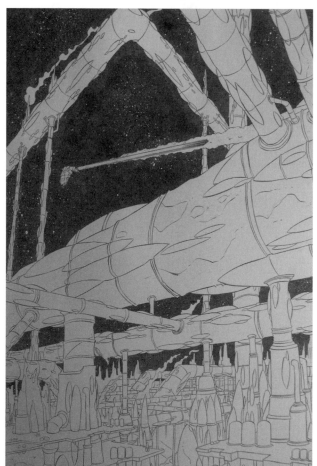

Chapter Four

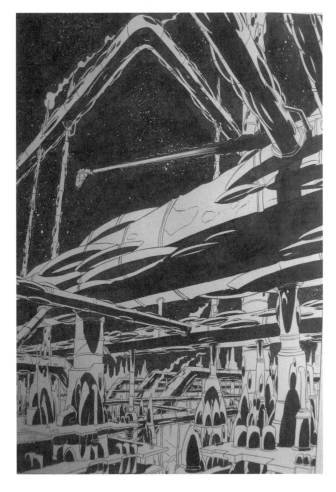

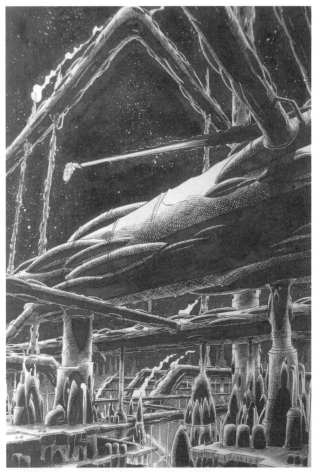

Step 3: Spotting blacks. This step entails laying down large areas of black ink with a brush. I always do this *after* going over the page with an eraser to eliminate residual pencil lines. Going over patches of black with an eraser can leave them dull and grayish.

Step 4 (above, right): Cross-hatching and rendering of objects to convey light and texture.

Step 5 (right): Adding final touches, especially spattered mist effect at the bottom of the page. At this point I'll also make any corrections that need to be made with white ink—for example, eliminating extraneous marks inside the panel borders, neatening up the lettering, and so on.

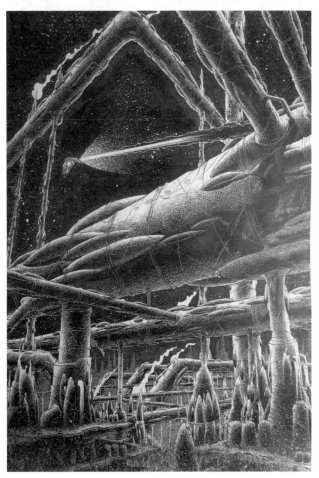

On Inking

Another page in various stages of completion:

Left: Just before doing final pencils

Step 1 (above): Pencilling in progress

Step 2 (below, left): Initial linework

Step 3 (below): Spot blacks, spatter with liquid frisket for night sky effect.

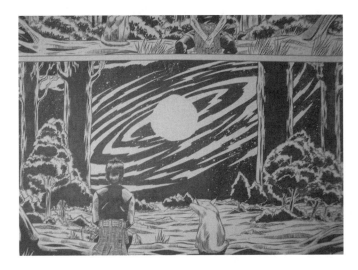

Step 4: Complete night sky effect. I added a lot of stars with a pen and white ink for this panel to make the galaxy look just right.

Above, right: The page nearing completion. All that remains to be done is to Xerox part of the background from panel three and paste it into panel four, and then final touch-up. I could have redrawn the background completely from scratch, but if it's the same background, it saves time to simply make a copy of it, then lay it in by cut and paste. And it makes for greater consistency.

Step 5 (middle, right): Laying down masking film (paper frisket) to mask areas not to be covered with spatter.

Step 6 (bottom, right): Using an X-Acto knife to remove masking film from area to be spattered. Although 2-ply Bristol board is quite durable, you run some risk of cutting the board, so it's important to use a light touch.

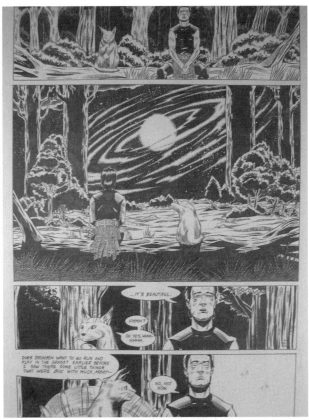

Step 7: Adding spatter

Step 8: Adding stars with white ink

This series shows a single panel, in various stages of completion:

Starting off with the final pencils

Second, basic linework is inked using my Hunt #102 crow quill

Third, blacks are spotted with my brush

Fourth, Xeroxed background from a previous panel is pasted in. The background still has to be completed and neatened up.

There's an awful lot more to be said about inking, but not enough room to say it all here. I'll sum up by saying that your top inking priorities are making the art clear and easy to read, and conveying depth, light, mass, and texture. As with tennis and playing guitar, it's all in the wrist, and it requires a tremendous amount of practice.

This is all very daunting, I know. Since I opened this chapter with a funny anecdote, I'll add some levity by closing it with another.

The story is told that the six year-old Lord Acton (the guy famous for having said "Power corrupts, and absolute power corrupts absolutely") was showing his sketchbook to his art tutor. The exchange went like this:

> Tutor: What's this?
> Lord Acton: That's Mummy.
> Tutor: And what's this?
> Lord Acton: That's a puppy.
> Tutor: And what's this?
> Lord Acton: That's Daddy and me playing cricket.
> Tutor (pointing to a mass of scribbles in the lower corner): And what is this?
> Lord Acton: That is art.

CHAPTER FIVE

ON LETTERING

GAMMA 3 SHUTTLE COCCIN-ELLE, THIS IS SLEEP STATION TRAFFIC CONTROL. IDENTIFY YOUR PERSONNEL AND TRANSMIT ITINERARY.

I INSERTED HUGGERT'S PROBESEC ID INTO THE COMMUNICATIONS PORT.

HUGGERT. ITINERARY CLASSIFIED. REQUESTING AUTO-GUIDANCE TO SECTOR 010178-B.

...CLEARED. RELINQUISH CONTROL TO AUTO-DOCKING. WELCOME TO SLEEP STATION.

THE NEXT MOMENT MY SCREENS WE ALIVE WITH OVERPRODUCED ADS FOR T SERVICES AVAILABLE WITHIN. SMILING SLEEP MERCHANTS, BEAUTIFUL PEOPLE HA PILY OBLIVIOUS BENEATH SHINY SHEETS,

The way in which I've structured the "making of" chapters can be slightly misleading. The devotion of the final chapter to lettering can give the impression that the lettering of your pages is always the last thing you do in the creation of your comics or graphic novel. It can also give the impression that lettering is the least important step in the creative process. The former impression is sometimes true—some comics artists do the lettering last, but many don't. The latter impression is certainly false. Lettering is as integral a part of the comics process as any of the stages we've looked at thus far. A bad lettering job can kill a comic as surely as a bad drawing job. And your lettering adds to and finally becomes a part of the unique look of your work. Imagine Will Eisner or Joe Sacco's work without their distinctive lettering. It would be impoverished.

I do the lettering for my pages halfway through the pencilling process—that is, after I've completed the final, detailed thumbnails but before I've started the final pencils. That explains why, in the pencilling chapter, some of the photographs of pages being pencilled show that they've already been lettered. I do it this way just to save time—it simply doesn't make sense for me to wait until I've done the final pencils to do the lettering, because then I'd be lettering on all that tight drawing I'd labored over. In the days when all lettering was done by hand, lettering almost always occurred after the final pencils were completed. The pencilled pages would be sent first to the letterer and then to the inker. And now that more and more lettering is being done by computer, lettering and inking are often done concurrently—the penciled page will be sent to the inker for inking, and scans of the pencilled page will be e-mailed to the letterer, so that he can start doing the lettering via software. This saves time, but it means more work for the inker, since the area of art that otherwise would have been covered with text now has to be inked. If you're lettering by hand, the general rule is to do it as early in the pencilling process as is possible, to save yourself time and effort.

I've been lettering all my own comics since I was eleven years old, and I consider my lettering barely passable. If it were any worse, if it called any more attention to itself, I'd hire someone else to do it, or I'd do it on the computer. But it is passable, I like doing it by hand, and I want my work to include its distinctive stamp. But DC and Marvel would never hire me as a letterer. I've built up competence through practice, but I have no talent for lettering.

Yes, lettering is a talent, and very few people have it. It's a talent as much as beautiful calligraphy is a talent. There is a debate within the industry over whether hand-done lettering is superior to lettering by computer (there are various lettering software programs in which you can create your own lettering fonts—FontLab and ScanFont, for example). The mainstream comics publishers are moving more and more towards the use of computer lettering as part of their overall effort to streamline and modernize the production process, where possible. Yet there is little reason to think that this will happen anytime soon in the production of literary graphic novels, simply because, once again, graphic novels aren't produced assembly-line style. Graphic novelists are far more likely to consider their own hand-lettering, however quirky, as part of the unique stamp of their work.

The array of lettering styles used in graphic novels is dizzying. But again, it is possible to zero in on a core set of tools and techniques that will not fail you.

Materials

The central tools of lettering are a T square and an AMES Lettering Guide. The AMES Guide is used for ruling uniformly spaced lines for lettering. As for pens, I use a Koh-I-Noor Rapidograph, although some professional letterers prefer dip pens. As I mentioned in the chapter on inking, Rapidographs yield a dead line, which you don't want in your drawing but which is perfectly appropriate for lettering. Rapidographs

Opposite: A page from *The Resonator* showing dialogue balloons and narration boxes

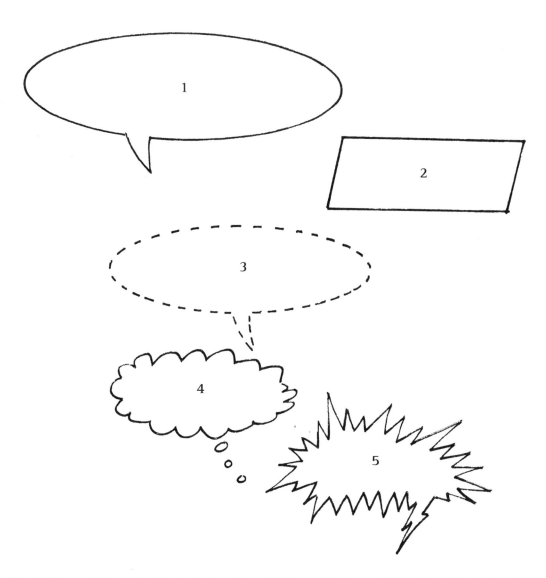

A variety of text balloons: 1. Standard dialogue; 2. Narration; 3. Whispered dialogue; 4. Thought; 5. Shouted or electronic dialogue (called a "burst" balloon)

also have to be refilled periodically (Koh-I-Noor puts out its own brand of special ink for Rapidographs called 3085-F Rapidograph Ultradraw), and they need to be disassembled and cleaned pretty often or they start to clog. Working with a dip pen can give your lettering more life and finesse (but I'm not that adventurous). I mainly use a .50 mm Rapidograph, but for words I want emphasized I use a .60 (and I italicize the word). You'll also need a variety of circular and oval templates for ruling lettering balloons—nothing makes a page look amateurish like hand-drawn balloons (unless, of course, you want your work to have that rough-hewn look as a matter of style).

Speaking of balloons, another universal convention across the comics world is the use of oval balloons for spoken dialogue, boxes for narration (first and third person), puffy cloud balloons for thoughts, and spiky "burst" balloons for shouts and screams. I avoided the latter two conventions in *The Resonator* because, of all the lettering conventions, these are commonly seen as the goofiest and most retro. The only place in *The Resonator* where I strayed from ordinary ovals and boxes is on page 8, where I used balloons with dashed outlines to indicate that Bronsen and Huggert are whispering.

BASIC LETTERING SUPPLIES

AMES Lettering Guide
Mechanical pencil
Rapidograph
T square
Variety of circular and oval templates

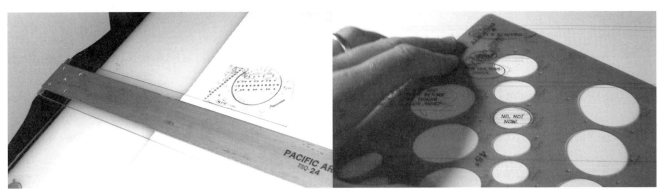

T square and AMES Lettering Guide

Using plastic templates to draw dialogue balloons is standard practice in mainstream comics. A lot of graphic novelists deliberately do it by hand for a quirkier look.

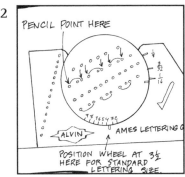

Using an AMES Lettering Guide:
1. Set up page as shown. Make sure the bottom of page is parallel to the T square and, to secure the page, tape the edges of the page to the board.
2. If your art area is 10-x-15 inches (standard original art size), the AMES Guide should be set at 3-1/2 inches for standard lettering size.
3. Drag the guide with your pencil successively across the page.
4. The result is uniformly spaced lettering lines, essential for professional- looking lettering.

Technique

I always do the lettering in pencil first, just in case I didn't allow enough room for what I'm writing (in which case I erase and start over).

Your lettering should be distinctive and clear, and it shouldn't call attention to itself. The same, in general, can be said of your pencilling and inking. Every part of the process should be submerged and at the service of telling the story—every time some aspect of your work calls attention to itself, the reader is jerked out of the story and reminded that he or she is reading a comic. I stayed away from lettered sound effects (BOOM! KA-POW!, etc.) in *The Resonator* for this reason, and you'll note that most contemporary graphic novelists do the same.

The placement of your dialogue and narration balloons is an integral part of the composition of your pages. Balloons should be positioned so that not only is the order in which they should be read immediately apparent, but also so that the reader's eye is effortlessly led across the page. Comics readers are lazy and, given the chance, they'll skim over the artwork you've labored on so tirelessly to quickly absorb the information in the balloons—to find out what happens next. My strategy is to always position dialogue balloons so that the reader's eye is dragged over a maximal area of the page.

Nothing, but nothing, will make me set a comic aside quicker than a confusing or confused pattern of balloon placements. If the play of reading a comic is turned into work for a dumb reason like that—one that can be easily avoided—it's an immediate turnoff.

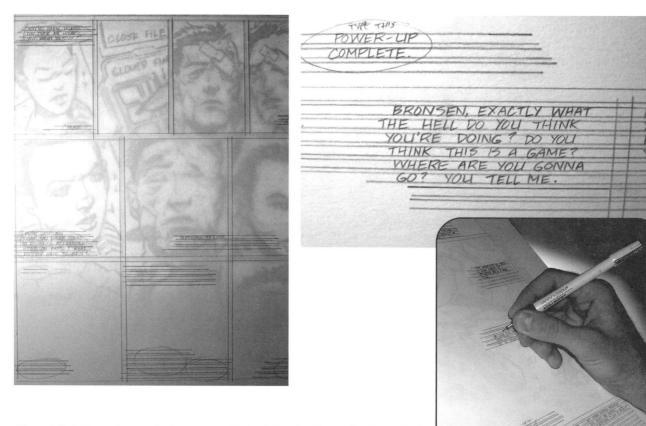

Above, left: A *Resonator* page in the process of being lettered with pencil, prior to final inked lettering. The enlarged thumbnail is shining through, thanks to my light box.

Above, right: Pencilled lettering from page 73 of *The Resonator*. The lines done with the AMES Lettering Guide are only done in pencil so they can be erased later. "Type this," written over "Power-up complete," is my reminder to myself to do that bit of text on the computer, print it out, and paste it in. The omniscient narration, the chapter breaks, and the computer-speak within the story were all done this way, using the "Chicago" font. The photo inset shows the same page in the process of final lettering. Note the faint image of the enlarged thumbnail shining through, thanks to my light box. After final lettering, balloons will be added around the text, and then I move on to doing the final pencils.

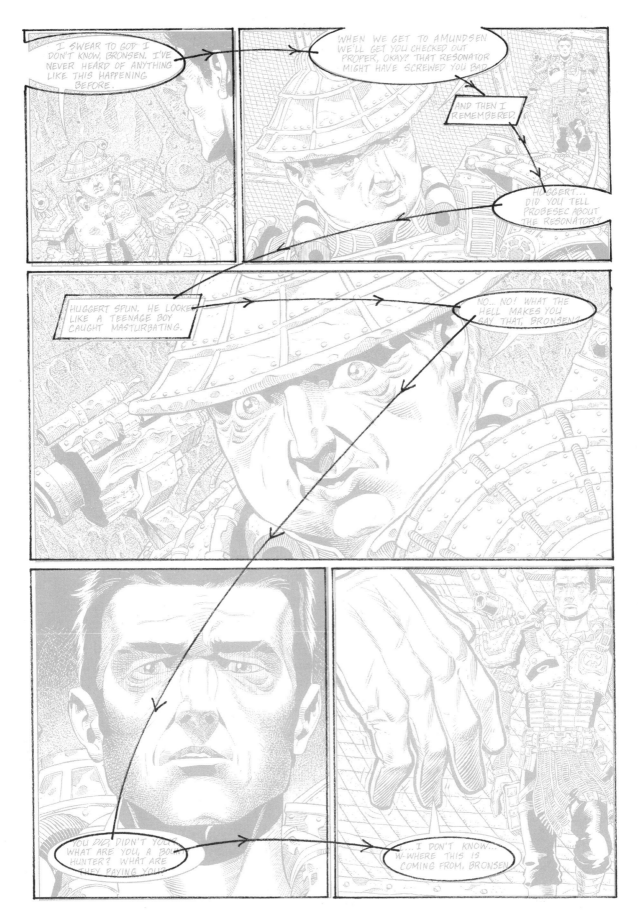

The balloon and narration box pattern for page 50 of *The Resonator*. Note the Z-pattern created by the balloon placements. The reader's eyes should be dragged over as much of the art as possible.

On Lettering

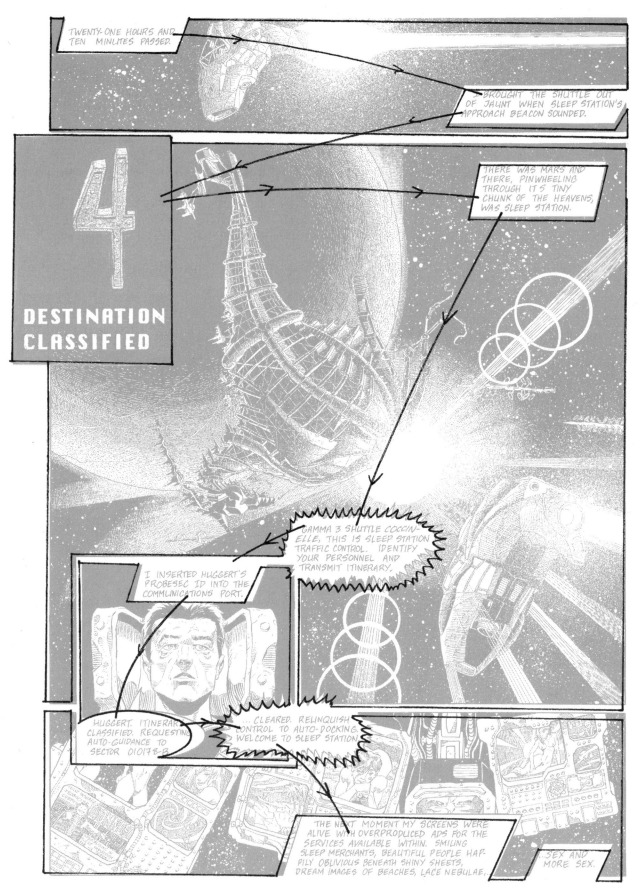

Page 59 of *The Resonator*. A fairly complicated page, but again there's the basic Z-pattern, with the reader's eyes being dragged across the page's focal point, the central sunburst in panel two.

INDEX

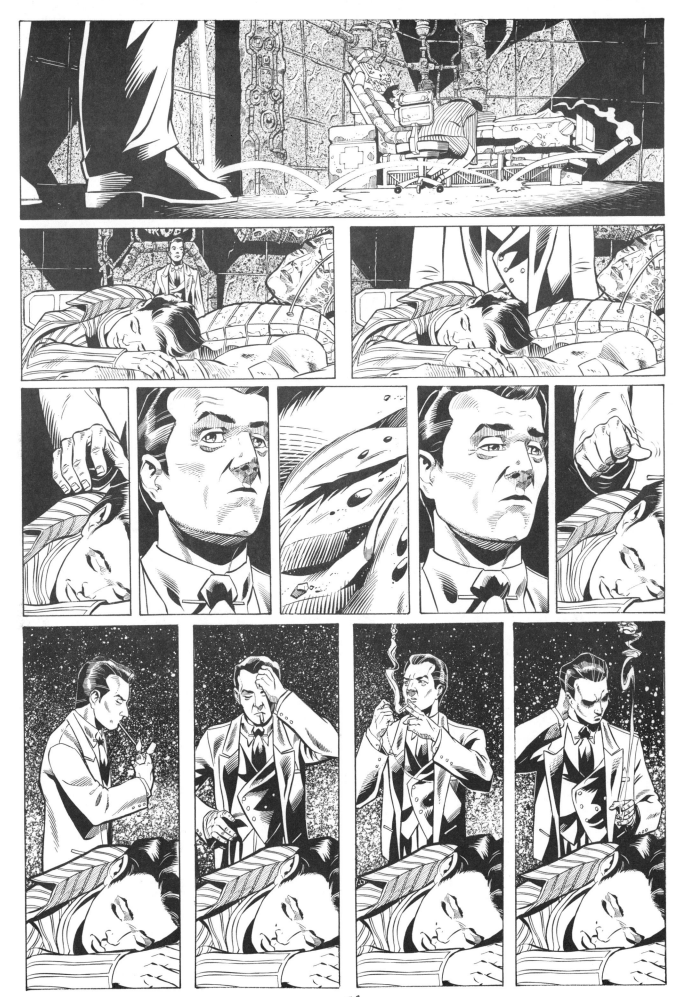

HE IS INCAPABLE OF VERBALIZING THE NEW INSTINCT THAT COMPELS HIM.

BUT SHE QUICKLY CALMS, FEELING ITS VIOLENT NEED AS STRONGLY AS HE DOES, PULLING HER CLOSER, THEIR EYES LOCKED.

...THIS IS WHY...

GODDAMNIT, HE'S MY PRISONER.

PROTOCOL OR NO, I'M GOING BACK IN THERE.

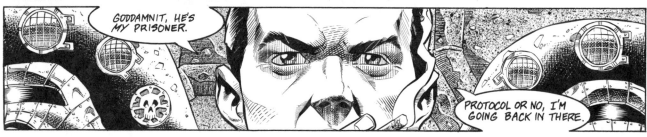
SURVIVING EXPLORING TOGETHER

95

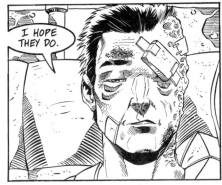

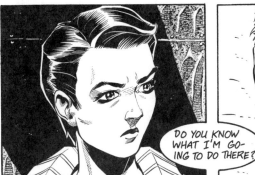

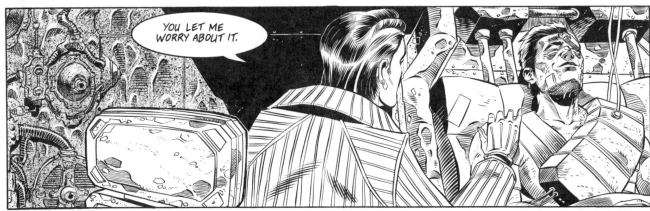

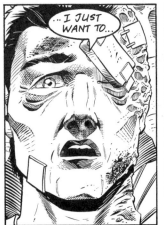

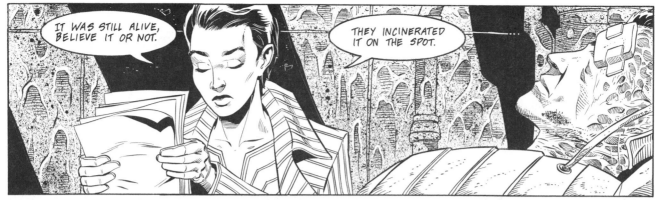

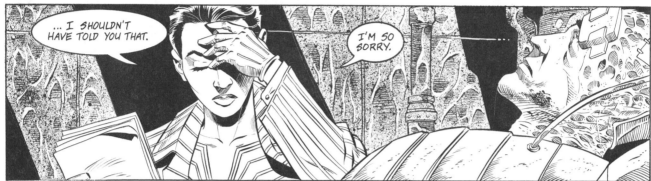

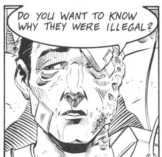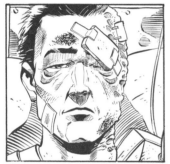

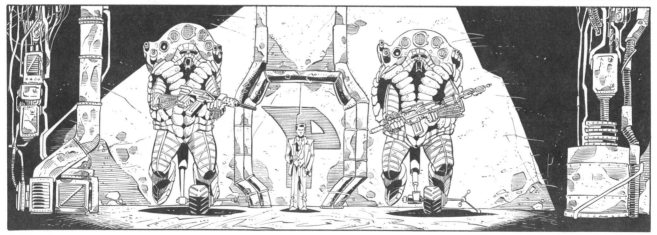

YOU'VE BEEN TALKING FOR OVER AN HOUR. YOU WANT TO STOP?

YEAH.

FILE CLOSED☐

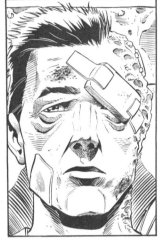

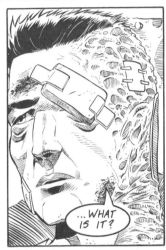

...WHAT IS IT?

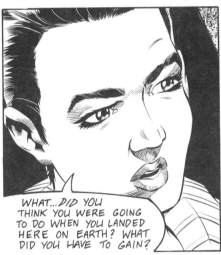

WHAT...DID YOU THINK YOU WERE GOING TO DO WHEN YOU LANDED HERE ON EARTH? WHAT DID YOU HAVE TO GAIN?

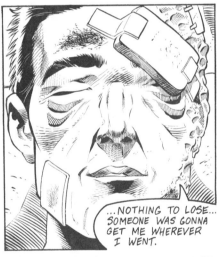

...NOTHING TO LOSE... SOMEONE WAS GONNA GET ME WHEREVER I WENT.

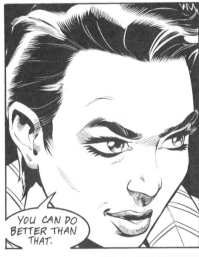

YOU CAN DO BETTER THAN THAT.

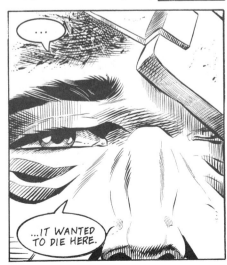

...

...IT WANTED TO DIE HERE.

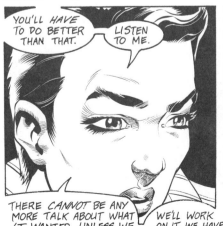

YOU'LL HAVE TO DO BETTER THAN THAT.

LISTEN TO ME.

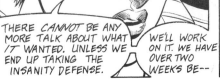

THERE CANNOT BE ANY MORE TALK ABOUT WHAT IT WANTED. UNLESS WE END UP TAKING THE INSANITY DEFENSE.

WE'LL WORK ON IT. WE HAVE OVER TWO WEEKS BE--

WHAT DID THEY DO WITH IT?

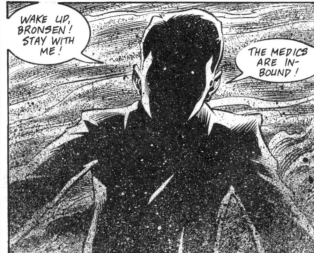

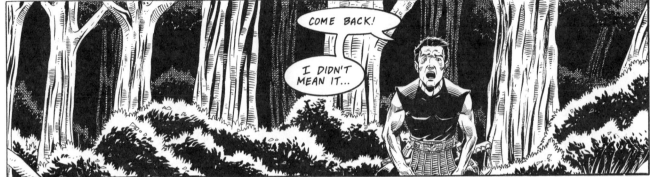

COME BACK!

I DIDN'T MEAN IT...

...WHAT *IS* THAT NOISE...?

HEY, YOU'RE STILL THERE!

...I LOVE YOU.

90

YOU'RE A PLACEBO!

AAHHRRGH...
...IT HURTS...

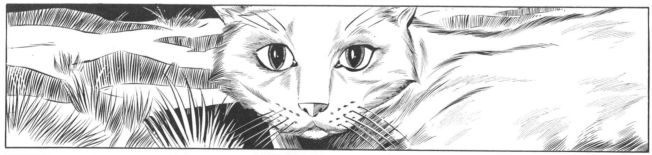

YOU DON'T HAVE ANY SPECIAL POWERS.

YOU'RE JUST AN ANIMAL THAT LIKES TO SLEEP ON WARM BODIES.

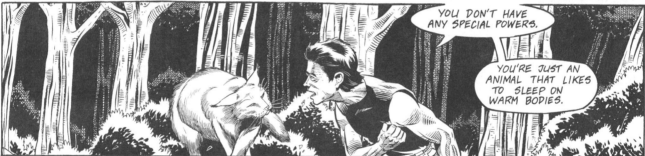

IT'S OKAY. I STOLE SOME-THING TOO.

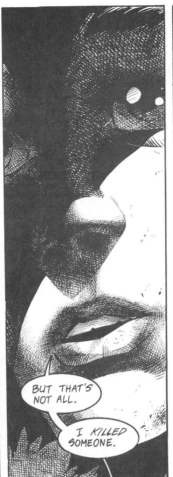

BUT THAT'S NOT ALL.

I *KILLED* SOMEONE.

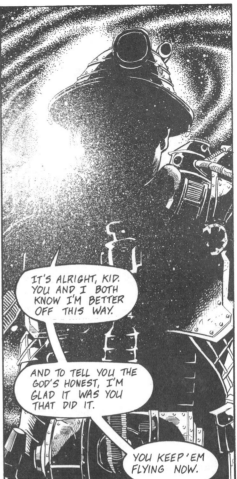

IT'S ALRIGHT, KID. YOU AND I BOTH KNOW I'M BETTER OFF THIS WAY.

AND TO TELL YOU THE GOD'S HONEST, I'M GLAD IT WAS YOU THAT DID IT.

YOU KEEP 'EM FLYING NOW.

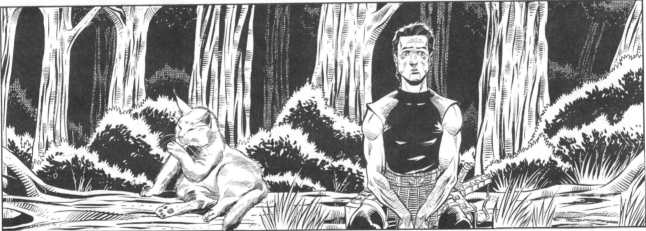

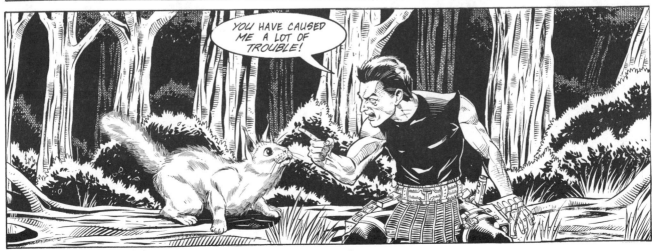

YOU HAVE CAUSED ME A LOT OF *TROUBLE!*

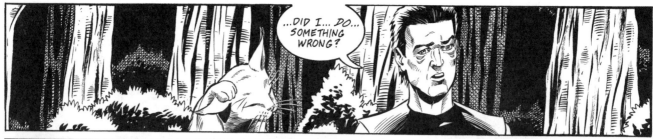

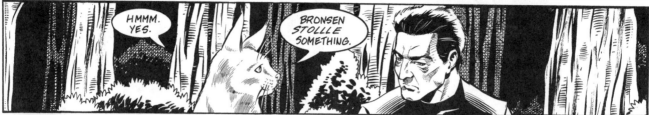

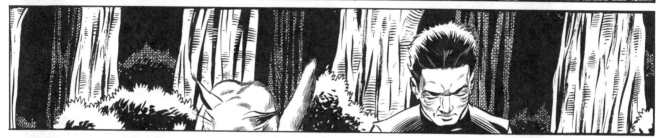

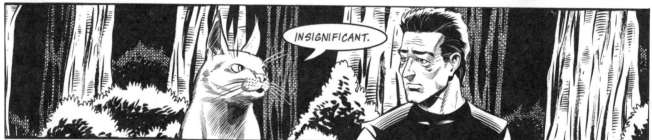

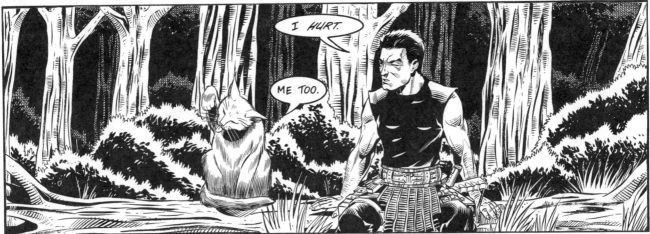

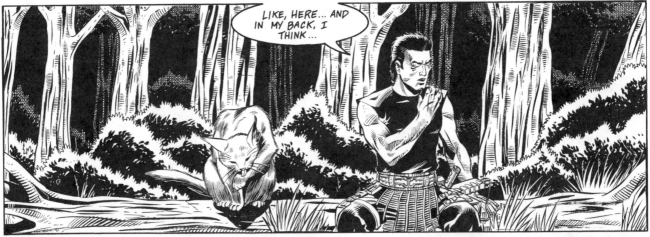

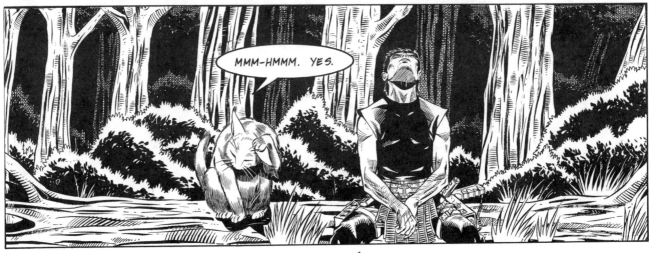

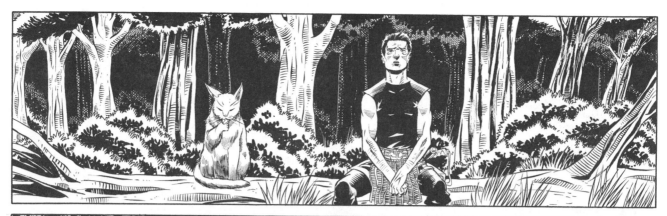

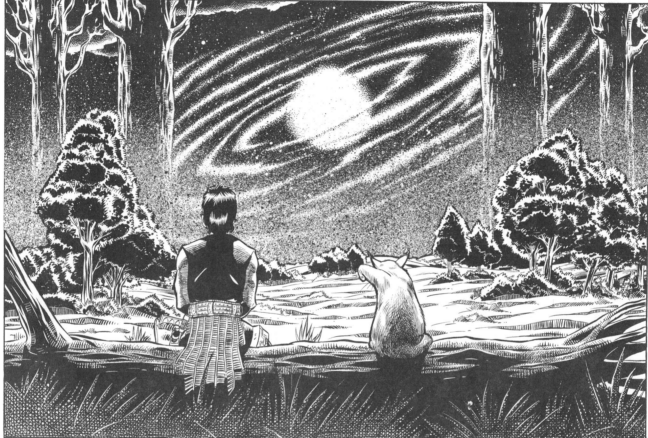

...IT'S BEAUTIFUL.

HMMM?

OH YES, MMM-HMMM.

DOES BRONSEN WANT TO GO RUN AND PLAY IN THE GRASS? EARLIER BEFORE I SAW THERE SOME LITTLE THINGS THAT WERE *BIG* WITH MUCH *MEAT*—

NO, NOT NOW.

I LOOKED UP.

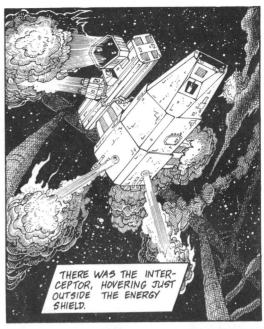

THERE WAS THE INTER-CEPTOR, HOVERING JUST OUTSIDE THE ENERGY SHIELD.

THAT'S SMART, STAND-ER. DON'T TRY TO LAND HERE. I'M NOT GOING ANYWHERE.

YOU GOT ME.

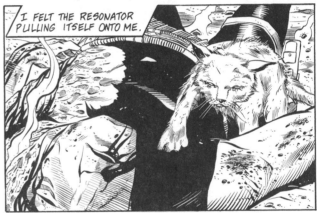

I FELT THE RESONATOR PULLING ITSELF ONTO ME.

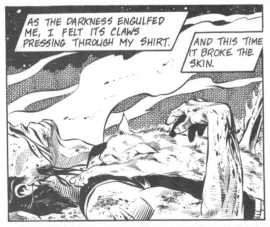

AS THE DARKNESS ENGULFED ME, I FELT ITS CLAWS PRESSING THROUGH MY SHIRT.

AND THIS TIME IT BROKE THE SKIN.

...INTELLIGENT CREATURE...

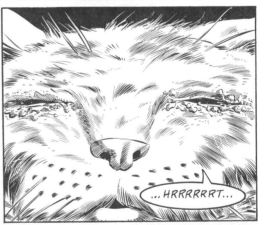

...HRRRRRRT...

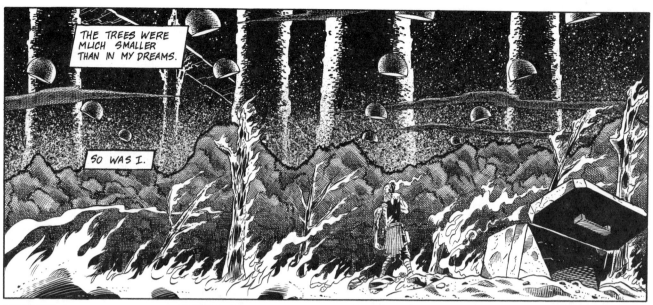

THE TREES WERE MUCH SMALLER THAN IN MY DREAMS.

SO WAS I.

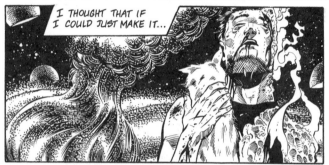

I THOUGHT THAT IF I COULD JUST MAKE IT...

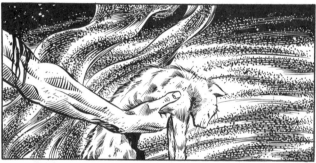

...THE FEW MORE FEET TO THAT TREE LINE...

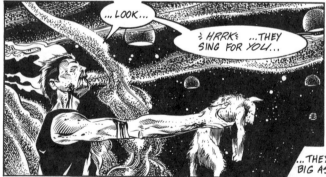

...LOOK...

≷HRRK≷ ...THEY SING FOR YOU...

...THEY'D LOOK JUST AS BIG AS THEY DID BEFORE.

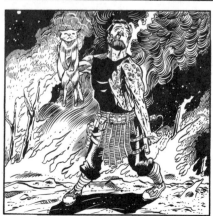

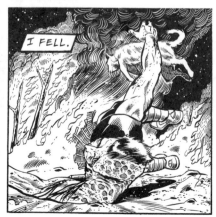

I FELL.

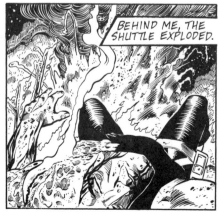

BEHIND ME, THE SHUTTLE EXPLODED.

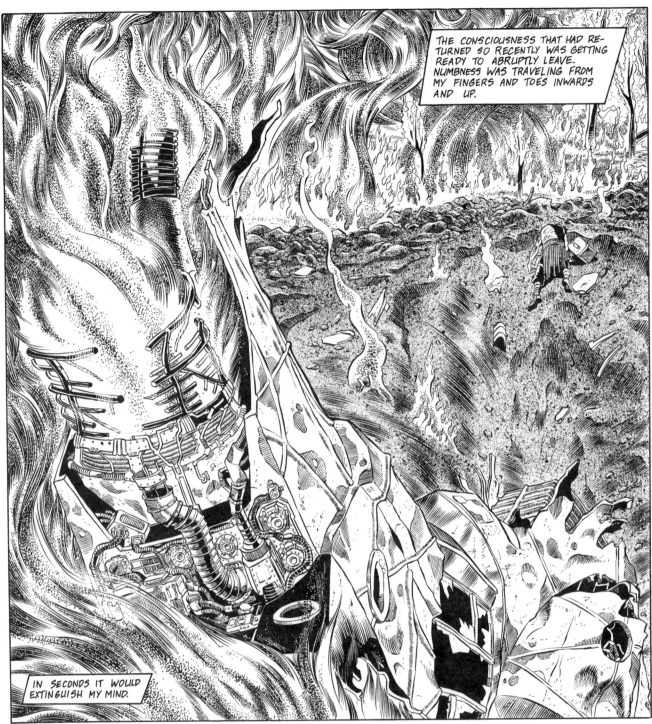

THE CONSCIOUSNESS THAT HAD RE-
TURNED SO RECENTLY WAS GETTING
READY TO ABRUPTLY LEAVE.
NUMBNESS WAS TRAVELING FROM
MY FINGERS AND TOES INWARDS
AND UP.

IN SECONDS IT WOULD
EXTINGUISH MY MIND.

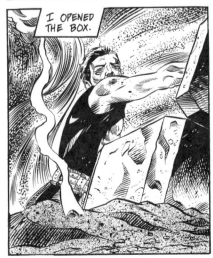

I OPENED
THE BOX.

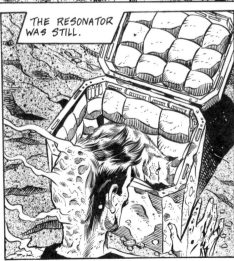

THE RESONATOR
WAS STILL.

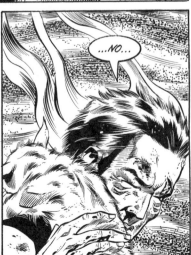

...NO...

5

THIS IS WHY

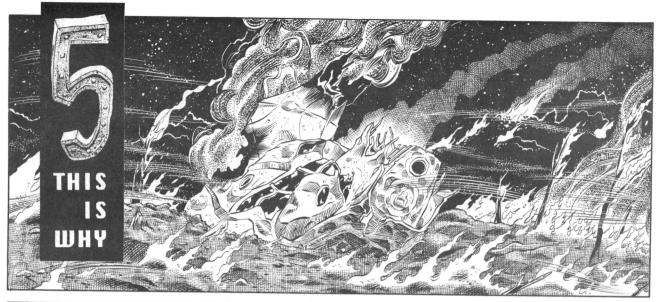

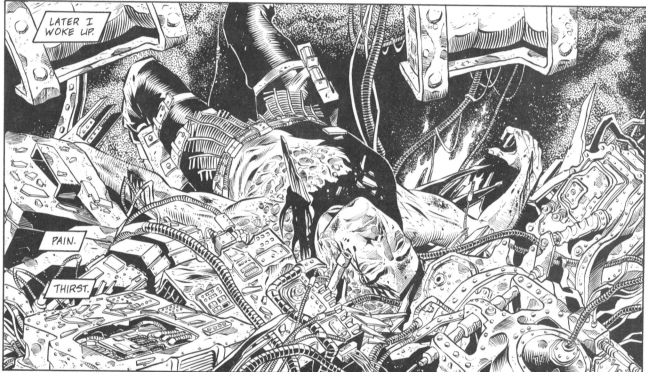

LATER I WOKE UP.

PAIN.

THIRST.

COOL AIR FLOODED AND BATHED ME.

I LURCHED UP AND OUT, PULLING THE RESONATOR'S BOX BEHIND ME.

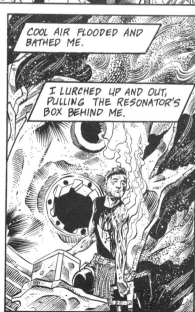

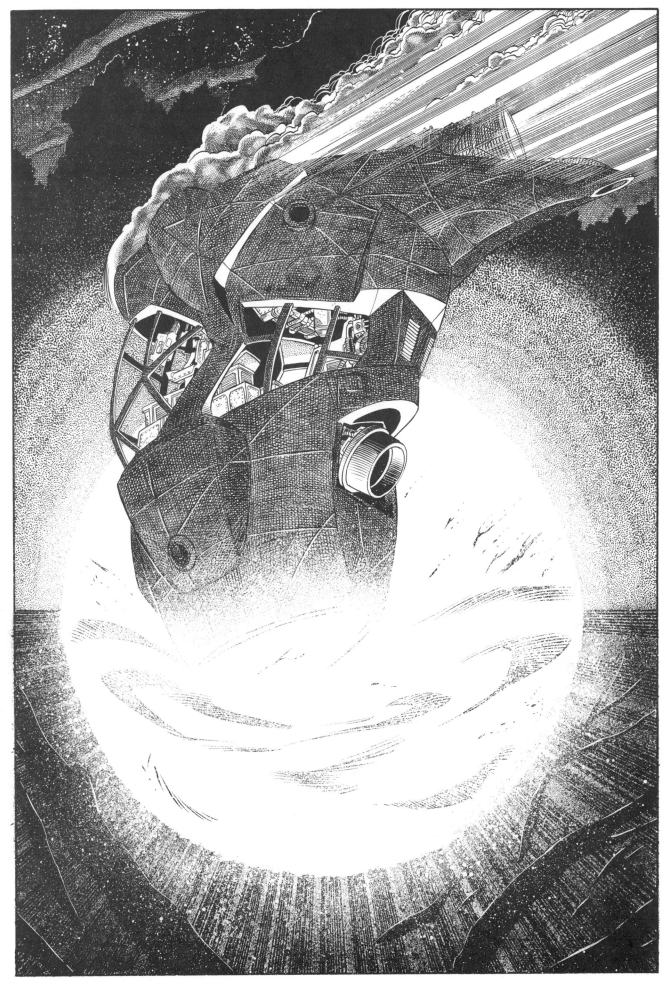

I JOLTED IN MY SEAT. THE SCREENS WENT BLANK AGAIN.

DAMN IT! DAMN IT!

45 SECONDS TO POWER-UP.

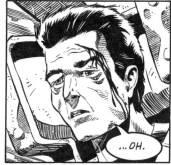

...OH.

THE GROUND SPED BY 50 METERS BELOW. THE SHUTTLE WAS DOING ITS BEST TO ANGLE ITSELF ON BATTERY POWER ALONE. BUT I KNEW THAT WITHOUT THRUSTERS IT PROBABLY WOULDN'T SURVIVE THE IMPACT.

I COULD HEAR THE TOPS OF TREES BEING SHEARED AWAY.

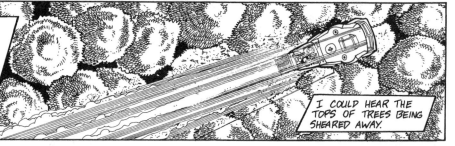

30 SECONDS TO POWER-UP.

I LEANED BACK AND PUT MY HAND ON THE RESONATOR'S BOX.

THE SHUTTLE LURCHED WILDLY, GROANING IN LAME PROTEST AGAINST DEATH.

FOR ME, THE WORLD PEELED BACK AND FELL AWAY ONCE AGAIN, AND I JUST BREATHED CALMLY AND KNEW THAT IT DIDN'T MATTER.

15 SECONDS TO POWER-UP.

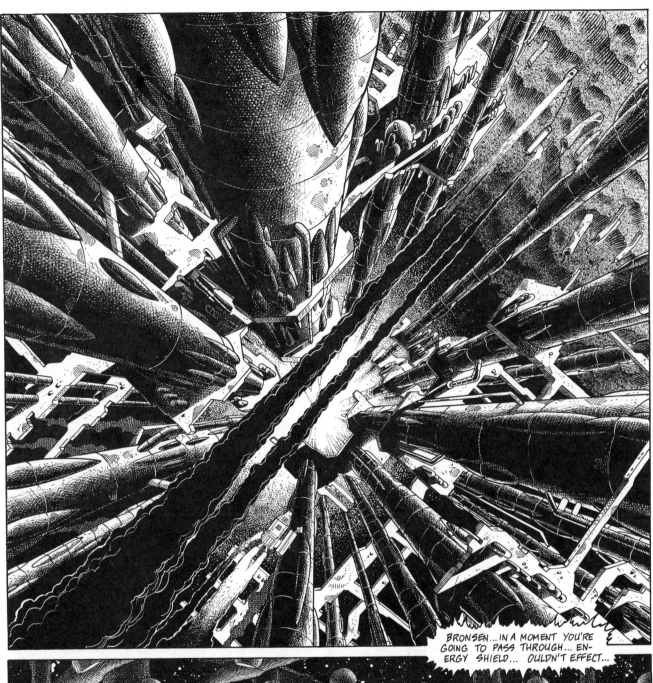

BRONSEN...IN A MOMENT YOU'RE GOING TO PASS THROUGH... ENERGY SHIELD... OULDN'T EFFECT...

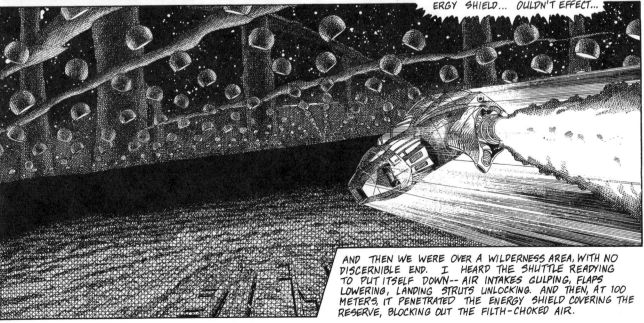

AND THEN WE WERE OVER A WILDERNESS AREA, WITH NO DISCERNIBLE END. I HEARD THE SHUTTLE READYING TO PUT ITSELF DOWN-- AIR INTAKES GULPING, FLAPS LOWERING, LANDING STRUTS UNLOCKING. AND THEN, AT 100 METERS, IT PENETRATED THE ENERGY SHIELD COVERING THE RESERVE, BLOCKING OUT THE FILTH-CHOKED AIR.

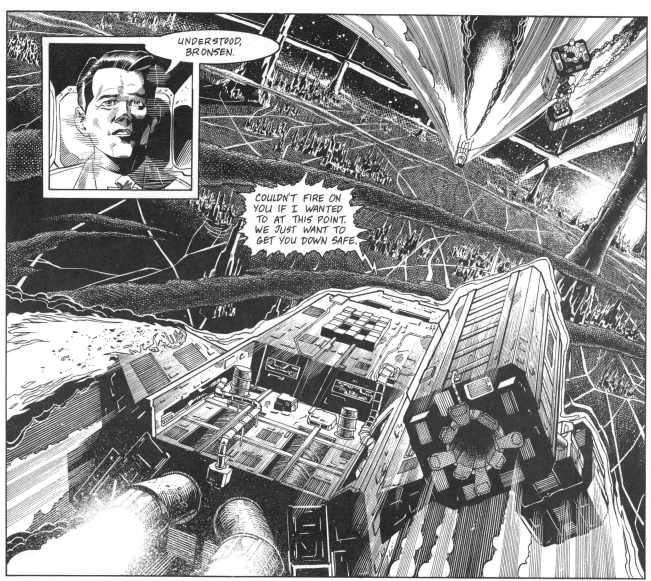

UNDERSTOOD, BRONSEN.

COULDN'T FIRE ON YOU IF I WANTED TO AT THIS POINT. WE JUST WANT TO GET YOU DOWN SAFE.

WE'RE BOTH COMING APART, SO YOU'VE GOTTA BE REAL CAREFUL, BRONSEN. COPY THAT?

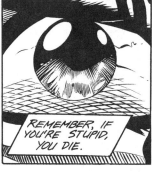

REMEMBER, IF YOU'RE STUPID, YOU DIE.

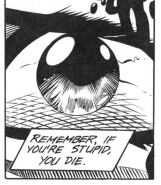

...I WANT TO LAND WHERE THERE'S TREES.

WHA... REPEAT THAT?

I WANT TO LAND WHERE THERE'S TREES!

..BRONSEN, I... DON'T THINK THERE ARE ANY—

FIND SOME, STANDER!

STAND BY.

...OKAY, BRONSEN, I'M SENDING COORDINATES TO YOUR NAVICOMPUTER NOW.

PROBECORP BIO-RESEARCH DIVISION: YUKON UNITED RESERVE. UNAUTHORIZED PERSONNEL STRICTLY PROHIBITED.

THE SHUTTLE WAS SHAKING MORE THAN EVER.

WARNING: SHUTTLE WILL NOT PASS PROBECORP INSPECTION.

980E450349
3450-3495-
38957-934
390-458-
3894570

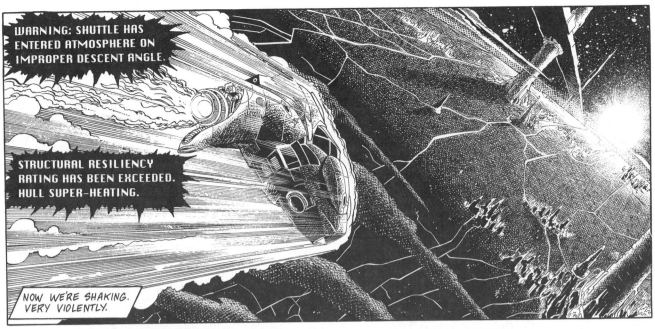

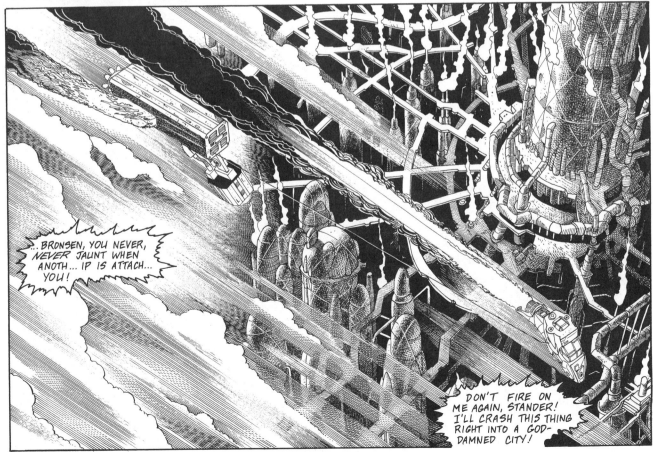

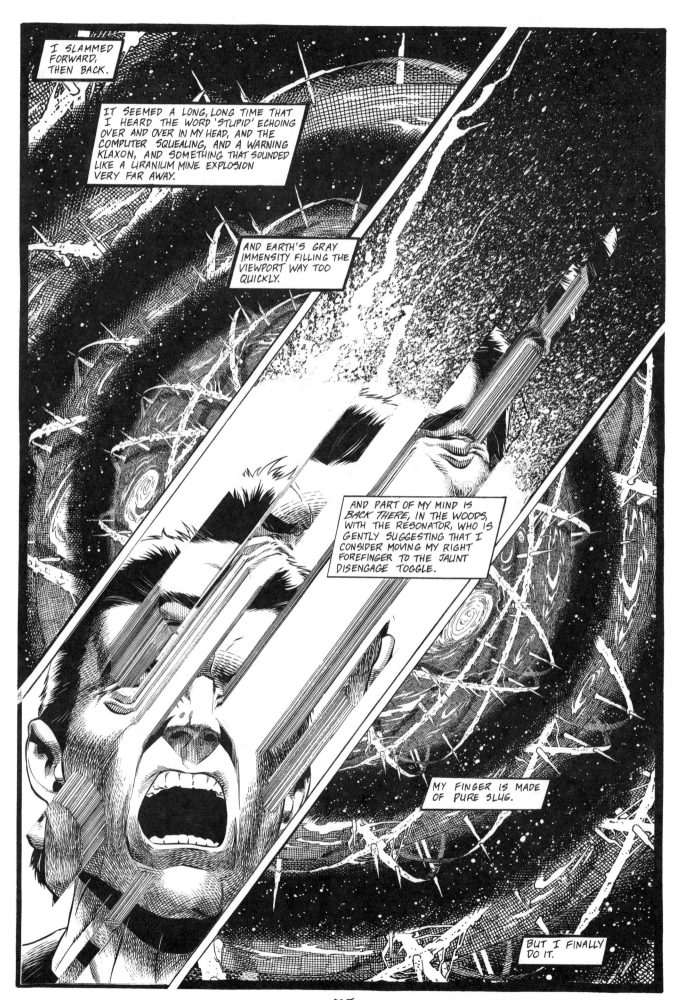

I SLAMMED FORWARD, THEN BACK.

IT SEEMED A LONG, LONG TIME THAT I HEARD THE WORD 'STUPID' ECHOING OVER AND OVER IN MY HEAD, AND THE COMPUTER SQUEALING, AND A WARNING KLAXON, AND SOMETHING THAT SOUNDED LIKE A URANIUM MINE EXPLOSION VERY FAR AWAY.

AND EARTH'S GRAY IMMENSITY FILLING THE VIEWPORT WAY TOO QUICKLY.

AND PART OF MY MIND IS *BACK THERE*, IN THE WOODS, WITH THE RESONATOR, WHO IS GENTLY SUGGESTING THAT I CONSIDER MOVING MY RIGHT FOREFINGER TO THE JAUNT DISENGAGE TOGGLE.

MY FINGER IS MADE OF PURE SLUG.

BUT I FINALLY DO IT.

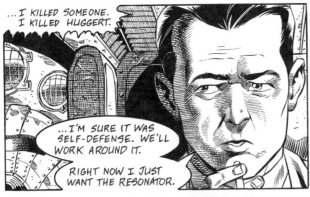

...I KILLED SOMEONE. I KILLED HUGGERT.

...I'M SURE IT WAS SELF-DEFENSE. WE'LL WORK AROUND IT.

RIGHT NOW I JUST WANT THE RESONATOR.

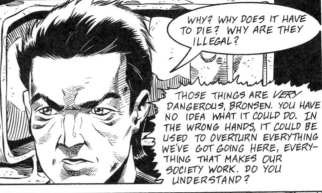

WHY? WHY DOES IT HAVE TO DIE? WHY ARE THEY ILLEGAL?

THOSE THINGS ARE *VERY* DANGEROUS, BRONSEN. YOU HAVE NO IDEA WHAT IT COULD DO. IN THE WRONG HANDS, IT COULD BE USED TO OVERTURN EVERYTHING WE'VE GOT GOING HERE, EVERYTHING THAT MAKES OUR SOCIETY WORK. DO YOU UNDERSTAND?

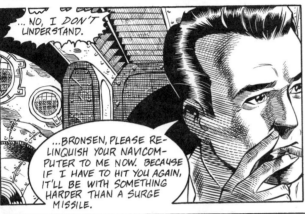

...NO, I *DON'T* UNDERSTAND.

...BRONSEN, PLEASE RELINQUISH YOUR NAVICOMPUTER TO ME NOW. BECAUSE IF I HAVE TO HIT YOU AGAIN, IT'LL BE WITH SOMETHING HARDER THAN A SURGE MISSILE.

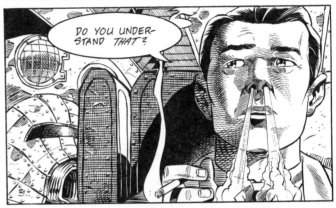

DO YOU UNDERSTAND *THAT*?

...

...

OKEY-DOKE.

>>OVERDRIVE<<

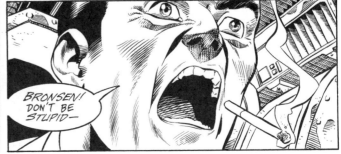

BRONSEN! DON'T BE STUPID—

74

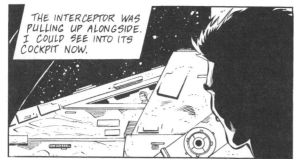

THE INTERCEPTOR WAS PULLING UP ALONGSIDE. I COULD SEE INTO ITS COCKPIT NOW.

SURE ENOUGH, THE MAN I'D PASSED ON THE WAY OUT OF SLEEP STATION.

15 SECON—
TO POWER—

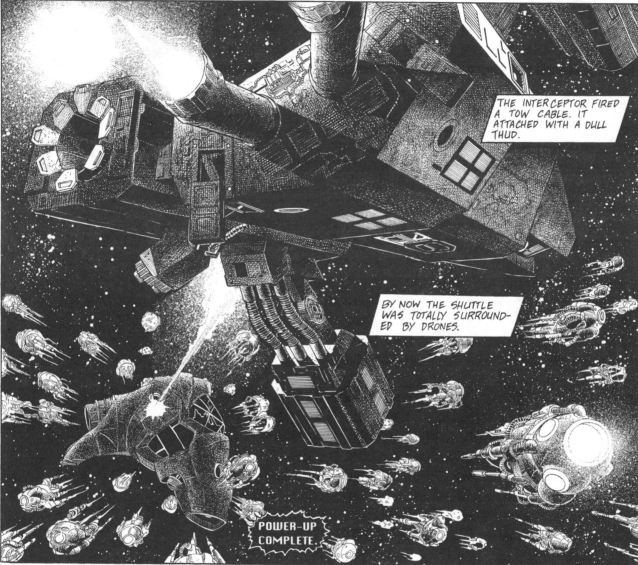

THE INTERCEPTOR FIRED A TOW CABLE. IT ATTACHED WITH A DULL THUD.

BY NOW THE SHUTTLE WAS TOTALLY SURROUND-ED BY DRONES.

POWER-UP COMPLETE.

--ONSEN, CAN YOU HEAR ME NOW?

YES.

WE WERE BEHIND YOU ALL THE WAY FROM SLEEP STATION. YOU'RE UNDER ARREST. COPY THAT?

...

BRONSEN, EXACTLY WHAT THE HELL DO YOU THINK YOU'RE DOING? DO YOU THINK THIS IS A GAME? WHERE ARE YOU GONNA GO? YOU TELL ME.

I JUST WANT TO LAND--

NOT GONNA HAPPEN, BRONSEN. YOU WON'T BE HARMED. I'LL DO EVERYTHING I CAN TO PROTECT YOU.

WORK WITH ME, AND YOU'LL COME THROUGH THIS JUST FINE.

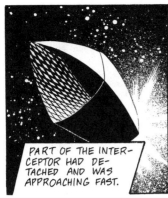

PART OF THE INTER-CEPTOR HAD DE-TACHED AND WAS APPROACHING FAST.

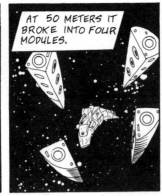

AT 50 METERS IT BROKE INTO FOUR MODULES.

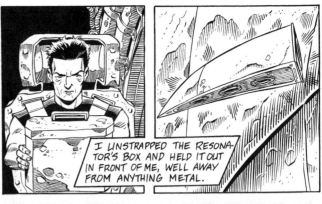

I UNSTRAPPED THE RESONA-TOR'S BOX AND HELD IT OUT IN FRONT OF ME, WELL AWAY FROM ANYTHING METAL.

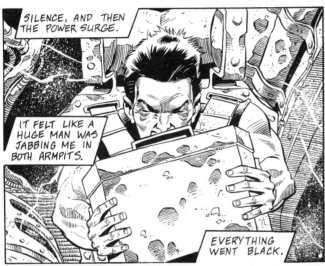

SILENCE, AND THEN THE POWER SURGE.

IT FELT LIKE A HUGE MAN WAS JABBING ME IN BOTH ARMPITS.

EVERYTHING WENT BLACK.

COMPUTER... HOW LONG TO POWER-UP?

45 SECONDS

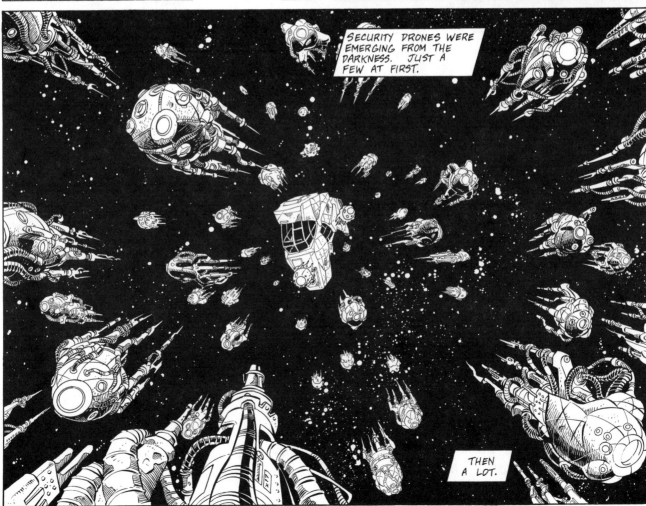

SECURITY DRONES WERE EMERGING FROM THE DARKNESS. JUST A FEW AT FIRST.

THEN A LOT.

SHIT. THEY KNOW.

I WIPED THE SWEAT OFF MY BROW AND ORDERED THE COMPUTER TO BEGIN THE ATMOSPHERE INSERTION SEQUENCE.

AND THEN A NEW VOICE INVADED THE COCKPIT.

MR. BRONSEN, THIS IS AGENT FIRST CLASS ENDICOTT STANDER, PROBE SECURITY AND PROTOCOL ENFORCEMENT. PLEASE HEAVE TO AND PREPARE TO BE TOWED.

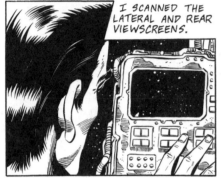

I SCANNED THE LATERAL AND REAR VIEWSCREENS.

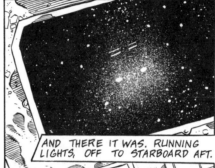

AND THERE IT WAS. RUNNING LIGHTS, OFF TO STARBOARD AFT.

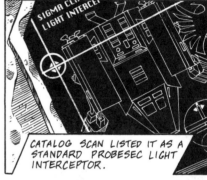

SIGMA CL... LIGHT INTERCE...

CATALOG SCAN LISTED IT AS A STANDARD PROBESEC LIGHT INTERCEPTOR.

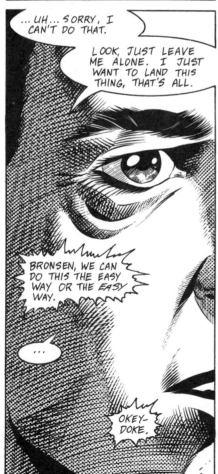

...UH... SORRY, I CAN'T DO THAT.

LOOK, JUST LEAVE ME ALONE. I JUST WANT TO LAND THIS THING, THAT'S ALL.

BRONSEN, WE CAN DO THIS THE EASY WAY OR THE *EASY* WAY.

...

OKEY-DOKE.

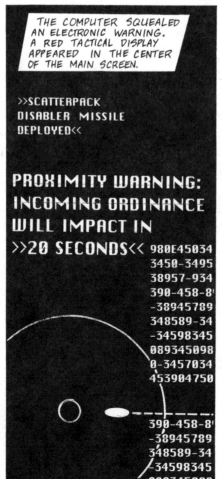

THE COMPUTER SQUEALED AN ELECTRONIC WARNING. A RED TACTICAL DISPLAY APPEARED IN THE CENTER OF THE MAIN SCREEN.

>>SCATTERPACK DISABLER MISSILE DEPLOYED<<

PROXIMITY WARNING: INCOMING ORDINANCE WILL IMPACT IN >>20 SECONDS<< 980E45034
3450-3495
38957-934
390-458-8
-38945789
348589-34
-34598345
089345098
0-3457034
453904750

390-458-8
-38945789
348589-34
-34598345

SHIT.

SHIT!

THIS WAS GONNA HURT REAL BAD.

GAMMA 3 SHUTTLE, THIS IS PROBECORP CENTRAL TRAFFIC CONTROL. YOU ARE ON AN APPROACH VECTOR FOR EARTH. RELAY YOUR ORIGIN, PERSONNEL, AND DESTINATION.

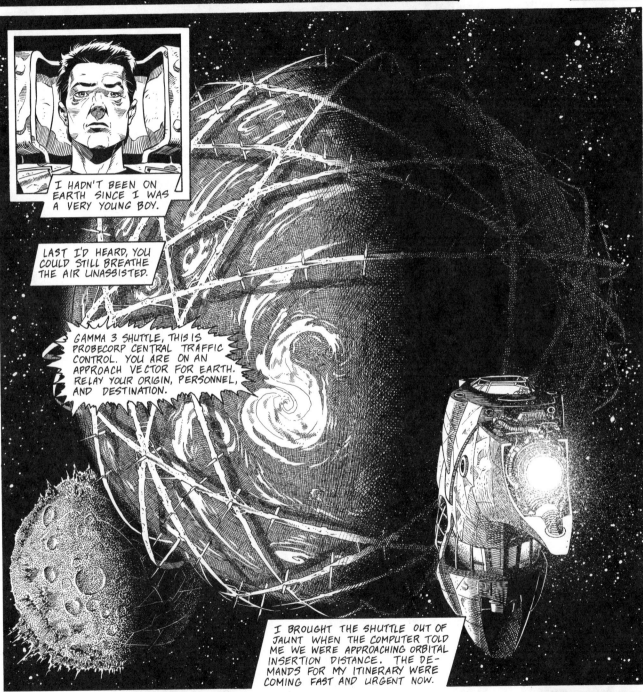

I HADN'T BEEN ON EARTH SINCE I WAS A VERY YOUNG BOY.

LAST I'D HEARD, YOU COULD STILL BREATHE THE AIR UNASSISTED.

GAMMA 3 SHUTTLE, THIS IS PROBECORP CENTRAL TRAFFIC CONTROL. YOU ARE ON AN APPROACH VECTOR FOR EARTH. RELAY YOUR ORIGIN, PERSONNEL, AND DESTINATION.

I BROUGHT THE SHUTTLE OUT OF JAUNT WHEN THE COMPUTER TOLD ME WE WERE APPROACHING ORBITAL INSERTION DISTANCE. THE DEMANDS FOR MY ITINERARY WERE COMING FAST AND URGENT NOW.

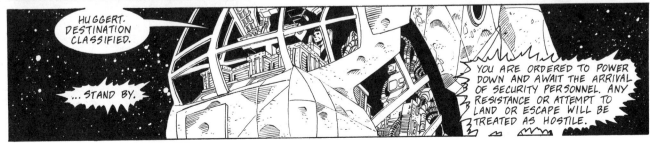

HUGGERT. DESTINATION CLASSIFIED.

...STAND BY.

YOU ARE ORDERED TO POWER DOWN AND AWAIT THE ARRIVAL OF SECURITY PERSONNEL. ANY RESISTANCE OR ATTEMPT TO LAND OR ESCAPE WILL BE TREATED AS HOSTILE.

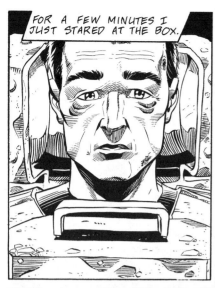

FOR A FEW MINUTES I JUST STARED AT THE BOX.

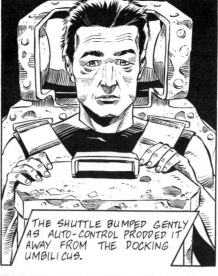

THE SHUTTLE BUMPED GENTLY AS AUTO-CONTROL PRODDED IT AWAY FROM THE DOCKING UMBILICUS.

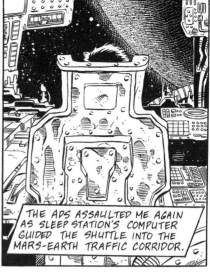

THE ADS ASSAULTED ME AGAIN AS SLEEP STATION'S COMPUTER GUIDED THE SHUTTLE INTO THE MARS-EARTH TRAFFIC CORRIDOR.

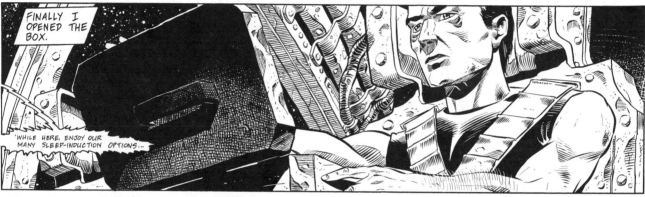

FINALLY I OPENED THE BOX.

'WHILE HERE, ENJOY OUR MANY SLEEP-INDUCTION OPTIONS...

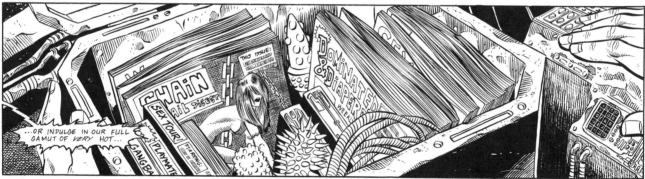

...OR INDULGE IN OUR FULL GAMUT OF VERY HOT...

...VERY INTENSE ADULT ENTERTAINMENT OPTIONS!

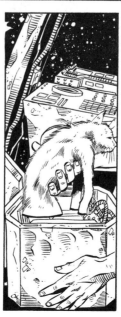

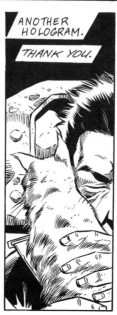

ANOTHER HOLOGRAM.

THANK YOU.

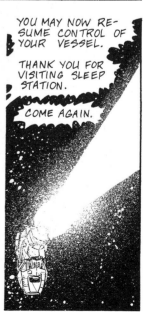

YOU MAY NOW RE-SUME CONTROL OF YOUR VESSEL.

THANK YOU FOR VISITING SLEEP STATION.

COME AGAIN.

69

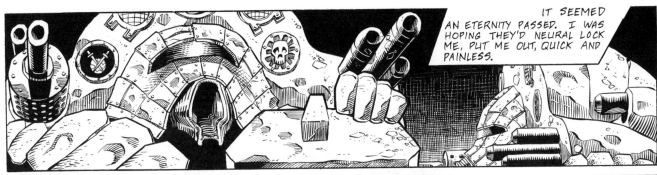

IT SEEMED AN ETERNITY PASSED. I WAS HOPING THEY'D NEURAL LOCK ME, PUT ME OUT, QUICK AND PAINLESS.

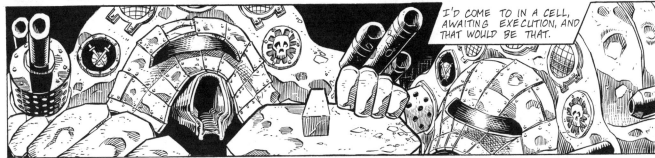

I'D COME TO IN A CELL, AWAITING EXECUTION, AND THAT WOULD BE THAT.

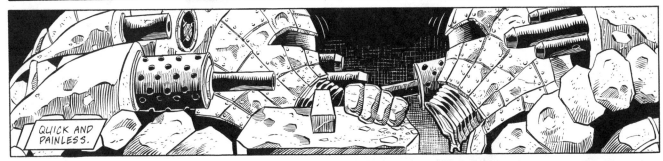

QUICK AND PAINLESS.

AND THEN THEIR HEADS SNAPPED UP, AS IF AT ATTENTION.

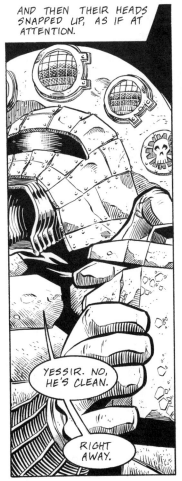

YESSIR. NO, HE'S CLEAN.

RIGHT AWAY.

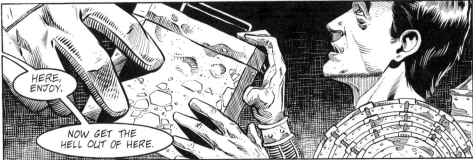

HERE, ENJOY.

NOW GET THE HELL OUT OF HERE.

THEY TURNED AND BOLTED OFF DOWN THE CORRIDOR.

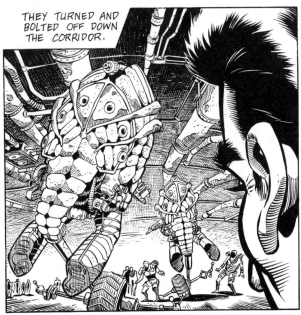

I REENTERED HUGGERT'S I.D. INTO THE PORT.

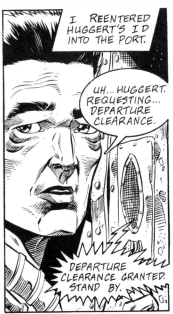

UH... HUGGERT. REQUESTING... DEPARTURE CLEARANCE.

DEPARTURE CLEARANCE GRANTED. STAND BY.

68

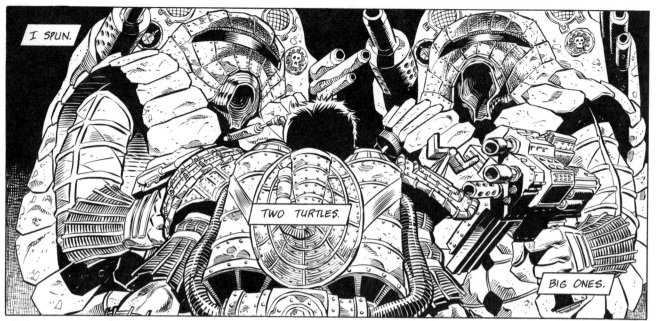

I SPUN.

TWO TURTLES.

BIG ONES.

YOU MISSED IT.

...W-WHAT?

YOU MISSED IT.

...I... I... MISSED...

YOUR SHIP, BUDDY. POLARPROBE 7. LEFT A LONG TIME AGO. YOU MUSTA' OVERSLEPT.

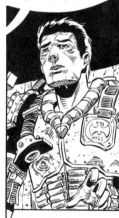

THEY BOTH LAUGHED BEHIND THEIR HELMETS.

OH, NO. I MEAN, I DIDN'T MISS IT. THEY UH, LET ME COME BACK IN A, UH, SHUTTLE-- I FORGOT SOME UH, UH, PERSONAL EFFECTS. I'M JUST HEADING BACK--

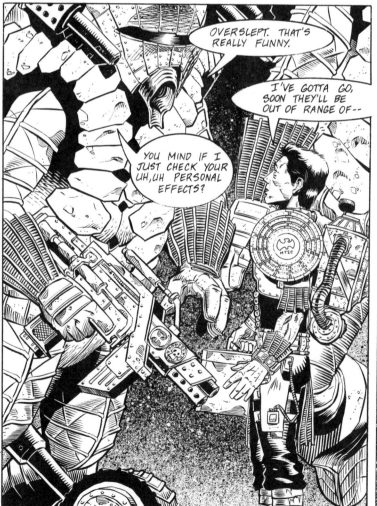

OVERSLEPT. THAT'S REALLY FUNNY.

I'VE GOTTA GO, SOON THEY'LL BE OUT OF RANGE OF--

YOU MIND IF I JUST CHECK YOUR UH, UH PERSONAL EFFECTS?

HE GRABBED THE BOX BEFORE I HAD EVEN PROCESSED THE QUESTION.

I--

67

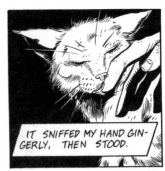

IT SNIFFED MY HAND GIN-GERLY, THEN STOOD.

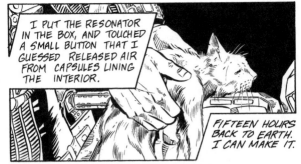

I PUT THE RESONATOR IN THE BOX, AND TOUCHED A SMALL BUTTON THAT I GUESSED RELEASED AIR FROM CAPSULES LINING THE INTERIOR.

FIFTEEN HOURS BACK TO EARTH. I CAN MAKE IT.

CLOSED SOLUTION

I LOCKED THE DOOR AND ACTIVATED THE 'CLOSED' SIGN.

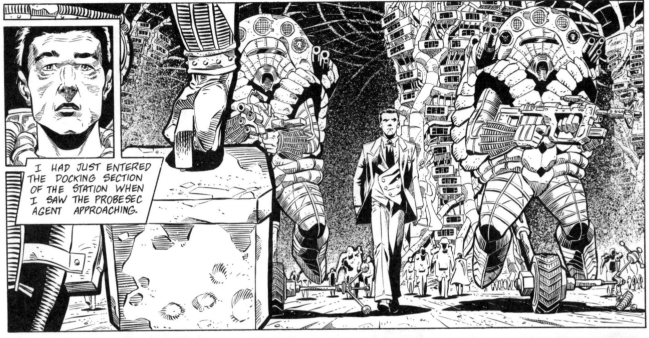

I HAD JUST ENTERED THE DOCKING SECTION OF THE STATION WHEN I SAW THE PROBESEC AGENT APPROACHING.

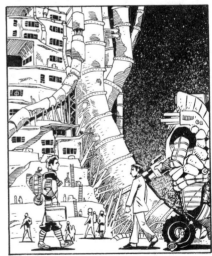

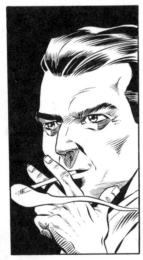

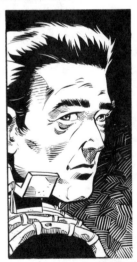

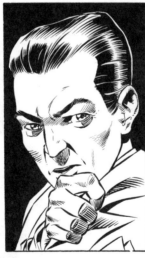

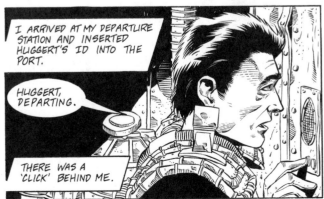

I ARRIVED AT MY DEPARTURE STATION AND INSERTED HUGGERT'S ID INTO THE PORT.

HUGGERT, DEPARTING.

THERE WAS A 'CLICK' BEHIND ME.

TURN AROUND, SIR.

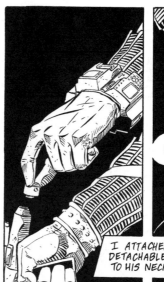

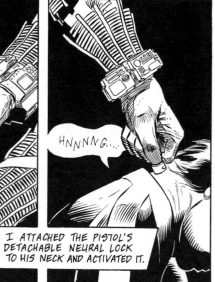

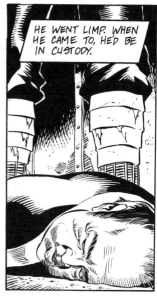

HE WENT LIMP. WHEN HE CAME TO, HE'D BE IN CUSTODY.

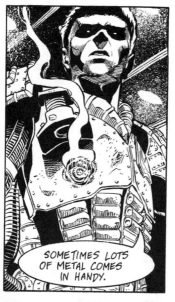

I ATTACHED THE PISTOL'S DETACHABLE NEURAL LOCK TO HIS NECK AND ACTIVATED IT.

HNNNNG...

SOMETIMES LOTS OF METAL COMES IN HANDY.

I THEN LOOKED FOR SOMETHING TO PUT THE RESONATOR IN.

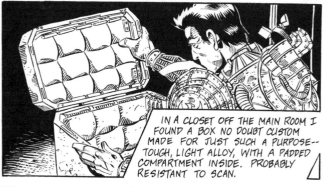

IN A CLOSET OFF THE MAIN ROOM I FOUND A BOX NO DOUBT CUSTOM MADE FOR JUST SUCH A PURPOSE-- TOUGH, LIGHT ALLOY, WITH A PADDED COMPARTMENT INSIDE. PROBABLY RESISTANT TO SCAN.

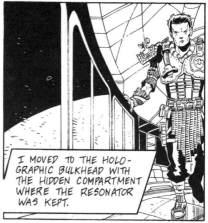

I MOVED TO THE HOLO-GRAPHIC BULKHEAD WITH THE HIDDEN COMPARTMENT WHERE THE RESONATOR WAS KEPT.

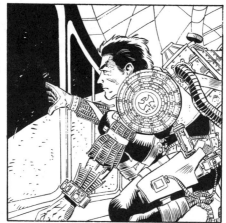

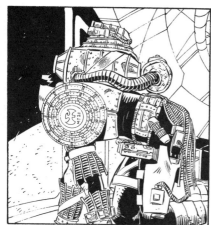

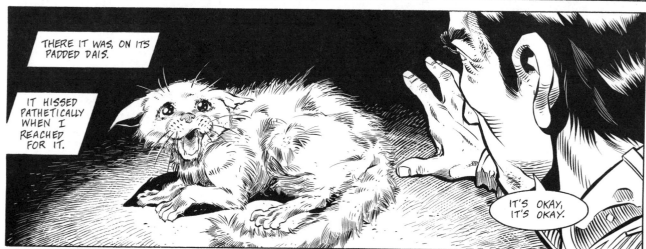

THERE IT WAS, ON ITS PADDED DAIS.

IT HISSED PATHETICALLY WHEN I REACHED FOR IT.

IT'S OKAY, IT'S OKAY.

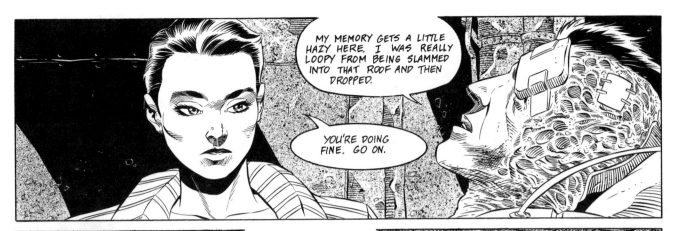

MY MEMORY GETS A LITTLE HAZY HERE. I WAS REALLY LOOPY FROM BEING SLAMMED INTO THAT ROOF AND THEN DROPPED.

YOU'RE DOING FINE. GO ON.

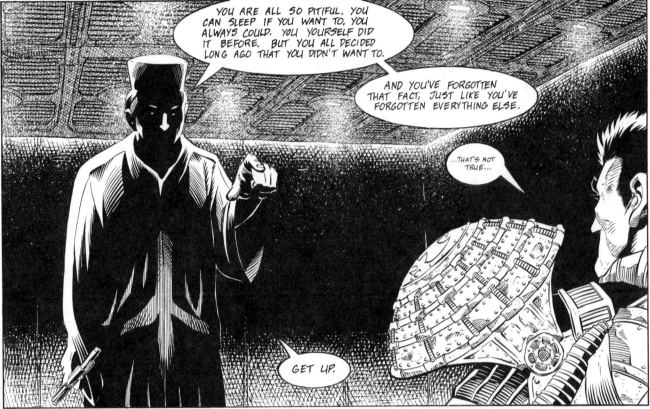

YOU ARE ALL SO PITIFUL. YOU CAN SLEEP IF YOU WANT TO, YOU ALWAYS COULD. YOU YOURSELF DID IT BEFORE. BUT YOU ALL DECIDED LONG AGO THAT YOU DIDN'T WANT TO.

AND YOU'VE FORGOTTEN THAT FACT, JUST LIKE YOU'VE FORGOTTEN EVERYTHING ELSE.

...THAT'S NOT TRUE...

GET UP.

I STRUGGLED TO MY FEET.

I KNEW THAT WAITING TO SEE WHERE WE WERE GOING WOULD BE THE LAST MISTAKE I'D EVER MAKE. THE SECOND HE GLANCED AT THE DOOR...

...I LUNGED.

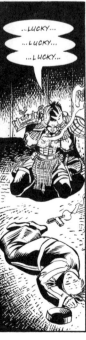

...LUCKY...
...LUCKY...
...LUCKY...

64

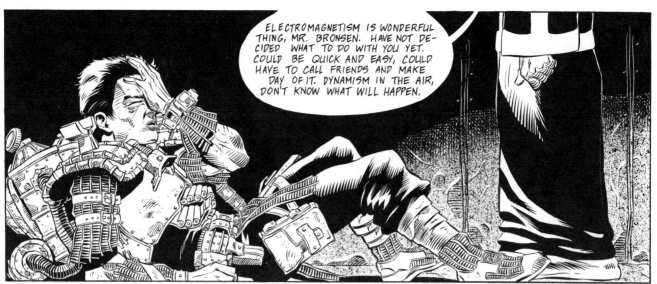

ELECTROMAGNETISM IS WONDERFUL THING, MR. BRONSEN. HAVE NOT DE- CIDED WHAT TO DO WITH YOU YET. COULD BE QUICK AND EASY, COULD HAVE TO CALL FRIENDS AND MAKE DAY OF IT. DYNAMISM IN THE AIR, DON'T KNOW WHAT WILL HAPPEN.

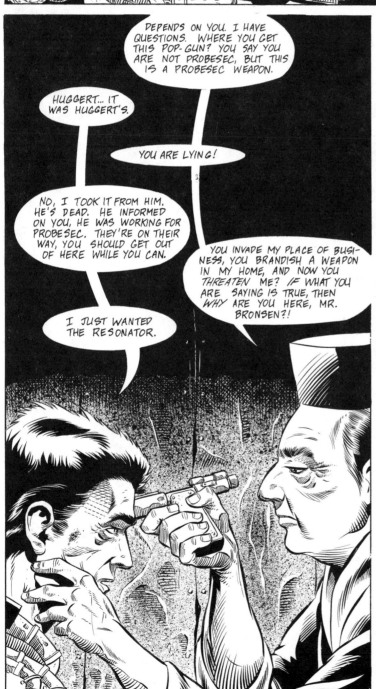

DEPENDS ON YOU. I HAVE QUESTIONS. WHERE YOU GET THIS POP-GUN? YOU SAY YOU ARE NOT PROBESEC, BUT THIS IS A PROBESEC WEAPON.

HUGGERT... IT WAS HUGGERT'S.

YOU ARE LYING!

NO, I TOOK IT FROM HIM. HE'S DEAD. HE INFORMED ON YOU, HE WAS WORKING FOR PROBESEC. THEY'RE ON THEIR WAY, YOU SHOULD GET OUT OF HERE WHILE YOU CAN.

YOU INVADE MY PLACE OF BUSI- NESS, YOU BRANDISH A WEAPON IN MY HOME, AND NOW YOU THREATEN ME? IF WHAT YOU ARE SAYING IS TRUE, THEN WHY ARE YOU HERE, MR. BRONSEN?!

I JUST WANTED THE RESONATOR.

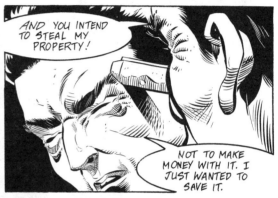

AND YOU INTEND TO STEAL MY PROPERTY!

NOT TO MAKE MONEY WITH IT. I JUST WANTED TO SAVE IT.

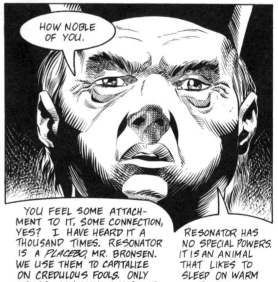

HOW NOBLE OF YOU.

YOU FEEL SOME ATTACH- MENT TO IT, SOME CONNECTION, YES? I HAVE HEARD IT A THOUSAND TIMES. RESONATOR IS A PLACEBO, MR. BRONSEN. WE USE THEM TO CAPITALIZE ON CREDULOUS FOOLS. ONLY DRUGS CAN MAKE YOU SLEEP.

RESONATOR HAS NO SPECIAL POWERS. IT IS AN ANIMAL THAT LIKES TO SLEEP ON WARM BODIES.

...NO...

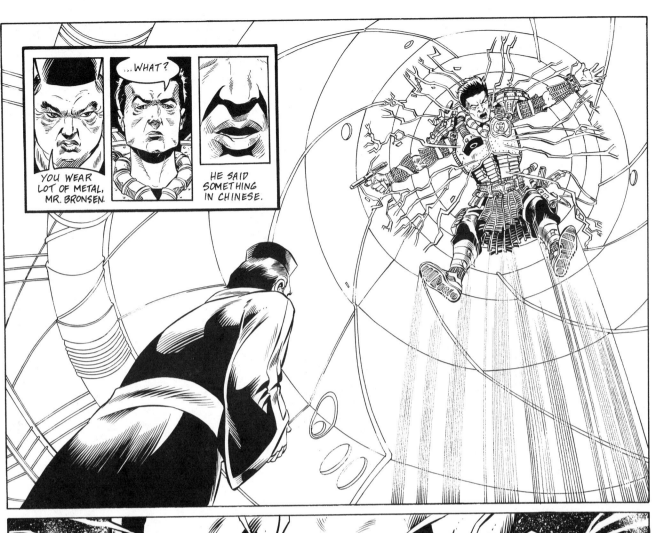

YOU WEAR LOT OF METAL, MR. BRONSEN.

...WHAT?

HE SAID SOMETHING IN CHINESE.

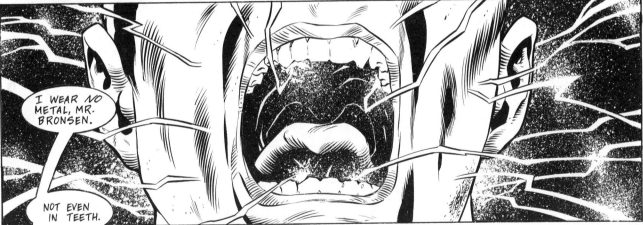

I WEAR *NO* METAL, MR. BRONSEN.

NOT EVEN IN TEETH.

TRACE AMOUNTS OF IRON IN BLOOD, OF COURSE...

...BUT CERTAIN-LY NOT ENOUGH TO MAKE ME FLY UP LIKE

...HEAVY... ...HEAVY... ...HEAVY...

...HEAVY...

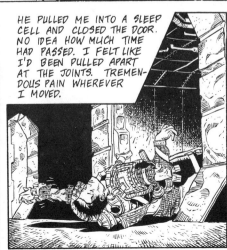

HE PULLED ME INTO A SLEEP CELL AND CLOSED THE DOOR. NO IDEA HOW MUCH TIME HAD PASSED. I FELT LIKE I'D BEEN PULLED APART AT THE JOINTS. TREMEN-DOUS PAIN WHEREVER I MOVED.

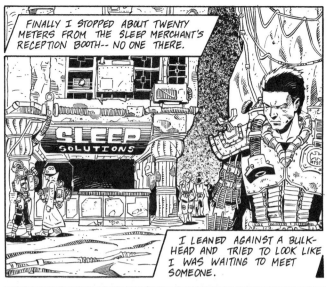

FINALLY I STOPPED ABOUT TWENTY METERS FROM THE SLEEP MERCHANT'S RECEPTION BOOTH-- NO ONE THERE.

I LEANED AGAINST A BULK-HEAD AND TRIED TO LOOK LIKE I WAS WAITING TO MEET SOMEONE.

THEN HE CAME OUT.

I BEAT THEM. THEY'RE NOT HERE YET.

WELCOME, SIR! HOW CAN I HELP YOU?

...MR. BRONSEN?

WHY YOU BACK SO SOON? WHY YOU NOT ON POLARPROBE 7?

FORGOT SOMETHING.

HIS FACE TOLD ME HE RECOGNIZED THE MAKE OF THE PISTOL.

LET'S GO BACK TO YOUR QUARTERS.

GO ON NOW, HURRY.

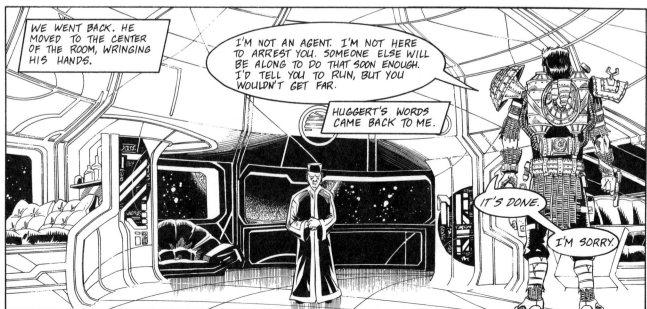

WE WENT BACK. HE MOVED TO THE CENTER OF THE ROOM, WRINGING HIS HANDS.

I'M NOT AN AGENT. I'M NOT HERE TO ARREST YOU. SOMEONE ELSE WILL BE ALONG TO DO THAT SOON ENOUGH. I'D TELL YOU TO RUN, BUT YOU WOULDN'T GET FAR.

HUGGERT'S WORDS CAME BACK TO ME.

IT'S DONE.

I'M SORRY.

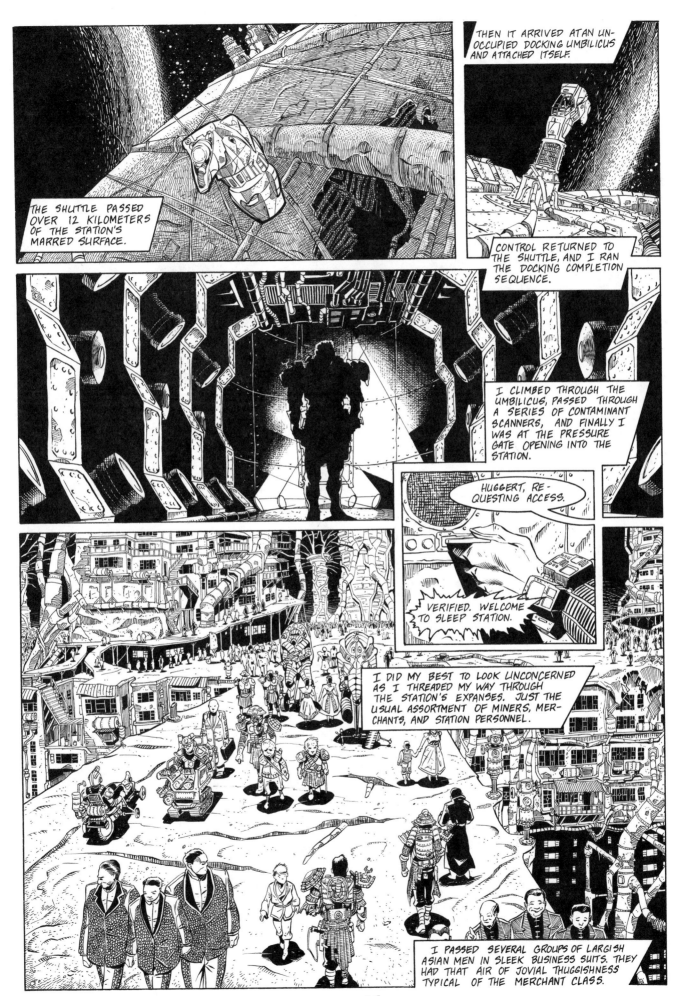

THE SHUTTLE PASSED OVER 12 KILOMETERS OF THE STATION'S MARRED SURFACE.

THEN IT ARRIVED AT AN UN-OCCUPIED DOCKING UMBILICUS AND ATTACHED ITSELF.

CONTROL RETURNED TO THE SHUTTLE, AND I RAN THE DOCKING COMPLETION SEQUENCE.

I CLIMBED THROUGH THE UMBILICUS, PASSED THROUGH A SERIES OF CONTAMINANT SCANNERS, AND FINALLY I WAS AT THE PRESSURE GATE OPENING INTO THE STATION.

HUGGERT, RE-QUESTING ACCESS.

VERIFIED. WELCOME TO SLEEP STATION.

I DID MY BEST TO LOOK UNCONCERNED AS I THREADED MY WAY THROUGH THE STATION'S EXPANSES. JUST THE USUAL ASSORTMENT OF MINERS, MER-CHANTS, AND STATION PERSONNEL.

I PASSED SEVERAL GROUPS OF LARGISH ASIAN MEN IN SLEEK BUSINESS SUITS. THEY HAD THAT AIR OF JOVIAL THUGGISHNESS TYPICAL OF THE MERCHANT CLASS.

TWENTY-ONE HOURS AND TEN MINUTES PASSED.

I BROUGHT THE SHUTTLE OUT OF JAUNT WHEN SLEEP STATION'S APPROACH BEACON SOUNDED.

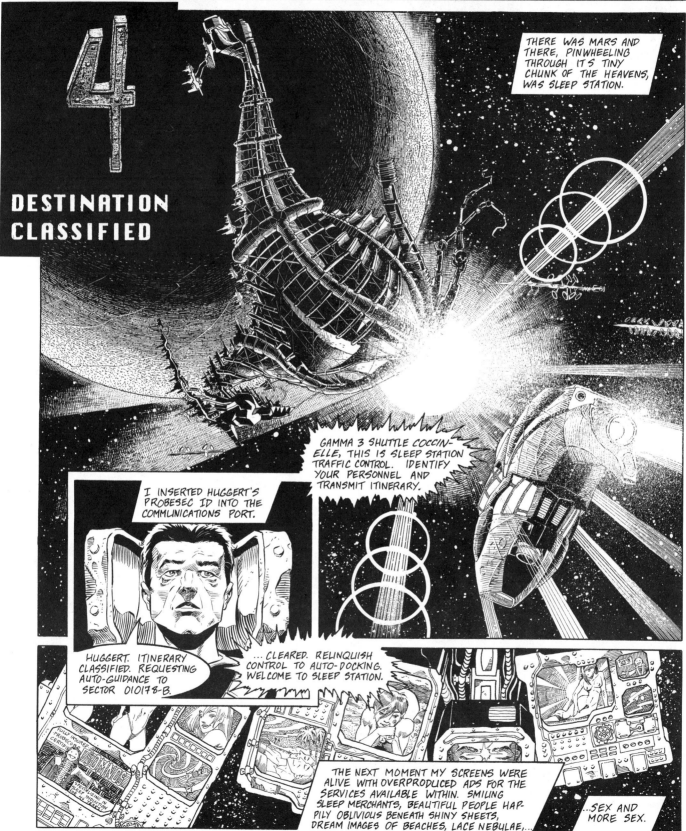

4
DESTINATION CLASSIFIED

THERE WAS MARS AND THERE, PINWHEELING THROUGH IT'S TINY CHUNK OF THE HEAVENS, WAS SLEEP STATION.

GAMMA 3 SHUTTLE COCCINELLE, THIS IS SLEEP STATION TRAFFIC CONTROL. IDENTIFY YOUR PERSONNEL AND TRANSMIT ITINERARY.

I INSERTED HUGGERT'S PROBESEC ID INTO THE COMMUNICATIONS PORT.

HUGGERT. ITINERARY CLASSIFIED. REQUESTING AUTO-GUIDANCE TO SECTOR 010178-B.

...CLEARED. RELINQUISH CONTROL TO AUTO-DOCKING. WELCOME TO SLEEP STATION.

THE NEXT MOMENT MY SCREENS WERE ALIVE WITH OVERPRODUCED ADS FOR THE SERVICES AVAILABLE WITHIN. SMILING SLEEP MERCHANTS, BEAUTIFUL PEOPLE HAPPILY OBLIVIOUS BENEATH SHINY SHEETS, DREAM IMAGES OF BEACHES, LACE NEBULAE,...

...SEX AND MORE SEX.

THE SHUTTLE WAS ESSENTIALLY A MINIATURIZED DRIVE PILE WITH A LIFE POD STUCK ON IT.

NOT MUCH ROOM TO MOVE AROUND, BUT STOCKED WITH ENOUGH SUPPLIES TO KEEP TWO MEN ALIVE FOR WEEKS.

TWENTY HOURS BACK TO SLEEP STATION. I CAN MAKE IT.

MY TURN TO STEAL SOMETHING INSIGNIFICANT.

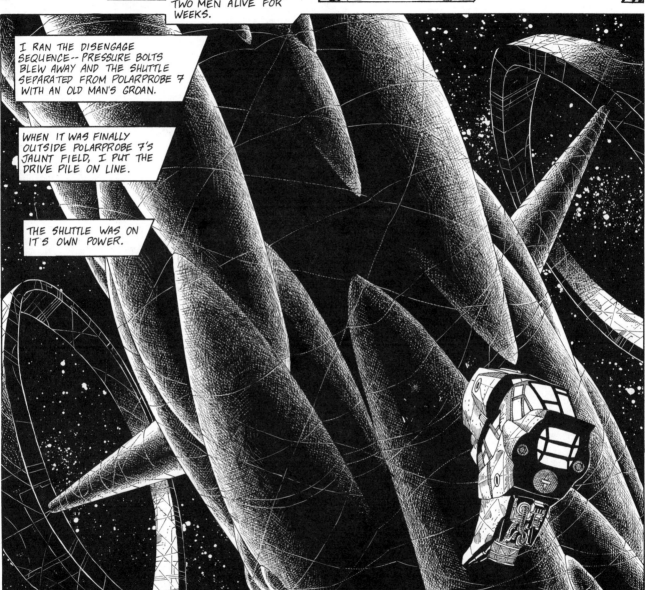

I RAN THE DISENGAGE SEQUENCE-- PRESSURE BOLTS BLEW AWAY AND THE SHUTTLE SEPARATED FROM POLARPROBE 7 WITH AN OLD MAN'S GROAN.

WHEN IT WAS FINALLY OUTSIDE POLARPROBE 7'S JAUNT FIELD, I PUT THE DRIVE PILE ON LINE.

THE SHUTTLE WAS ON ITS OWN POWER.

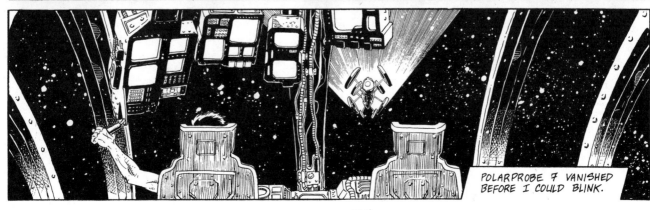

POLARPROBE 7 VANISHED BEFORE I COULD BLINK.

ALMOST FORGOT TO DO THIS.

I MADE A COPY OF THE 'STATUS: NORMAL' SIGNAL THE *CAM* WAS ISSUING TO THE SHIP'S SECURITY SYSTEM, AND ORDERED THE COMPUTER TO PLAY A CONTINUOUS LOOP OF THE COPY INTO THE SHIP'S SECURITY NET.

THEN I PULLED THE GUTS OUT OF THE SHUTTLE'S STATUS MONITOR.

AARON BRONSEN JR WAS HERE SEPT 3157

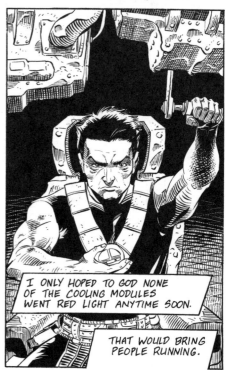

I KNEW IT MIGHT BE MERE MINUTES BEFORE SOMEONE IN SECURITY NOTICED THIS OBVIOUS MANEUVER, BUT THEN AGAIN MAYBE NO ONE WOULD NOTICE TILL AFTER THE SHIP HAD REACHED GANYMEDE.

PEOPLE DIDN'T EXACTLY STEAL SHUTTLES EVERY DAY, SO WHO'D BE LOOKING FOR IT?

I ONLY HOPED TO GOD NONE OF THE COOLING MODULES WENT RED LIGHT ANYTIME SOON.

THAT WOULD BRING PEOPLE RUNNING.

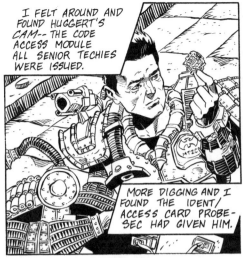

I FELT AROUND AND FOUND HUGGERT'S *CAM*-- THE CODE ACCESS MODULE ALL SENIOR TECHIES WERE ISSUED.

MORE DIGGING AND I FOUND THE IDENT/ACCESS CARD PROBE-SEC HAD GIVEN HIM.

I STUFFED IT AND THE *CAM* INTO MY POCKET, AND RE-TRIEVED THE PISTOL.

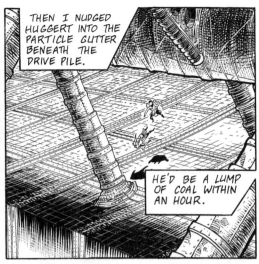

THEN I NUDGED HUGGERT INTO THE PARTICLE GUTTER BENEATH THE DRIVE PILE.

HE'D BE A LUMP OF COAL WITHIN AN HOUR.

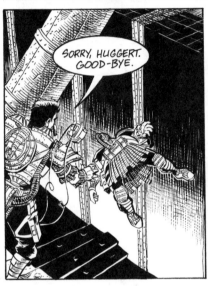

SORRY, HUGGERT. GOOD-BYE.

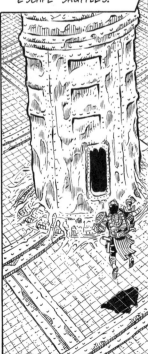

I ENTERED AN ACCESS CORRIDOR THAT CONNECT-ED THE ENGINE INTER-FACE WITH ONE OF THE ESCAPE SHUTTLES.

THE SHUTTLES WERE THERE IN CASE OF A DRIVE PILE MELTDOWN OR SOME OTHER UNCONTAINABLE DI SASTER. THE LIFE NODES WOULD DETACH AND THE TECHIES NEAR THE ENGINES WOULD EXIT IN THE SHUTTLES.

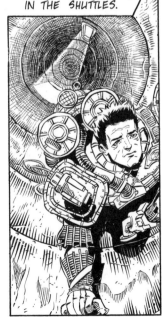

PROBLEM WAS THEY HAD NEVER BEEN USED. THE SHUTTLES WERE PROBABLY ORIGINAL EQUIPMENT, AS OLD AS POLARPROBE 7. I HAD NO IDEA IF THEY WORKED.

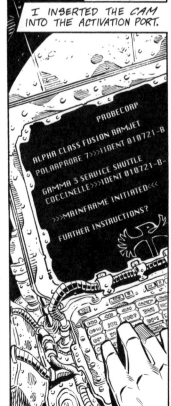

I INSERTED THE *CAM* INTO THE ACTIVATION PORT.

PROBECORP

ALPHA CLASS FUSION RAMJET
POLARPROBE 7>>>IDENT 010721-B

GAMMA 3 SERVICE SHUTTLE
COCCINELLE>>>IDENT 010721-B-

>>>MAINFRAME INITIATED<<<

FURTHER INSTRUCTIONS?

I COULD SMELL BURNED MEAT.

DOLLOPS OF BLOOD, TINY CHUNKS OF CARBONIZED BONE, AND THE PISTOL WERE ALL SPINNING OFF ON THEIR OWN TRAJECTORIES.

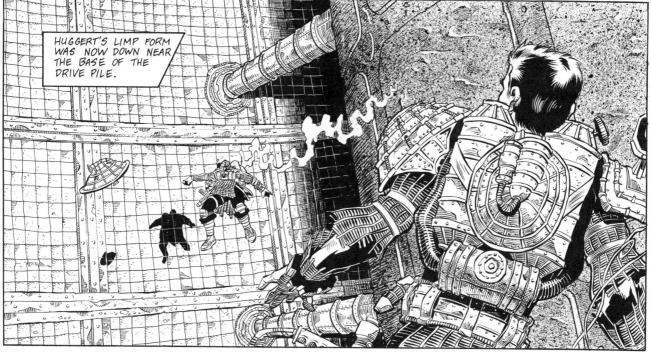

HUGGERT'S LIMP FORM WAS NOW DOWN NEAR THE BASE OF THE DRIVE PILE.

THE PISTOL'S BLAST HAD STRUCK BENEATH HIS LEFT EAR-- HIS HEAD WAS BENT WAY BACK, HIS NECK MUST HAVE BEEN BROKEN INSTANTLY BY THE IMPACT.

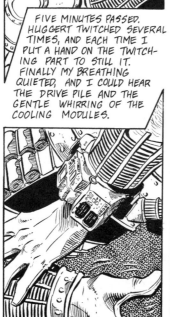

FIVE MINUTES PASSED. HUGGERT TWITCHED SEVERAL TIMES, AND EACH TIME I PUT A HAND ON THE TWITCHING PART TO STILL IT. FINALLY MY BREATHING QUIETED, AND I COULD HEAR THE DRIVE PILE AND THE GENTLE WHIRRING OF THE COOLING MODULES.

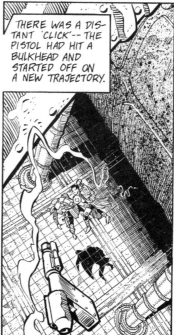

THERE WAS A DISTANT 'CLICK'-- THE PISTOL HAD HIT A BULKHEAD AND STARTED OFF ON A NEW TRAJECTORY.

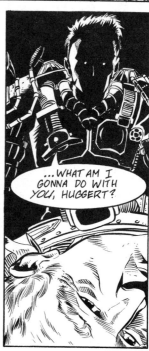

...WHAT AM I GONNA DO WITH YOU, HUGGERT?

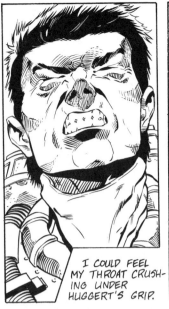

PANICKED, BEYOND REASON, CORNERED, HE WAS MASSIVELY STRONG.

I COULD FEEL MY THROAT CRUSHING UNDER HUGGERT'S GRIP.

THEN I FELT HIS GUN ARM COMING DOWN. THEN IT BUCKLED AT THE ELBOW.

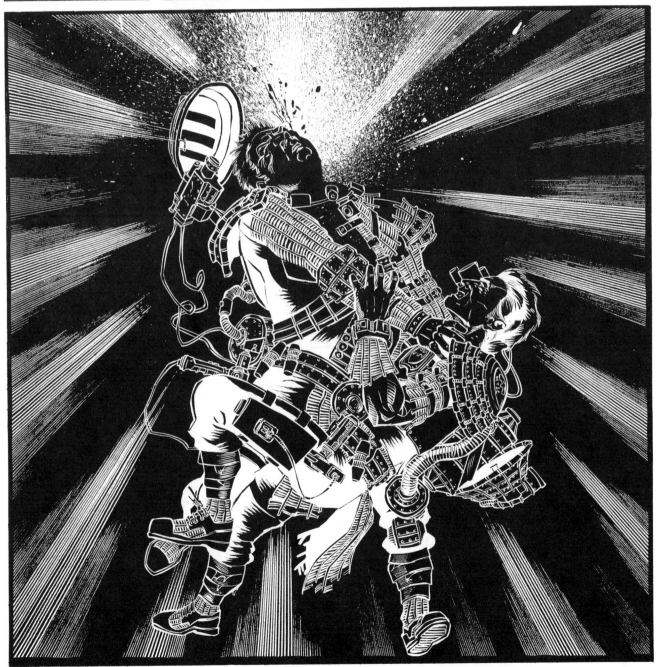

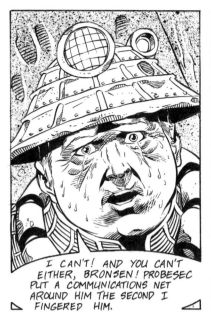

I CAN'T! AND YOU CAN'T EITHER, BRONSEN! PROBESEC PUT A COMMUNICATIONS NET AROUND HIM THE SECOND I FINGERED HIM.

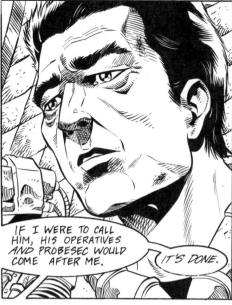

IF I WERE TO CALL HIM, HIS OPERATIVES AND PROBESEC WOULD COME AFTER ME.

IT'S DONE.

BRONSEN, WHAT AM I GONNA DO WITH YOU? THIS WASN'T SUPPOSED TO HAPPEN... SOMEONE'S GOTTA TELL ME WHAT TO DO... BRONSEN, YOU TELL ME WHAT TO DO AND I'LL DO IT...

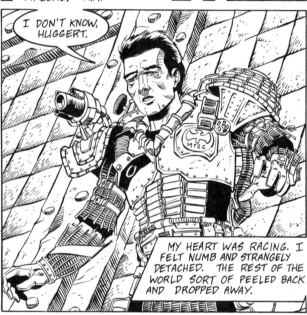

I DON'T KNOW, HUGGERT.

MY HEART WAS RACING. I FELT NUMB AND STRANGELY DETACHED. THE REST OF THE WORLD SORT OF PEELED BACK AND DROPPED AWAY.

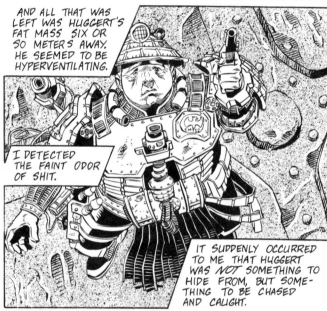

AND ALL THAT WAS LEFT WAS HUGGERT'S FAT MASS SIX OR SO METERS AWAY. HE SEEMED TO BE HYPERVENTILATING.

I DETECTED THE FAINT ODOR OF SHIT.

IT SUDDENLY OCCURRED TO ME THAT HUGGERT WAS NOT SOMETHING TO HIDE FROM, BUT SOMETHING TO BE CHASED AND CAUGHT.

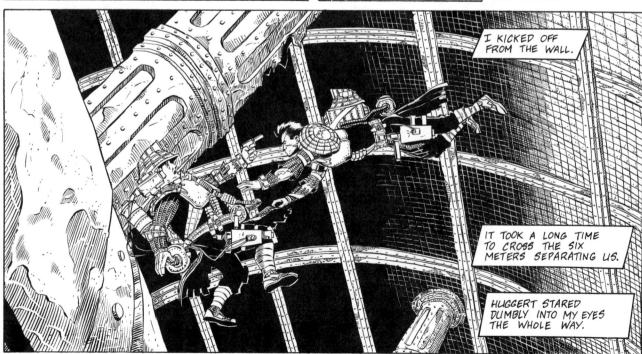

I KICKED OFF FROM THE WALL.

IT TOOK A LONG TIME TO CROSS THE SIX METERS SEPARATING US.

HUGGERT STARED DUMBLY INTO MY EYES THE WHOLE WAY.

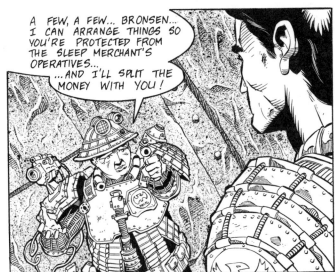

A FEW, A FEW... BRONSEN... I CAN ARRANGE THINGS SO YOU'RE PROTECTED FROM THE SLEEP MERCHANT'S OPERATIVES...

...AND I'LL SPLIT THE MONEY WITH YOU!

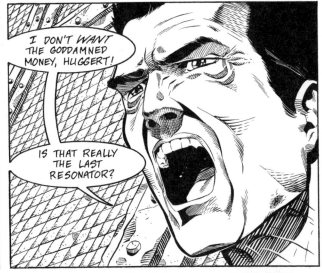

I DON'T *WANT* THE GODDAMNED MONEY, HUGGERT!

IS THAT REALLY THE LAST RESONATOR?

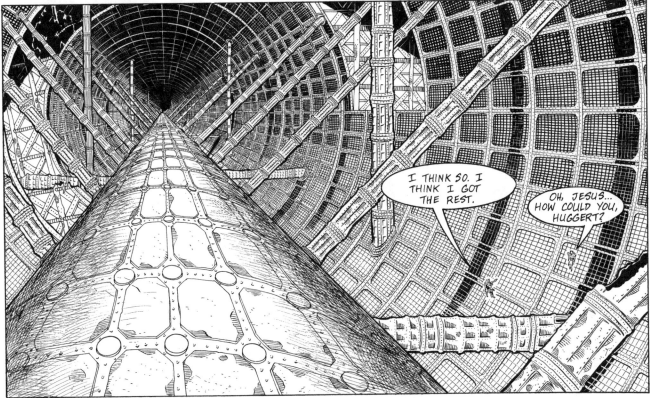

I THINK SO. I THINK I GOT THE REST.

OH, JESUS... HOW COULD YOU, HUGGERT?

I'M 86 YEARS OLD, BRONSEN! MY EYES, MY REACTION TIME IS SHOT! SOON ENOUGH THEY'LL SEND ME TO THE TOOLING PLANTS AT MARS-ERDMANN. THAT'S WHAT THEY DO TO US WHEN WE GET TOO OLD. THEY'LL DO IT TO YOU, TOO! PIECING TOGETHER COMPONENTS IN A ROOM WITH A THOUSAND OTHER USELESS OLD MEN. I DON'T WANT TO DIE THAT WAY.

WITH THE MONEY THEY'RE PAYING ME, I CAN BUY MY OWN PLACE, AT VEGAS STATION, OR SLEEP STATION.

WHEN DID YOU TELL THEM?

YESTERDAY, BEFORE WE LEFT.

AGENTS ARE PROBABLY ON THEIR WAY TO SLEEP STATION RIGHT NOW.

HUGGERT... PLEASE... YOU'VE GOT TO CALL THE SLEEP MERCHANT AND WARN HIM.

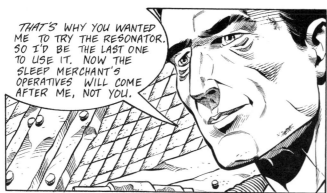

THAT'S WHY YOU WANTED ME TO TRY THE RESONATOR. SO I'D BE THE LAST ONE TO USE IT. NOW THE SLEEP MERCHANT'S OPERATIVES WILL COME AFTER ME, NOT YOU.

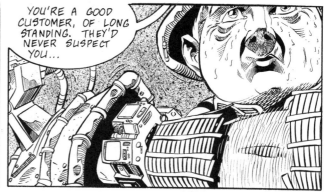

YOU'RE A GOOD CUSTOMER, OF LONG STANDING. THEY'D NEVER SUSPECT YOU...

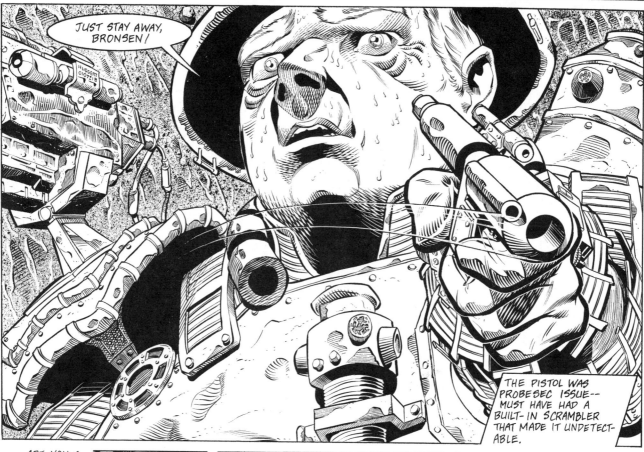

JUST STAY AWAY, BRONSEN!

THE PISTOL WAS PROBESEC ISSUE-- MUST HAVE HAD A BUILT-IN SCRAMBLER THAT MADE IT UNDETECT- ABLE.

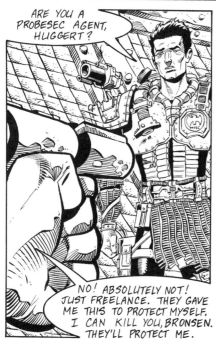

ARE YOU A PROBESEC AGENT, HUGGERT?

NO! ABSOLUTELY NOT! JUST FREELANCE. THEY GAVE ME THIS TO PROTECT MYSELF. I CAN KILL YOU, BRONSEN. THEY'LL PROTECT ME.

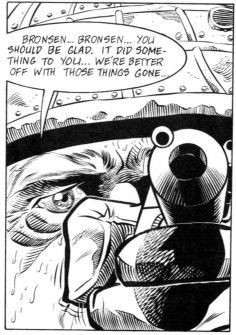

BRONSEN... BRONSEN... YOU SHOULD BE GLAD. IT DID SOME- THING TO YOU... WE'RE BETTER OFF WITH THOSE THINGS GONE...

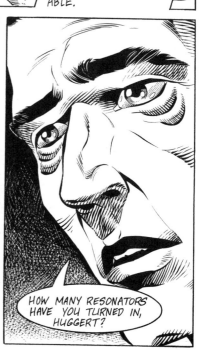

HOW MANY RESONATORS HAVE YOU TURNED IN, HUGGERT?

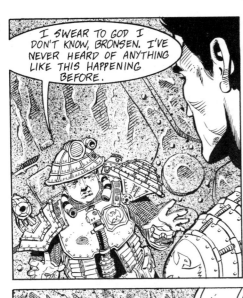

I SWEAR TO GOD I DON'T KNOW, BRONSEN. I'VE NEVER HEARD OF ANYTHING LIKE THIS HAPPENING BEFORE.

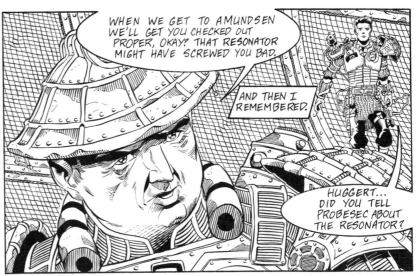

WHEN WE GET TO AMUNDSEN WE'LL GET YOU CHECKED OUT PROPER, OKAY? THAT RESONATOR MIGHT HAVE SCREWED YOU BAD.

AND THEN I REMEMBERED.

HUGGERT... DID YOU TELL PROBESEC ABOUT THE RESONATOR?

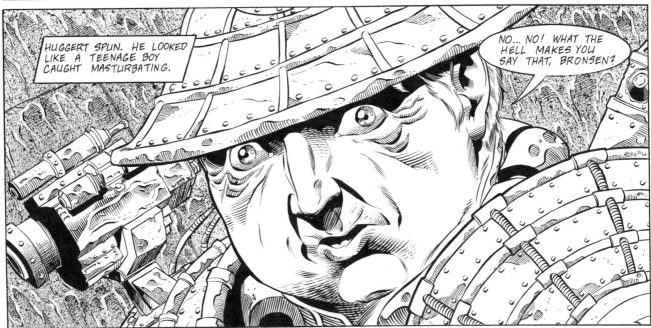

HUGGERT SPUN. HE LOOKED LIKE A TEENAGE BOY CAUGHT MASTURBATING.

NO... NO! WHAT THE HELL MAKES YOU SAY THAT, BRONSEN?

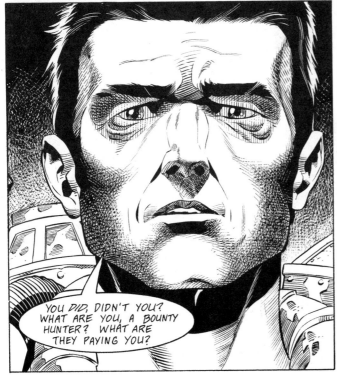

YOU DID, DIDN'T YOU? WHAT ARE YOU, A BOUNTY HUNTER? WHAT ARE THEY PAYING YOU?

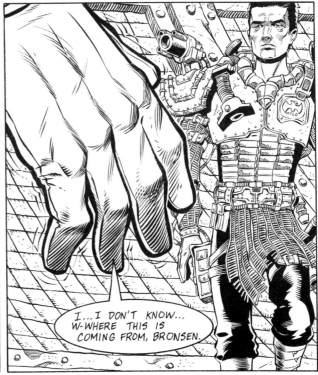

I... I DON'T KNOW... W-WHERE THIS IS COMING FROM, BRONSEN.

I DID A QUICK SPOT CHECK-- A YELLOW LIGHT ON COOLING MODULE A-19, WHICH WAS SEALED. HUGGERT WAS IN THERE, FIXING SOMETHING.

IMAGES FLITTED ABOUT IN MY MIND, RECEDING COY-LY INTO THE DARKNESS WHEN I TRIED TO FIXATE ON THEM.

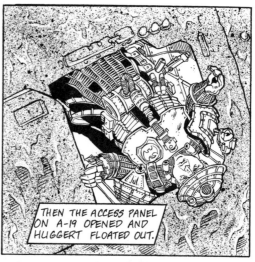

THEN THE ACCESS PANEL ON A-19 OPENED AND HUGGERT FLOATED OUT.

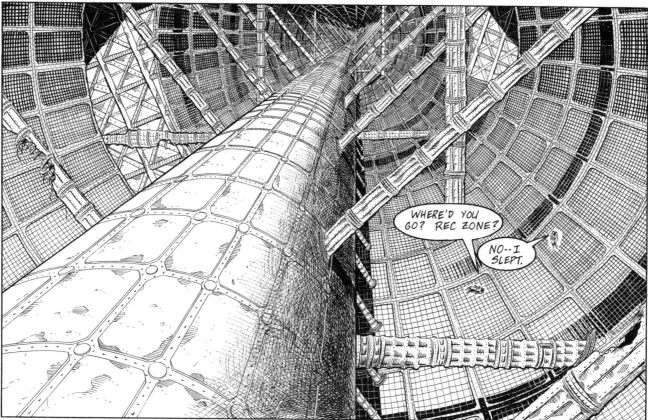

WHERE'D YOU GO? REC ZONE?

NO-- I SLEPT.

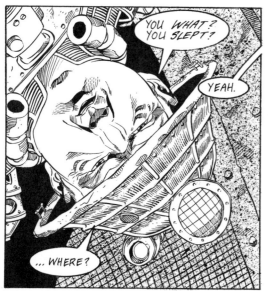

YOU *WHAT?* YOU *SLEPT?*

YEAH.

...WHERE?

UP IN THE MAINTE-NANCE GRID BETWEEN LEVELS 1 AND 2. IT'S EMPTY UP THERE, NO ONE SAW ME.

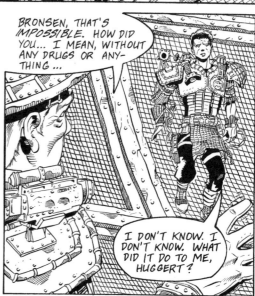

BRONSEN, THAT'S *IMPOSSIBLE.* HOW DID YOU... I MEAN, WITHOUT ANY DRUGS OR ANY-THING...

I DON'T KNOW. I DON'T KNOW. WHAT DID IT DO TO ME, HUGGERT?

49

IT TOOK ME A MINUTE TO REMEMBER WHERE I WAS.

I DIDN'T REMEMBER ANYTHING ABOUT THE DREAM, NOT YET AT LEAST.

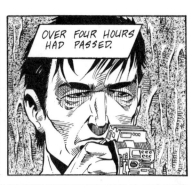

OVER FOUR HOURS HAD PASSED.

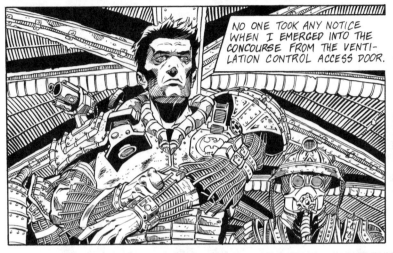

NO ONE TOOK ANY NOTICE WHEN I EMERGED INTO THE CONCOURSE FROM THE VENTILATION CONTROL ACCESS DOOR.

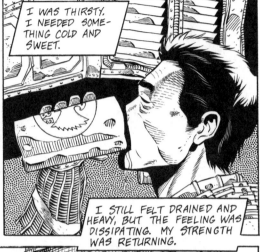

I WAS THIRSTY, I NEEDED SOMETHING COLD AND SWEET.

I STILL FELT DRAINED AND HEAVY, BUT THE FEELING WAS DISSIPATING. MY STRENGTH WAS RETURNING.

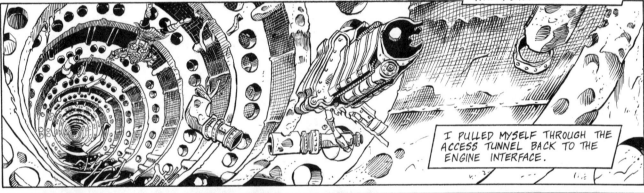

I PULLED MYSELF THROUGH THE ACCESS TUNNEL BACK TO THE ENGINE INTERFACE.

NO SIGN OF HUGGERT.

48

IT LEANED IN CLOSER AND CLOSER, UNTIL I WAS IN ONE OF THOSE POOLS, AND THERE WAS ABSOLUTELY NOTHING ELSE.

NOW I FELT FEAR. NOW I *WAS* FEAR.

AND WHEN I HEARD THE RESONATOR'S VOICE AGAIN, IT CAME AT ME FROM A MEASURELESS REMOVE, ALL AT ONCE JUST OUTSIDE THE NARROW CIRCLE OF MY VISION AND FROM A THOUSAND MILES AWAY.

'HE WILL KILL ME.'

'HOW DO YOU KNOW?' MY MIND ASKED, EVEN THOUGH I ALREADY KNEW THE ANSWER.

'HE TOLD ME,' OUR MINDS SAID TOGETHER.

ONE OF THEM SEEMED TO HAVE A FACE THAT DIDN'T VANISH WHEN I STARED AT IT.

IT WAS MASKLIKE, FROZEN, LIKE AN OLD PHOTO.

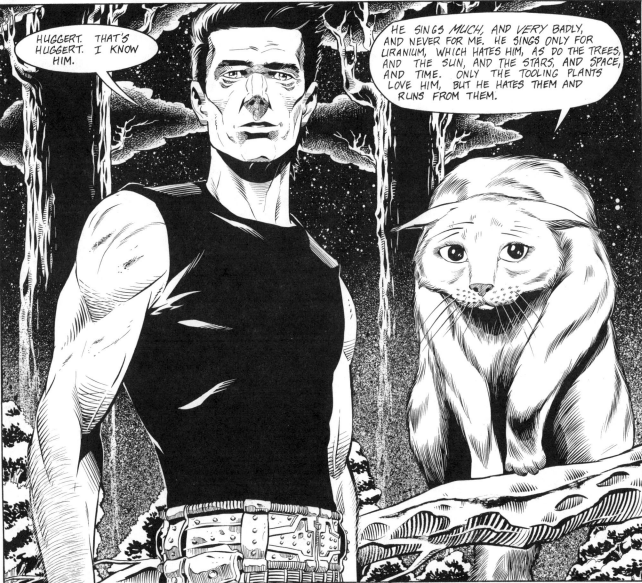

HUGGERT. THAT'S HUGGERT. I KNOW HIM.

HE SINGS MUCH, AND VERY BADLY, AND NEVER FOR ME. HE SINGS ONLY FOR URANIUM, WHICH HATES HIM, AS DO THE TREES, AND THE SUN, AND THE STARS, AND SPACE, AND TIME. ONLY THE TOOLING PLANTS LOVE HIM, BUT HE HATES THEM AND RUNS FROM THEM.

OH, COME ON. HE'S A GROUCH, BUT HE'S NOT THAT BAD.

THE RESONATOR'S EYES DILATED INTO HUGE BLACK POOLS.

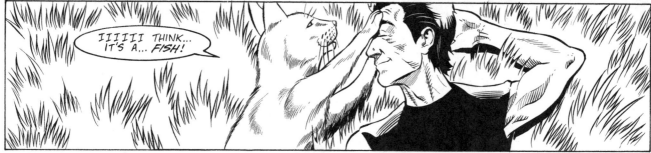

IIIIII THINK...
IT'S A... *FISH!*

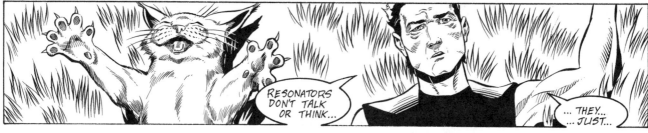

RESONATORS
DON'T TALK
OR THINK...

... THEY...
...JUST...

HEY!

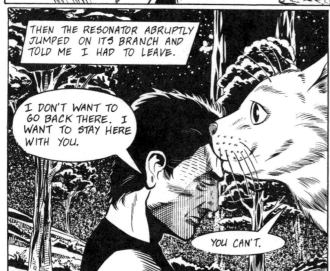

THEN THE RESONATOR ABRUPTLY
JUMPED ON ITS BRANCH AND
TOLD ME I HAD TO LEAVE.

I DON'T WANT TO
GO BACK THERE. I
WANT TO STAY HERE
WITH YOU.

YOU CAN'T.

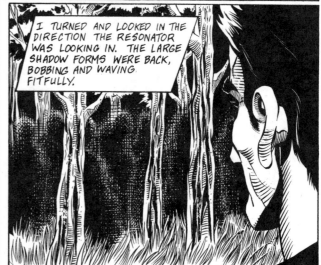

I TURNED AND LOOKED IN THE
DIRECTION THE RESONATOR
WAS LOOKING IN. THE LARGE
SHADOW FORMS WERE BACK,
BOBBING AND WAVING
FITFULLY.

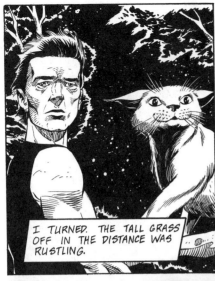
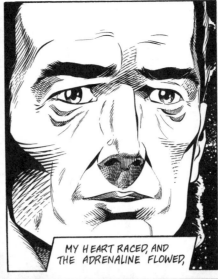
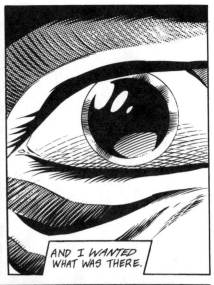

I TURNED. THE TALL GRASS OFF IN THE DISTANCE WAS RUSTLING.

MY HEART RACED, AND THE ADRENALINE FLOWED,

AND I *WANTED* WHAT WAS THERE.

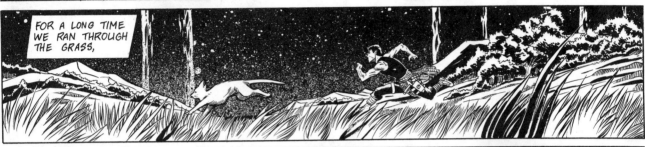

FOR A LONG TIME WE RAN THROUGH THE GRASS,

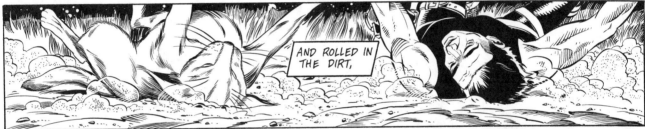

AND ROLLED IN THE DIRT,

AND CHASED THE LITTLE THINGS TO BE CHASED AND CAUGHT.

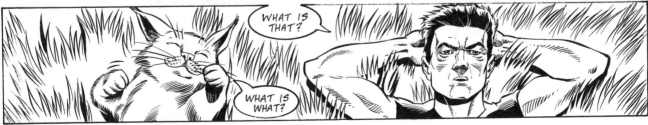

WHAT IS THAT?

WHAT IS WHAT?

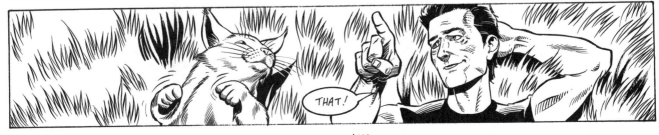

THAT!

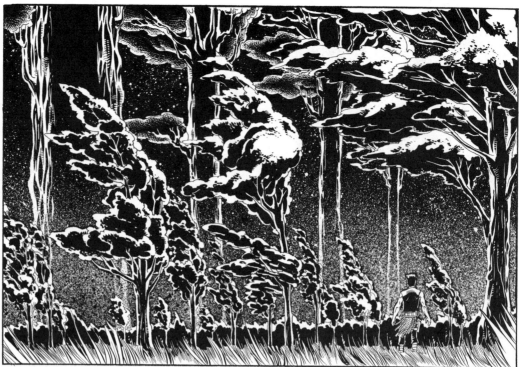

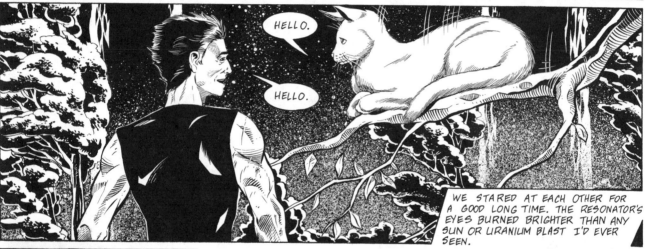

HELLO.

HELLO.

WE STARED AT EACH OTHER FOR A GOOD LONG TIME. THE RESONATOR'S EYES BURNED BRIGHTER THAN ANY SUN OR URANIUM BLAST I'D EVER SEEN.

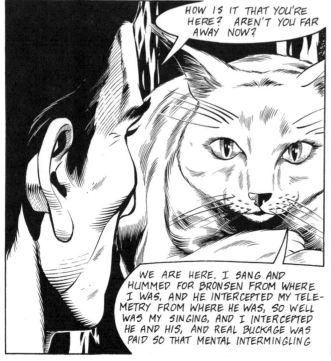

HOW IS IT THAT YOU'RE HERE? AREN'T YOU FAR AWAY NOW?

WE ARE HERE. I SANG AND HUMMED FOR BRONSEN FROM WHERE I WAS, AND HE INTERCEPTED MY TELEMETRY FROM WHERE HE WAS, SO WELL WAS MY SINGING, AND I INTERCEPTED HE AND HIS, AND REAL BUCKAGE WAS PAID SO THAT MENTAL INTERMINGLING

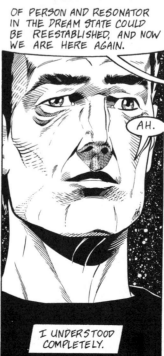

OF PERSON AND RESONATOR IN THE DREAM STATE COULD BE REESTABLISHED, AND NOW WE ARE HERE AGAIN.

AH.

I UNDERSTOOD COMPLETELY.

LOOK!

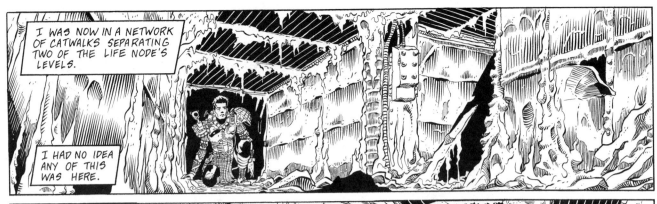

I WAS NOW IN A NETWORK OF CATWALKS SEPARATING TWO OF THE LIFE NODE'S LEVELS.

I HAD NO IDEA ANY OF THIS WAS HERE.

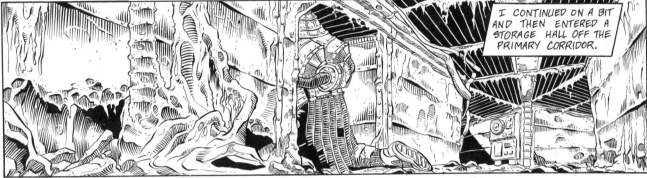

I CONTINUED ON A BIT AND THEN ENTERED A STORAGE HALL OFF THE PRIMARY CORRIDOR.

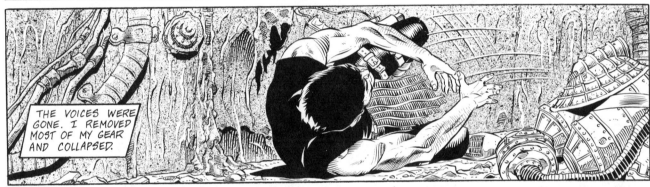

THE VOICES WERE GONE. I REMOVED MOST OF MY GEAR AND COLLAPSED.

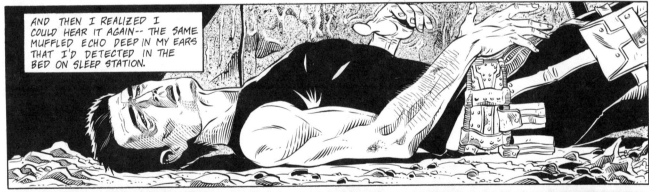

AND THEN I REALIZED I COULD HEAR IT AGAIN-- THE SAME MUFFLED ECHO DEEP IN MY EARS THAT I'D DETECTED IN THE BED ON SLEEP STATION.

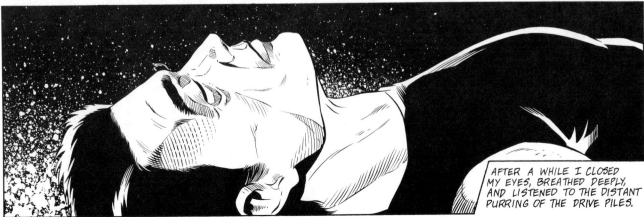

AFTER A WHILE I CLOSED MY EYES, BREATHED DEEPLY, AND LISTENED TO THE DISTANT PURRING OF THE DRIVE PILES.

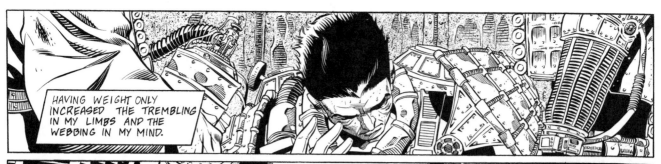

HAVING WEIGHT ONLY INCREASED THE TREMBLING IN MY LIMBS AND THE WEBBING IN MY MIND.

THE ONLY THING THAT STAYED IN MY MENTAL FOCUS WAS THE SLOWLY GATHERING DISGUST I FELT FOR THE VOICES AND SMELLS BOMBARDING ME.

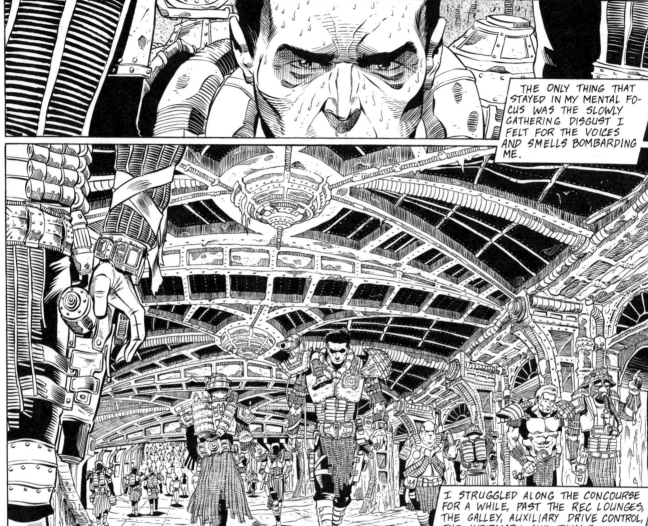

I STRUGGLED ALONG THE CONCOURSE FOR A WHILE, PAST THE REC LOUNGES, THE GALLEY, AUXILIARY DRIVE CONTROL, THE INFIRMARY. AND THEN I REALIZED WHAT WAS HAPPENING.

I WAS FALLING ASLEEP. I DIDN'T KNOW WHY IT WAS HAPPENING, BUT I DID KNOW I'D BE IN TROUBLE IF ANYONE SAW IT HAPPEN. I HAD TO BE ALONE.

I SAW A VENTILATION CONTROL ACCESS DOOR. I ENTERED IT, TRYING MY BEST TO LOOK LIKE I WAS ON A MAINTENANCE RUN.

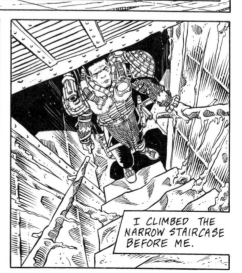

I CLIMBED THE NARROW STAIRCASE BEFORE ME.

SORRY... I HIT GENERAL ASSESSMENT AND IT JUST WENT OFF.

YOU HIT PRESSURE RELEASE! NEVER HIT PRESSURE RELEASE ON A YELLOW LIGHT!

REMEMBER, IF YOU'RE STUPID, YOU DIE.

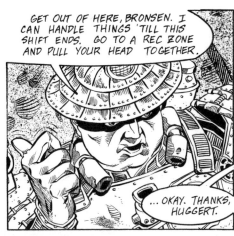

GET OUT OF HERE, BRONSEN. I CAN HANDLE THINGS 'TILL THIS SHIFT ENDS. GO TO A REC ZONE AND PULL YOUR HEAD TOGETHER.

...OKAY. THANKS, HUGGERT.

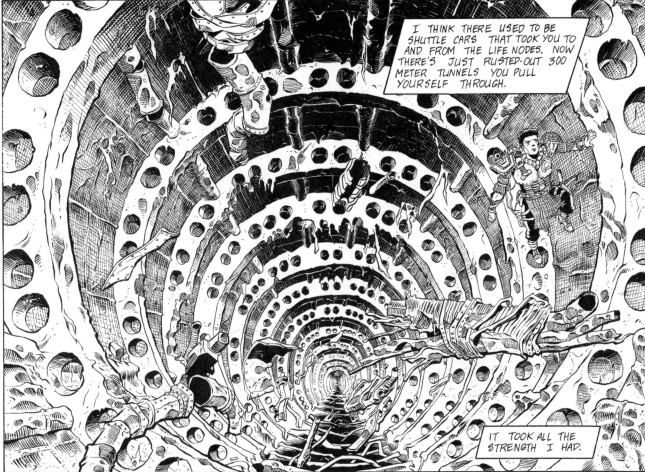

I THINK THERE USED TO BE SHUTTLE CARS THAT TOOK YOU TO AND FROM THE LIFE NODES. NOW THERE'S JUST RUSTED-OUT 300 METER TUNNELS YOU PULL YOURSELF THROUGH.

IT TOOK ALL THE STRENGTH I HAD.

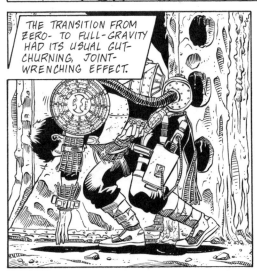

THE TRANSITION FROM ZERO- TO FULL-GRAVITY HAD ITS USUAL GUT-CHURNING, JOINT-WRENCHING EFFECT.

I SLUMPED AGAINST A BULKHEAD AND RUBBED MY BURNING EYES. PEOPLE WERE BRUSHING PAST AND BUMPING INTO ME, GOING TO AND FROM WORK DETAILS IN THE GALLEYS, THE CENTRAL SHAFT, ONE OF THE DRIVE PILES.

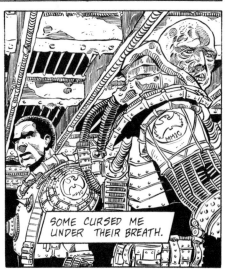

SOME CURSED ME UNDER THEIR BREATH.

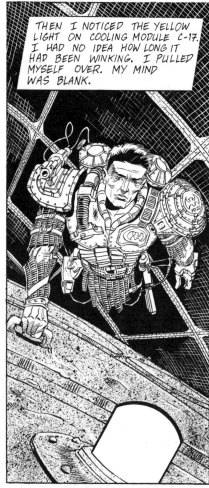

THEN I NOTICED THE YELLOW LIGHT ON COOLING MODULE C-17. I HAD NO IDEA HOW LONG IT HAD BEEN WINKING. I PULLED MYSELF OVER. MY MIND WAS BLANK.

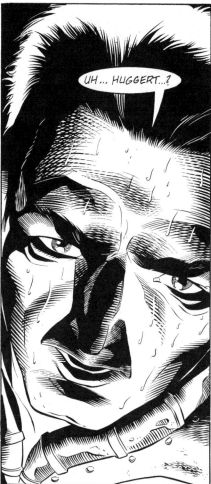

UH... HUGGERT...?

WHAT IS HAPPENING TO ME?

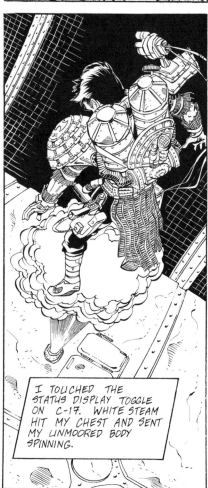

I TOUCHED THE STATUS DISPLAY TOGGLE ON C-17. WHITE STEAM HIT MY CHEST AND SENT MY UNMOORED BODY SPINNING.

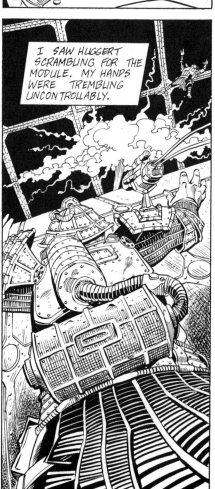

I SAW HUGGERT SCRAMBLING FOR THE MODULE. MY HANDS WERE TREMBLING UNCONTROLLABLY.

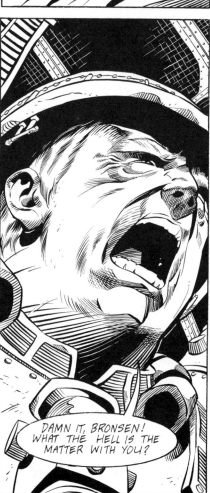

DAMN IT, BRONSEN! WHAT THE HELL IS THE MATTER WITH YOU?

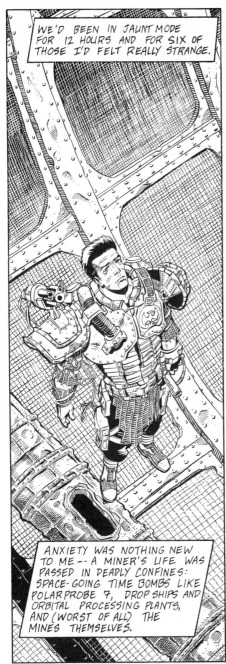

WE'D BEEN IN JAUNT MODE FOR 12 HOURS AND FOR SIX OF THOSE I'D FELT REALLY STRANGE.

ANXIETY WAS NOTHING NEW TO ME -- A MINER'S LIFE WAS PASSED IN DEADLY CONFINES: SPACE-GOING TIME BOMBS LIKE POLAR PROBE 7, DROP SHIPS AND ORBITAL PROCESSING PLANTS, AND (WORST OF ALL) THE MINES THEMSELVES.

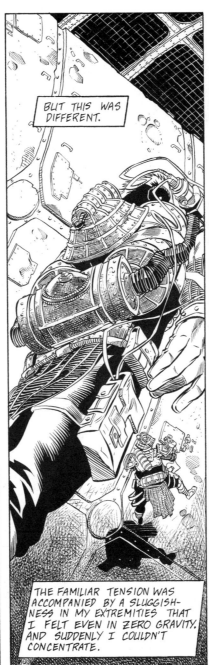

BUT THIS WAS DIFFERENT.

THE FAMILIAR TENSION WAS ACCOMPANIED BY A SLUGGISH-NESS IN MY EXTREMITIES THAT I FELT EVEN IN ZERO GRAVITY. AND SUDDENLY I COULDN'T CONCENTRATE.

THIS SCARED THE HELL OUT OF ME.

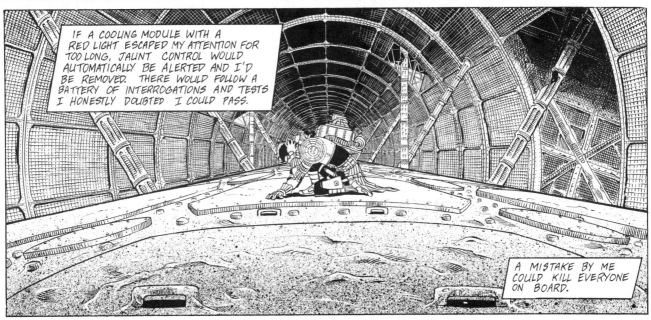

IF A COOLING MODULE WITH A RED LIGHT ESCAPED MY ATTENTION FOR TOO LONG, JAUNT CONTROL WOULD AUTOMATICALLY BE ALERTED AND I'D BE REMOVED. THERE WOULD FOLLOW A BATTERY OF INTERROGATIONS AND TESTS I HONESTLY DOUBTED I COULD PASS.

A MISTAKE BY ME COULD KILL EVERYONE ON BOARD.

THESE SHIPS BORE FEW SIGNS OF THEIR ORIGINAL USE AS TROOP TRANSPORTS AND MISSILE PLATFORMS.

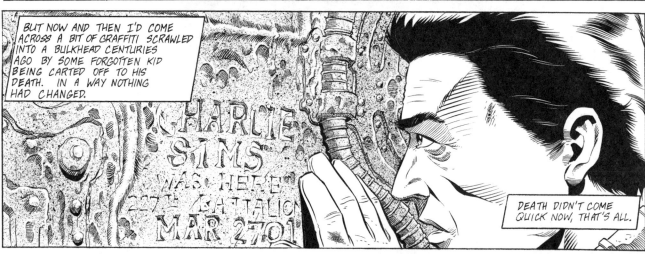

BUT NOW AND THEN I'D COME ACROSS A BIT OF GRAFFITI SCRAWLED INTO A BULKHEAD CENTURIES AGO BY SOME FORGOTTEN KID BEING CARTED OFF TO HIS DEATH. IN A WAY NOTHING HAD CHANGED.

CHARLIE SIMS WAS HERE 227th BATTALION MAR 2701

DEATH DIDN'T COME QUICK NOW, THAT'S ALL.

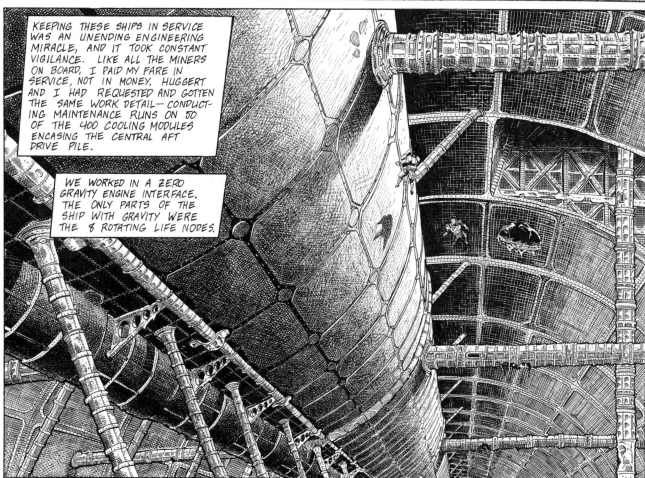

KEEPING THESE SHIPS IN SERVICE WAS AN UNENDING ENGINEERING MIRACLE, AND IT TOOK CONSTANT VIGILANCE. LIKE ALL THE MINERS ON BOARD, I PAID MY FARE IN SERVICE, NOT IN MONEY. HUGGERT AND I HAD REQUESTED AND GOTTEN THE SAME WORK DETAIL—CONDUCTING MAINTENANCE RUNS ON 50 OF THE 400 COOLING MODULES ENCASING THE CENTRAL AFT DRIVE PILE.

WE WORKED IN A ZERO GRAVITY ENGINE INTERFACE. THE ONLY PARTS OF THE SHIP WITH GRAVITY WERE THE 8 ROTATING LIFE NODES.

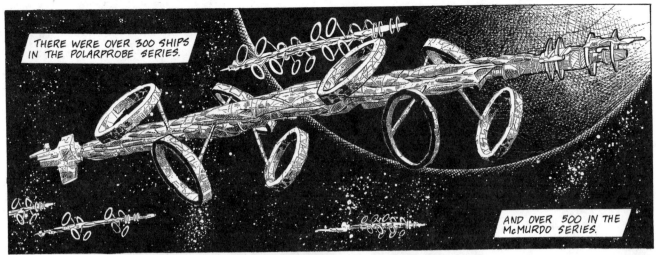

THERE WERE OVER 300 SHIPS IN THE POLARPROBE SERIES.

AND OVER 500 IN THE McMURDO SERIES.

AND OVER 700 IN THE HYPERBOREAN SERIES.

AND OVER 30 OTHER SERIES, EACH BOASTING COMPARABLE NUMBERS.

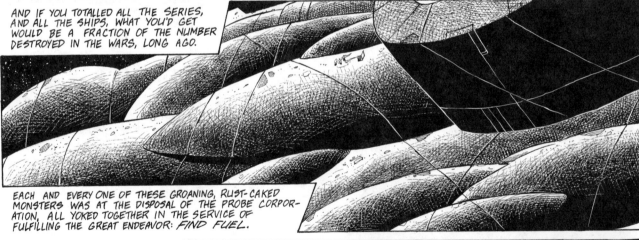

AND IF YOU TOTALLED ALL THE SERIES, AND ALL THE SHIPS, WHAT YOU'D GET WOULD BE A FRACTION OF THE NUMBER DESTROYED IN THE WARS, LONG AGO.

EACH AND EVERY ONE OF THESE GROANING, RUST-CAKED MONSTERS WAS AT THE DISPOSAL OF THE PROBE CORPORATION, ALL YOKED TOGETHER IN THE SERVICE OF FULFILLING THE GREAT ENDEAVOR: *FIND FUEL*.

AND WHY WAS FUEL NEEDED?

TO KEEP THE SHIPS FLYING, OF COURSE.

THAT WAS THE PROBE CORPORATION'S FIRST DIRECTIVE, AND ITS LAST, TO WHICH ALL OTHER CONCERNS WERE UTTERLY AND FOREVER SUB-SERVIENT: *KEEP THEM FLYING*. IN THE FACE OF THIS DISPENSATION, NO QUESTIONS OR OPPOSITION COULD BE BROOKED.

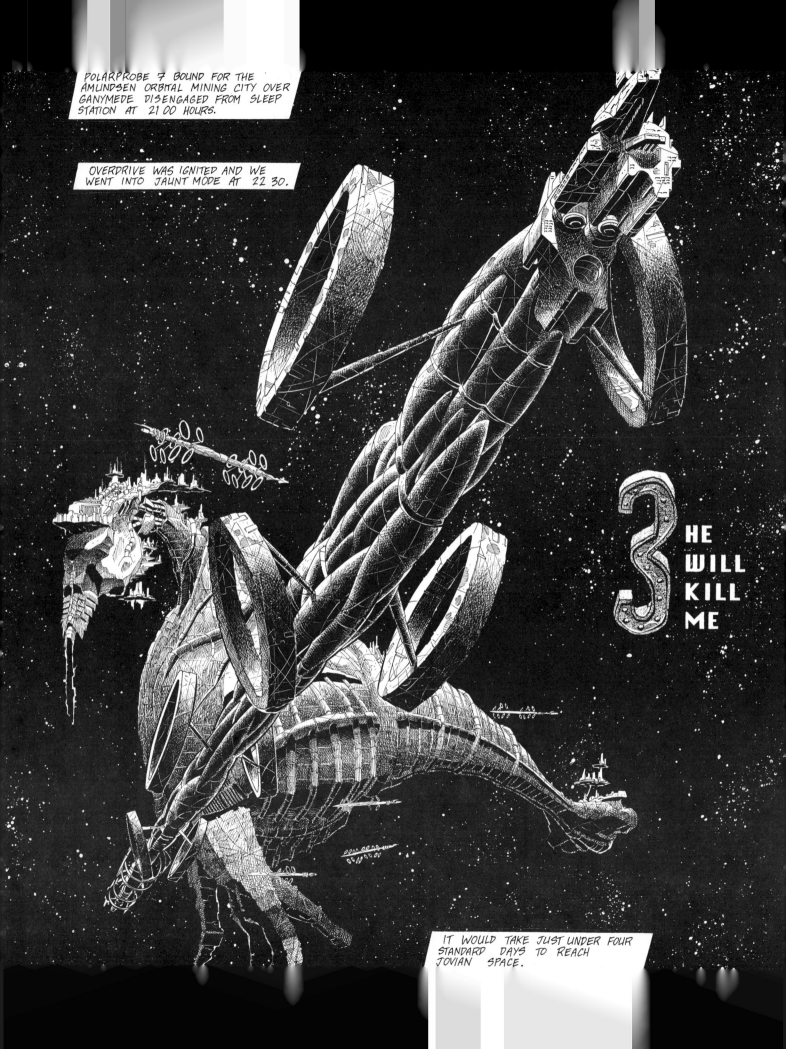

POLARPROBE 7 BOUND FOR THE
AMUNDSEN ORBITAL MINING CITY OVER
GANYMEDE DISENGAGED FROM SLEEP
STATION AT 21 00 HOURS.

OVERDRIVE WAS IGNITED AND WE
WENT INTO JAUNT MODE AT 22 30.

3

HE
WILL
KILL
ME

IT WOULD TAKE JUST UNDER FOUR
STANDARD DAYS TO REACH
JOVIAN SPACE.

WELL... NEXT TIME I'M HERE I'M GONNA TRY THAT RESONATOR AGAIN.

GOOD LUCK. THAT WON'T BE FOR OVER A YEAR, AND I DOUBT THAT RESONATOR'S GOT SIX MONTHS LEFT IN IT.

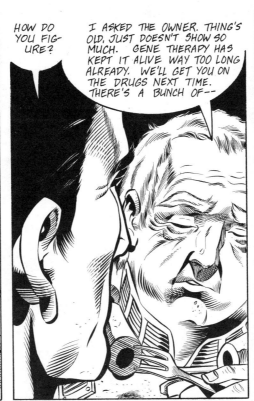

HOW DO YOU FIGURE?

I ASKED THE OWNER. THING'S OLD, JUST DOESN'T SHOW SO MUCH. GENE THERAPY HAS KEPT IT ALIVE WAY TOO LONG ALREADY. WE'LL GET YOU ON THE DRUGS NEXT TIME. THERE'S A BUNCH OF--

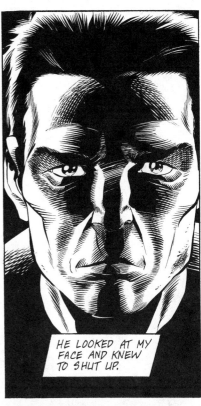

HE LOOKED AT MY FACE AND KNEW TO SHUT UP.

TEN LONG MINUTES LATER THE BOARDING CALL CAME.

34

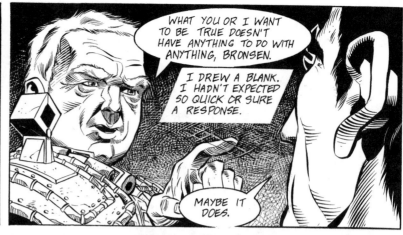

HUGGERT... WOULDN'T YOU... *LIKE* IT TO BE TRUE THAT PEOPLE AND RESONATORS CAN INTERMINGLE MENTALLY IN THE DREAM STATE?

WHAT YOU OR I WANT TO BE TRUE DOESN'T HAVE ANYTHING TO DO WITH ANYTHING, BRONSEN.

I DREW A BLANK. I HADN'T EXPECTED SO QUICK OR SURE A RESPONSE.

MAYBE IT DOES.

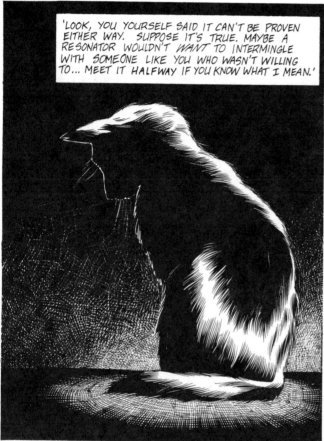

'LOOK, YOU YOURSELF SAID IT CAN'T BE PROVEN EITHER WAY. SUPPOSE IT'S TRUE. MAYBE A RESONATOR WOULDN'T *WANT* TO INTERMINGLE WITH SOMEONE LIKE YOU WHO WASN'T WILLING TO... MEET IT *HALFWAY* IF YOU KNOW WHAT I MEAN.'

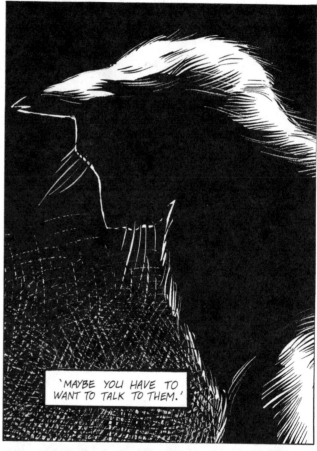

'MAYBE YOU HAVE TO WANT TO TALK TO THEM.'

I DON'T KNOW WHAT YOU'RE GETTING AT. I TOLD YOU PEOPLE *USED* TO GET PAID TO THINK ABOUT THIS STUFF.

THEY DON'T ANYMORE, AND EVEN IF THEY DID, YOU'RE NOT ONE OF THEM. WE'RE MINERS, AND THAT'S ALL YOU NEED TO KNOW.

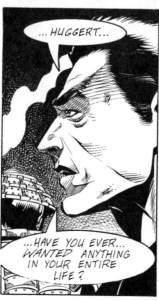

...HUGGERT...

...HAVE YOU EVER... *WANTED* ANYTHING IN YOUR ENTIRE LIFE?

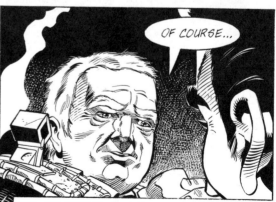

OF COURSE...

THE AIR AROUND US SEEMED TO BREATHE THE WORDS 'TO BE RICH.' BUT HUGGERT KNEW I MEANT SOMETHING BESIDES THE DESIRES EVERY MINER HAS STUCK IN HIM LIKE A PACIFIER AT BIRTH. THERE FOLLOWED AN UNCOMFORTABLE PAUSE. I'D BROACHED SOMETHING FORBIDDEN. I REGRETTED IT. THIS CONVERSATION COULDN'T BE AMICABLE AGAIN.

33

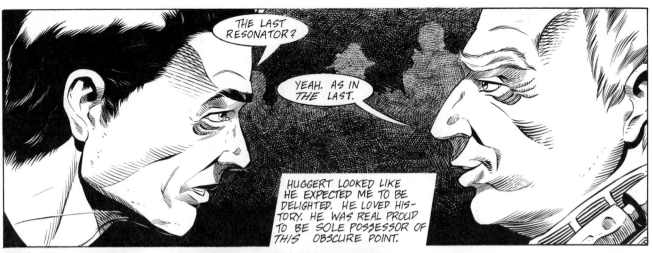

THE LAST RESONATOR?

YEAH. AS IN *THE LAST.*

HUGGERT LOOKED LIKE HE EXPECTED ME TO BE DELIGHTED. HE LOVED HISTORY. HE WAS REAL PROUD TO BE SOLE POSSESSOR OF *THIS* OBSCURE POINT.

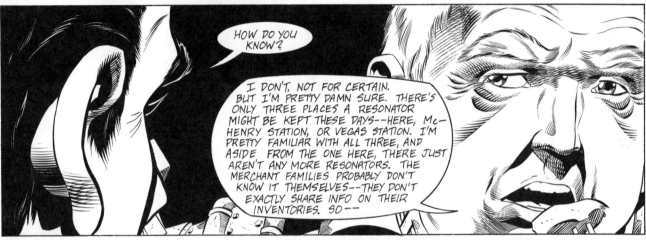

HOW DO YOU KNOW?

I DON'T, NOT FOR CERTAIN. BUT I'M PRETTY DAMN SURE. THERE'S ONLY THREE PLACES A RESONATOR MIGHT BE KEPT THESE DAYS--HERE, McHENRY STATION, OR VEGAS STATION. I'M PRETTY FAMILIAR WITH ALL THREE, AND ASIDE FROM THE ONE HERE, THERE JUST AREN'T ANY MORE RESONATORS. THE MERCHANT FAMILIES PROBABLY DON'T KNOW IT THEMSELVES--THEY DON'T EXACTLY SHARE INFO ON THEIR INVENTORIES. SO--

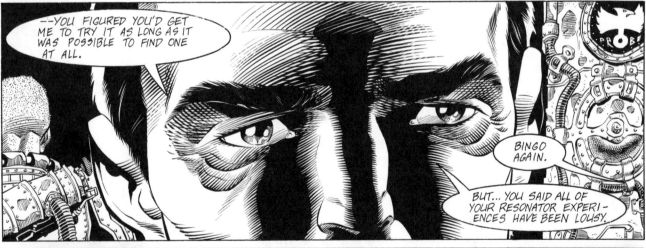

--YOU FIGURED YOU'D GET ME TO TRY IT AS LONG AS IT WAS POSSIBLE TO FIND ONE AT ALL.

BINGO AGAIN.

BUT... YOU SAID ALL OF YOUR RESONATOR EXPERIENCES HAVE BEEN LOUSY.

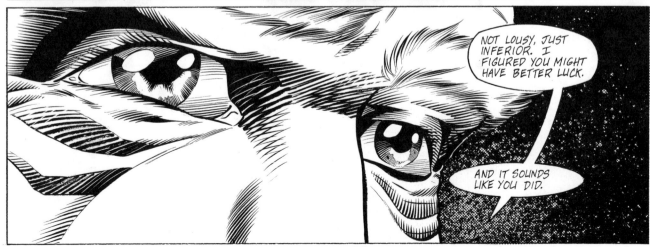

NOT LOUSY, JUST INFERIOR. I FIGURED YOU MIGHT HAVE BETTER LUCK.

AND IT SOUNDS LIKE YOU DID.

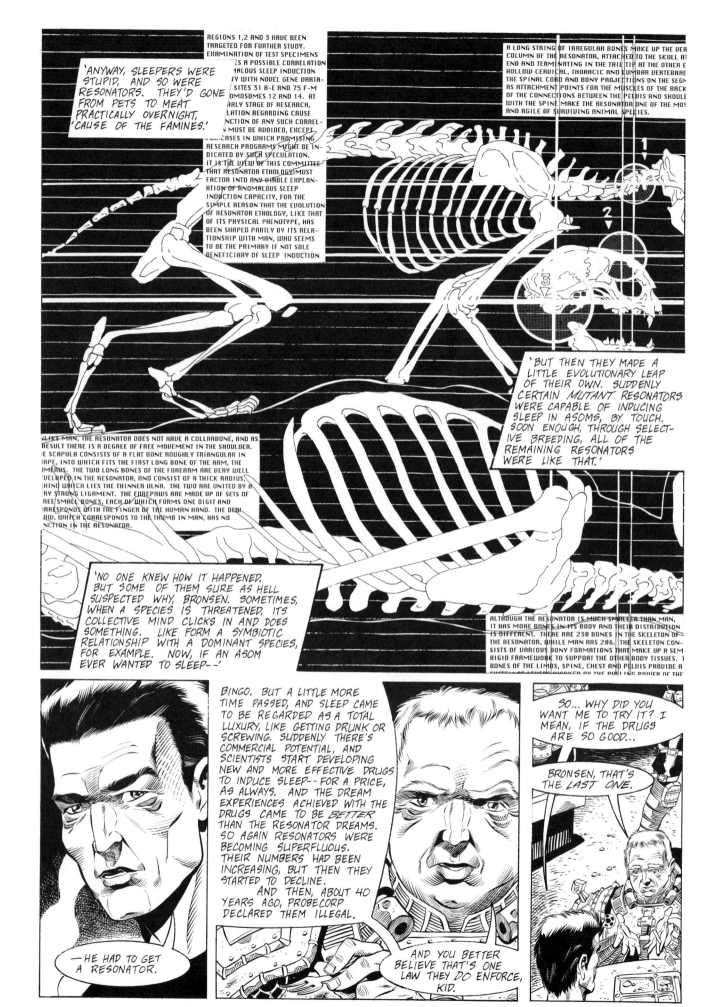

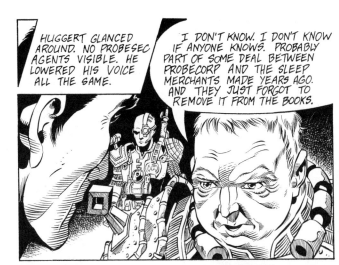

HUGGERT GLANCED AROUND. NO PROBESEC AGENTS VISIBLE. HE LOWERED HIS VOICE ALL THE SAME.

I DON'T KNOW. I DON'T KNOW IF ANYONE KNOWS. PROBABLY PART OF SOME DEAL BETWEEN PROBECORP AND THE SLEEP MERCHANTS MADE YEARS AGO. AND THEY JUST FORGOT TO REMOVE IT FROM THE BOOKS.

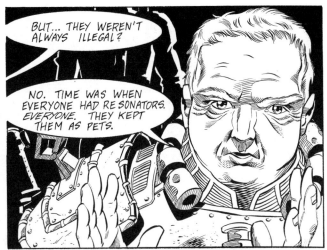

BUT... THEY WEREN'T ALWAYS ILLEGAL?

NO. TIME WAS WHEN EVERYONE HAD RESONATORS. EVERYONE. THEY KEPT THEM AS PETS.

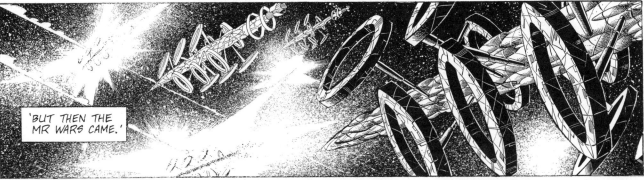

'BUT THEN THE MR WARS CAME.'

'AND THEN THE FAMINES. PEOPLE STARTED EATING EVERY-THING THAT MOVED, INCLUD-ING THEIR RESONATORS. THEY WERE IN DANGER OF TOTAL EXTINCTION. AND THEN PEOPLE STOPPED SLEEPING.'

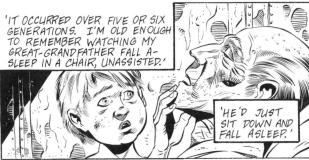

'IT OCCURRED OVER FIVE OR SIX GENERATIONS. I'M OLD ENOUGH TO REMEMBER WATCHING MY GREAT-GRANDFATHER FALL A-SLEEP IN A CHAIR, UNASSISTED.'

'HE'D JUST SIT DOWN AND FALL ASLEEP.'

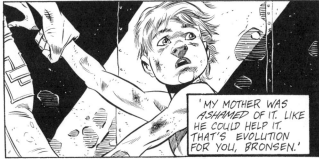

'MY MOTHER WAS ASHAMED OF IT. LIKE HE COULD HELP IT. THAT'S EVOLUTION FOR YOU, BRONSEN.'

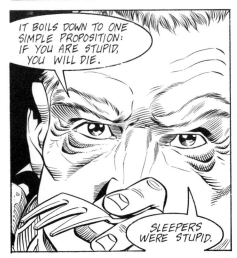

IT BOILS DOWN TO ONE SIMPLE PROPOSITION: IF YOU ARE STUPID, YOU WILL DIE.

SLEEPERS WERE STUPID.

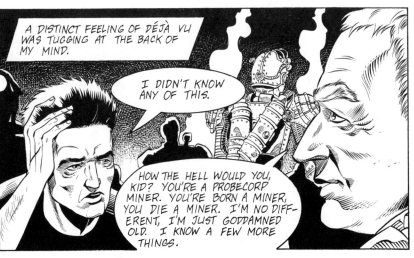

A DISTINCT FEELING OF DÉJÀ VU WAS TUGGING AT THE BACK OF MY MIND.

I DIDN'T KNOW ANY OF THIS.

HOW THE HELL WOULD YOU, KID? YOU'RE A PROBECORP MINER. YOU'RE BORN A MINER, YOU DIE A MINER. I'M NO DIFF-ERENT, I'M JUST GODDAMNED OLD. I KNOW A FEW MORE THINGS.

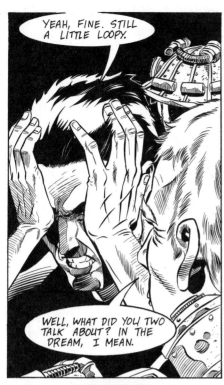

YEAH, FINE. STILL A LITTLE LOOPY.

WELL, WHAT DID YOU TWO TALK ABOUT? IN THE DREAM, I MEAN.

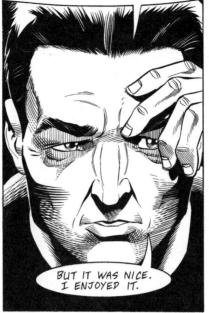

I SAID I DON'T REMEMBER. IT SEEMS LIKE IT WAS A LOT OF NONSENSE... ABOUT SINGING AND... EATING? IT'S EMBARRASSING.

BUT IT WAS NICE. I ENJOYED IT.

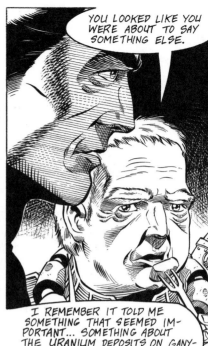

YOU LOOKED LIKE YOU WERE ABOUT TO SAY SOMETHING ELSE.

I REMEMBER IT TOLD ME SOMETHING THAT SEEMED IMPORTANT... SOMETHING ABOUT THE URANIUM DEPOSITS ON GANYMEDE... AND I FELT LIKE I HAD EVERYTHING FIGURED OUT.

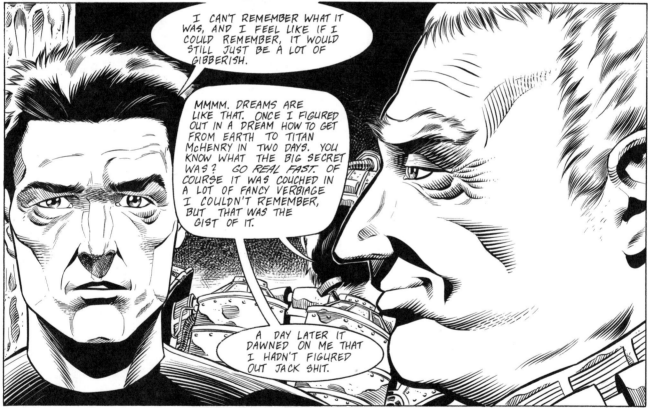

I CAN'T REMEMBER WHAT IT WAS, AND I FEEL LIKE IF I COULD REMEMBER, IT WOULD STILL JUST BE A LOT OF GIBBERISH.

MMMM. DREAMS ARE LIKE THAT. ONCE I FIGURED OUT IN A DREAM HOW TO GET FROM EARTH TO TITAN McHENRY IN TWO DAYS. YOU KNOW WHAT THE BIG SECRET WAS? *GO REAL FAST.* OF COURSE IT WAS COUCHED IN A LOT OF FANCY VERBIAGE I COULDN'T REMEMBER, BUT THAT WAS THE GIST OF IT.

A DAY LATER IT DAWNED ON ME THAT I HADN'T FIGURED OUT JACK SHIT.

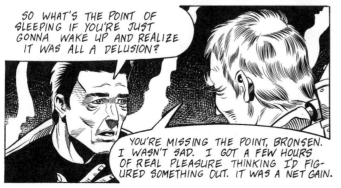

SO WHAT'S THE POINT OF SLEEPING IF YOU'RE JUST GONNA WAKE UP AND REALIZE IT WAS ALL A DELUSION?

YOU'RE MISSING THE POINT, BRONSEN. I WASN'T SAD. I GOT A FEW HOURS OF REAL PLEASURE THINKING I'D FIGURED SOMETHING OUT. IT WAS A NET GAIN.

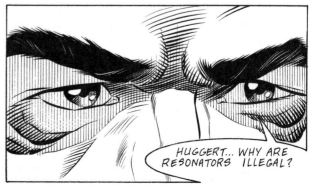

HUGGERT... WHY ARE RESONATORS ILLEGAL?

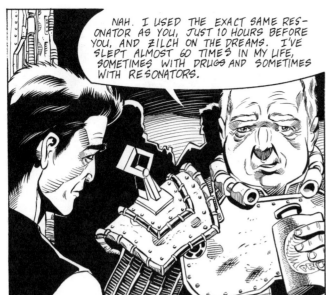

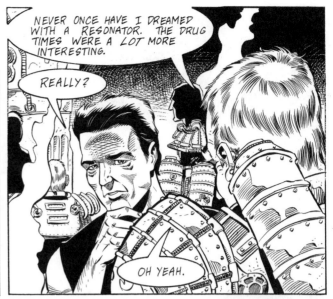

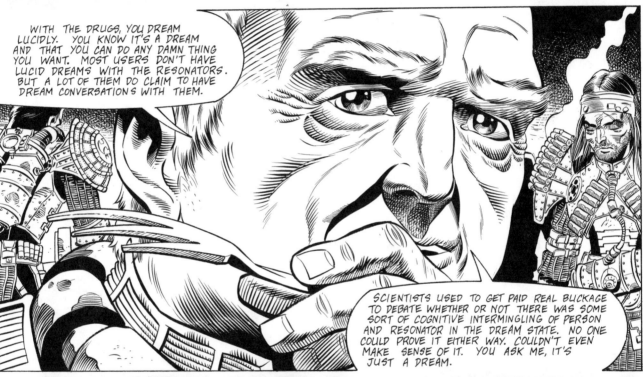

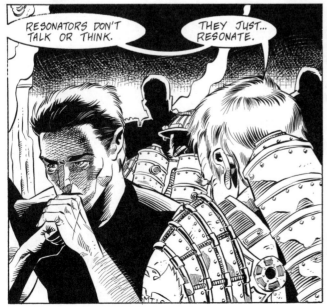

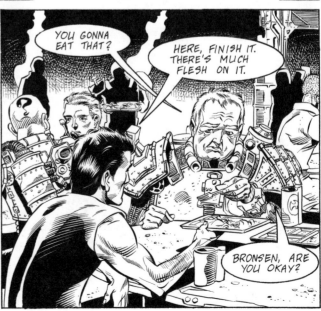

28

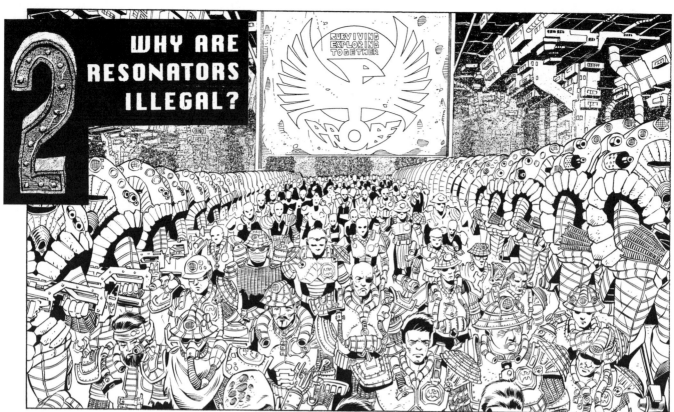

SURVIVING
EXPLORING
TOGETHER

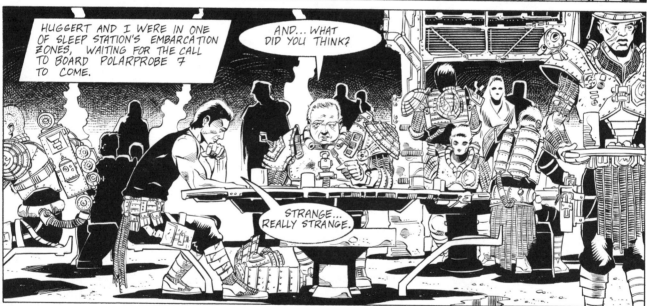

HUGGERT AND I WERE IN ONE OF SLEEP STATION'S EMBARCATION ZONES, WAITING FOR THE CALL TO BOARD POLARPROBE 7 TO COME.

AND... WHAT DID YOU THINK?

STRANGE... REALLY STRANGE.

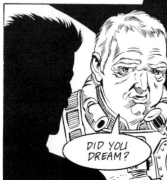

HUGGERT WAS A SENIOR MINING TECHNICIAN, FIRST CLASS. TOO OLD AND WAY TOO FAT FOR THE DANGEROUS WORK HE DID.

DID YOU DREAM?

I DON'T KNOW WHAT THE HELL ELSE IT COULD HAVE BEEN.

I'D MET HIM TWO MONTHS EARLIER, ON MARS. HE'S THE ONE WHO HAD URGED ME TO TRY THE RESONATOR.

YOU'RE PROBABLY THINKING: FATHER FIGURE. SAME THING OCCURRED TO ME. YOU MAY BE RIGHT.

SO... HOW WAS IT?

I DON'T KNOW... IT'S HARD TO REMEMBER. THE RESONATOR WAS THERE WITH ME... I THINK WE WERE TALKING.

WHY ARE YOU SMILING? DID YOU DREAM?

...HUH...D...DEBIT... DEBIT?

DEBIT CHIP, MR. BRONSEN, SETTLE BILL.

I SEEMED TO REMEMBER THAT I HAD BOUGHT SOMETHING FROM THIS MAN.

I PASSED HIM MY CHIP.

THIS WAY, MR. BRONSEN. CLOTHES IN LOCKER, THIS WAY.

OTHERS WAITING, MR. BRONSEN, THIS WAY, NOW PLEASE.

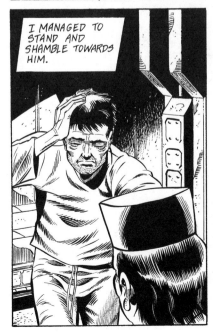

I MANAGED TO STAND AND SHAMBLE TOWARDS HIM.

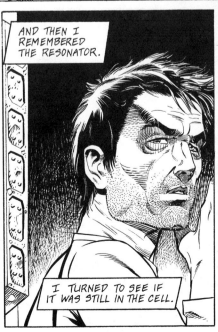

AND THEN I REMEMBERED THE RESONATOR.

I TURNED TO SEE IF IT WAS STILL IN THE CELL?

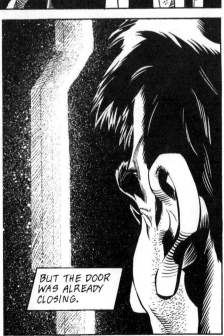

BUT THE DOOR WAS ALREADY CLOSING.

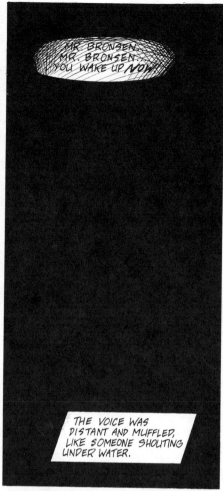

MR. BRONSEN... MR. BRONSEN... YOU WAKE UP *NOW!!*

THE VOICE WAS DISTANT AND MUFFLED, LIKE SOMEONE SHOUTING UNDER WATER.

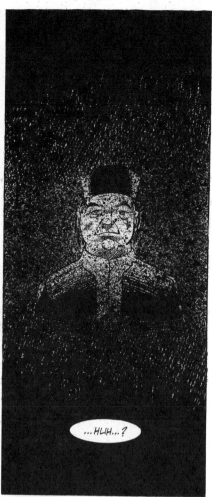

...HUH...?

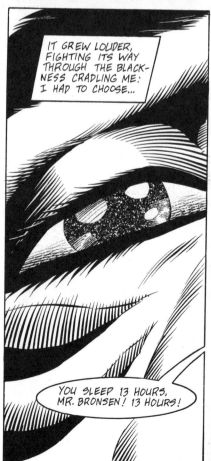

IT GREW LOUDER, FIGHTING ITS WAY THROUGH THE BLACKNESS CRADLING ME. I HAD TO CHOOSE...

YOU SLEEP 13 HOURS, MR. BRONSEN! 13 HOURS!

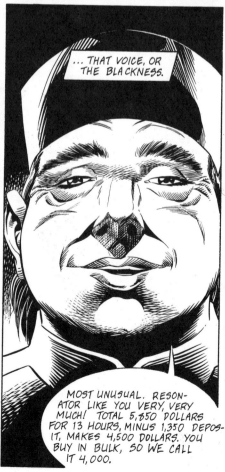

...THAT VOICE, OR THE BLACKNESS.

MOST UNUSUAL. RESONATOR LIKE YOU VERY, VERY MUCH! TOTAL 5,850 DOLLARS FOR 13 HOURS, MINUS 1,350 DEPOSIT, MAKES 4,500 DOLLARS. YOU BUY IN BULK, SO WE CALL IT 4,000.

DEBIT CHIP, PLEASE?

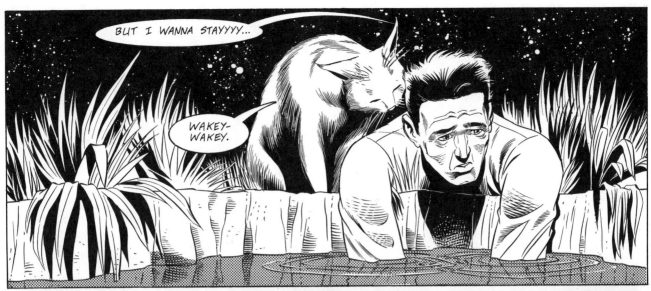

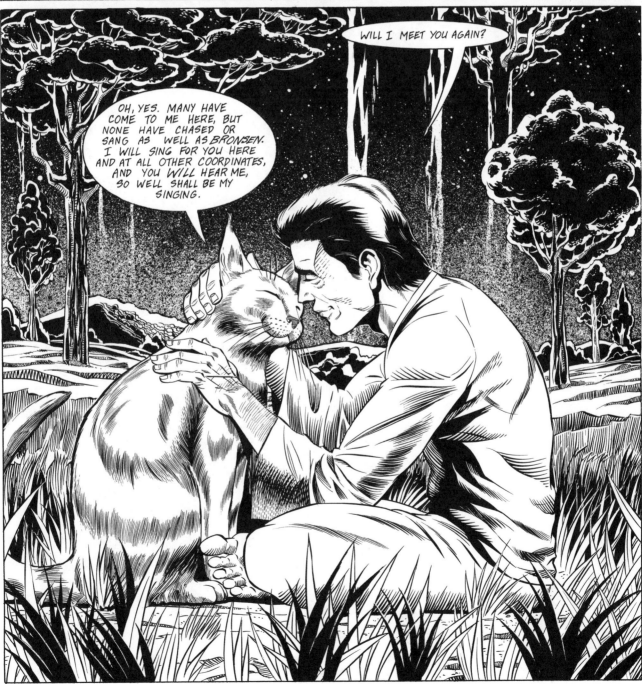

THE RESONATOR WHISPERED THE SECRET IN MY EAR.

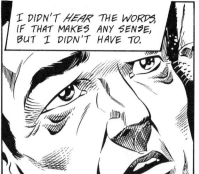

I DIDN'T *HEAR* THE WORDS, IF THAT MAKES ANY SENSE, BUT I DIDN'T HAVE TO.

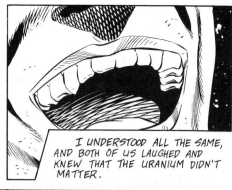

I UNDERSTOOD ALL THE SAME, AND BOTH OF US LAUGHED AND KNEW THAT THE URANIUM DIDN'T MATTER.

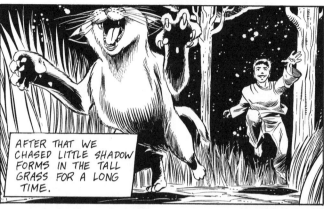

AFTER THAT WE CHASED LITTLE SHADOW FORMS IN THE TALL GRASS FOR A LONG TIME.

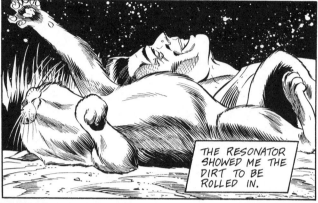

THE RESONATOR SHOWED ME THE DIRT TO BE ROLLED IN.

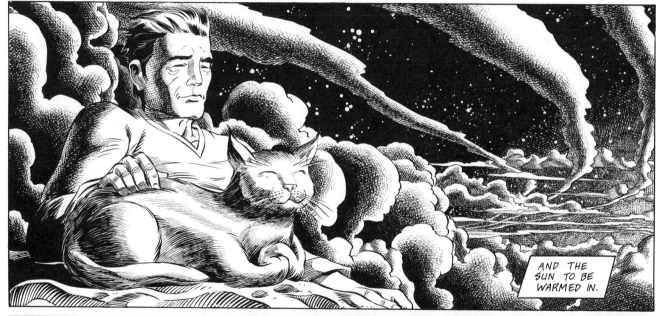

AND THE SUN TO BE WARMED IN.

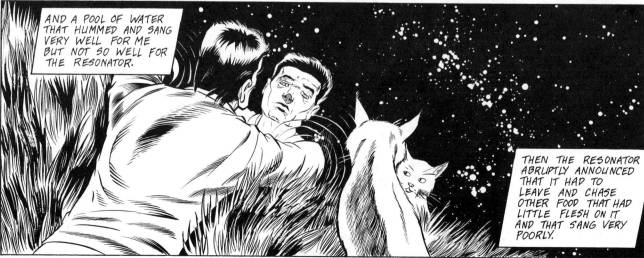

AND A POOL OF WATER THAT HUMMED AND SANG VERY WELL FOR ME BUT NOT SO WELL FOR THE RESONATOR.

THEN THE RESONATOR ABRUPTLY ANNOUNCED THAT IT HAD TO LEAVE AND CHASE OTHER FOOD THAT HAD LITTLE FLESH ON IT AND THAT SANG VERY POORLY.

23

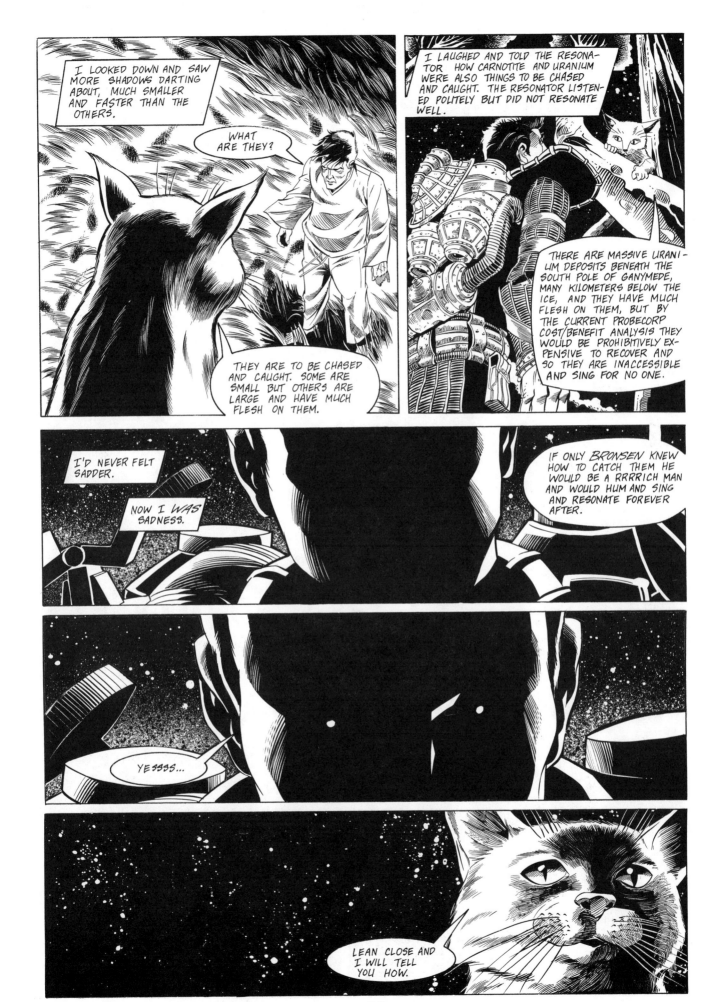

DO YOU SLEEP A LOT?

RRRITT-OWRRN-- MMMM-HMMMM.

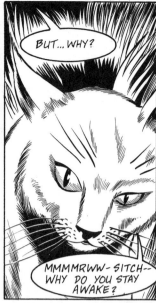

BUT... WHY?

MMMMRWW-SITCH-- WHY DO YOU STAY AWAKE?

HA HA HA HA HA HA

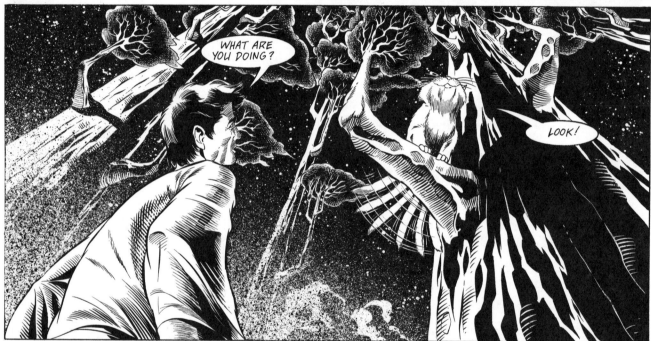

WHAT ARE YOU DOING?

LOOK!

I SEEMED TO SEE SEVERAL LARGE SHADOWS RUSTLING ABOUT IN THE TREES SEVERAL METERS AWAY.

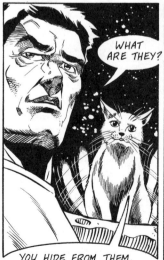

WHAT ARE THEY?

YOU HIDE FROM THEM. THEY SING BADLY MUCH AND NEVER FOR ME. REMEMBER: IF YOU'RE STUPID, YOU DIE.

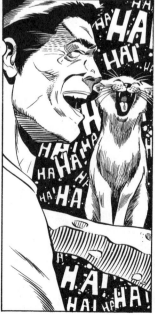

HA HA HA! HA HA HA HA HA

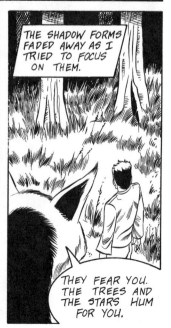

THE SHADOW FORMS FADED AWAY AS I TRIED TO FOCUS ON THEM.

THEY FEAR YOU. THE TREES AND THE STARS HUM FOR YOU.

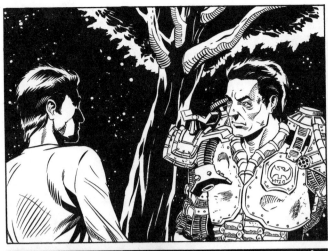

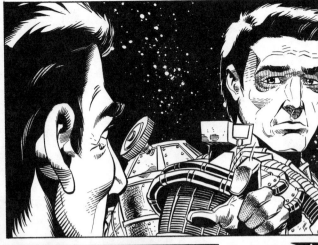

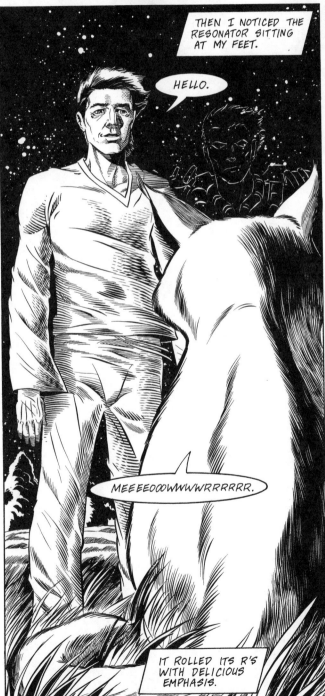

THEN I NOTICED THE RESONATOR SITTING AT MY FEET.

HELLO.

MEEEEEOOOWWWWRRRRRRR.

IT ROLLED ITS R'S WITH DELICIOUS EMPHASIS.

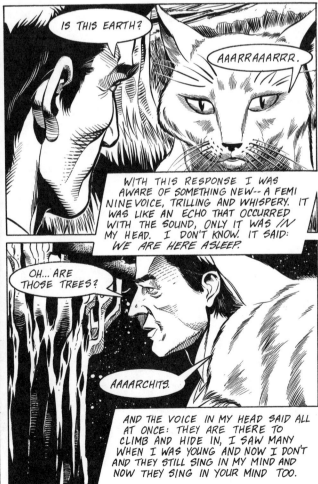

I'M SO HAPPY TO SEE YOU.

RRRROW-CHIT!

THERE WAS TOTAL INTIMACY BETWEEN US, LIKE WE WERE OLD FRIENDS.

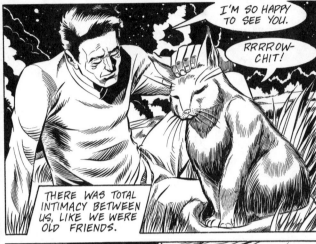

IS THIS EARTH?

AAARRAAARRR.

WITH THIS RESPONSE I WAS AWARE OF SOMETHING NEW-- A FEMININE VOICE, TRILLING AND WHISPERY. IT WAS LIKE AN ECHO THAT OCCURRED WITH THE SOUND, ONLY IT WAS IN MY HEAD. I DON'T KNOW. IT SAID: WE ARE HERE ASLEEP.

OH... ARE THOSE TREES?

AAAARCHITS.

AND THE VOICE IN MY HEAD SAID ALL AT ONCE: THEY ARE THERE TO CLIMB AND HIDE IN, I SAW MANY WHEN I WAS YOUNG AND NOW I DON'T AND THEY STILL SING IN MY MIND AND NOW THEY SING IN YOUR MIND TOO.

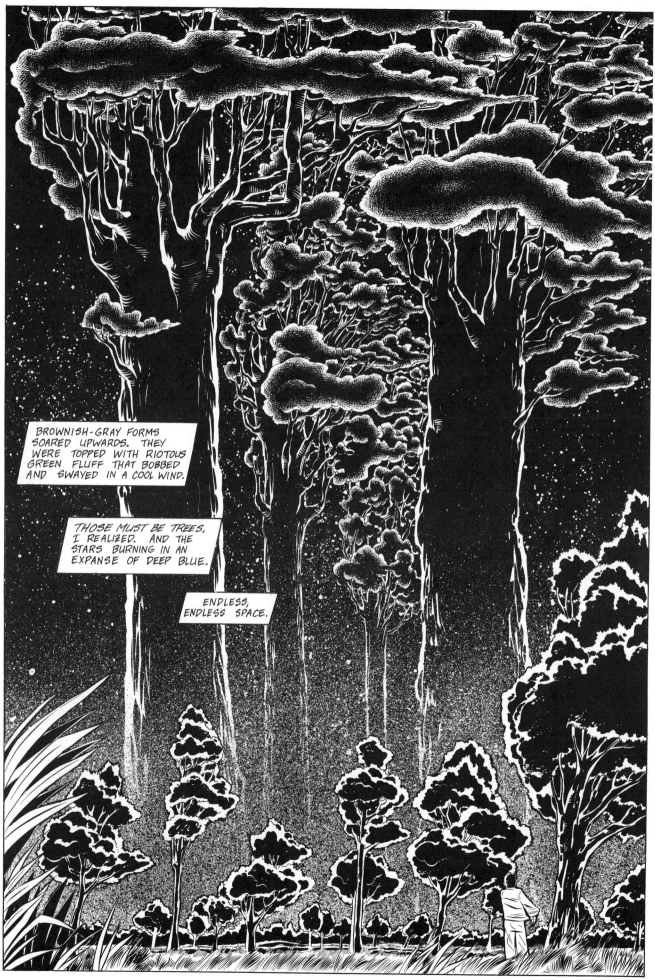

BROWNISH-GRAY FORMS
SOARED UPWARDS. THEY
WERE TOPPED WITH RIOTOUS
GREEN FLUFF THAT BOBBED
AND SWAYED IN A COOL WIND.

THOSE MUST BE TREES,
I REALIZED. AND THE
STARS BURNING IN AN
EXPANSE OF DEEP BLUE.

ENDLESS,
ENDLESS SPACE.

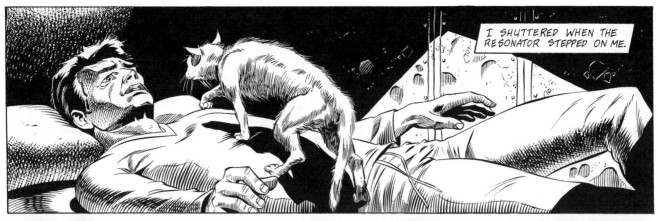

I SHUTTERED WHEN THE RESONATOR STEPPED ON ME.

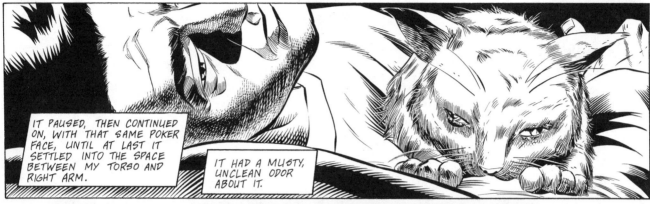

IT PAUSED, THEN CONTINUED ON, WITH THAT SAME POKER FACE, UNTIL AT LAST IT SETTLED INTO THE SPACE BETWEEN MY TORSO AND RIGHT ARM.

IT HAD A MUSTY, UNCLEAN ODOR ABOUT IT.

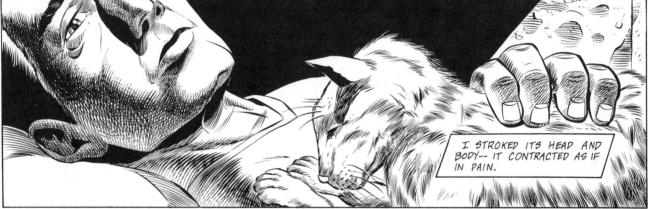

I STROKED ITS HEAD AND BODY-- IT CONTRACTED AS IF IN PAIN.

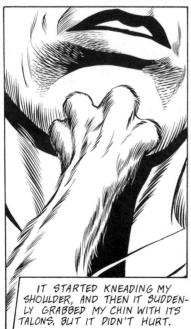

IT STARTED KNEADING MY SHOULDER, AND THEN IT SUDDEN-LY GRABBED MY CHIN WITH ITS TALONS, BUT IT DIDN'T HURT.

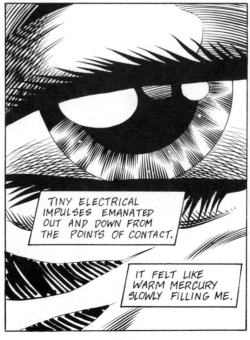

TINY ELECTRICAL IMPULSES EMANATED OUT AND DOWN FROM THE POINTS OF CONTACT.

IT FELT LIKE WARM MERCURY SLOWLY FILLING ME.

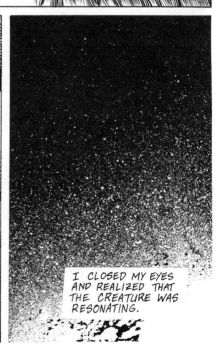

I CLOSED MY EYES AND REALIZED THAT THE CREATURE WAS RESONATING.

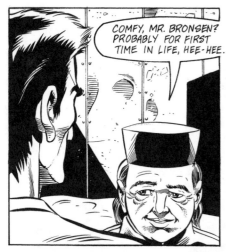

COMFY, MR. BRONSEN? PROBABLY FOR FIRST TIME IN LIFE, HEE-HEE.

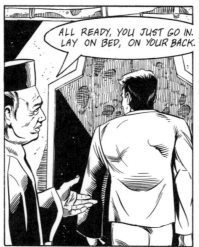

ALL READY, YOU JUST GO IN. LAY ON BED, ON YOUR BACK.

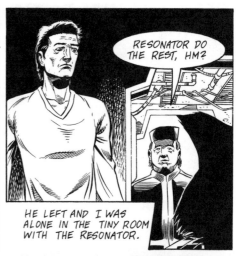

RESONATOR DO THE REST, HM?

HE LEFT AND I WAS ALONE IN THE TINY ROOM WITH THE RESONATOR.

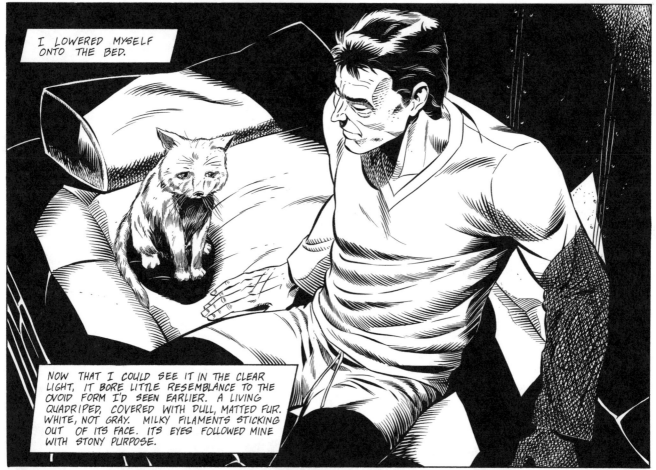

I LOWERED MYSELF ONTO THE BED.

NOW THAT I COULD SEE IT IN THE CLEAR LIGHT, IT BORE LITTLE RESEMBLANCE TO THE OVOID FORM I'D SEEN EARLIER. A LIVING QUADRIPED, COVERED WITH DULL, MATTED FUR. WHITE, NOT GRAY. MILKY FILAMENTS STICKING OUT OF ITS FACE. ITS EYES FOLLOWED MINE WITH STONY PURPOSE.

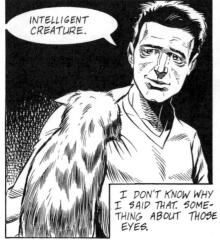

INTELLIGENT CREATURE.

I DON'T KNOW WHY I SAID THAT. SOMETHING ABOUT THOSE EYES.

I BECAME AWARE OF A ROAR IN MY HEAD, A SLOWLY GATHERING, HOLLOW SOUND I'D NEVER HEARD BEFORE.

THE ECHO, I REALIZED, OF 20 YEARS OF CLOSE PROXIMITY TO EXPLOSIVES AND DRILL MACHINERY.

IT HAD NEVER, UNTIL THAT MOMENT, BEEN QUIET ENOUGH FOR ME TO HEAR IT.

I RETURNED 13 HOURS LATER.

GOOD AS YOUR WORD, MR. BRONSEN. THIS WAY, PLEASE.

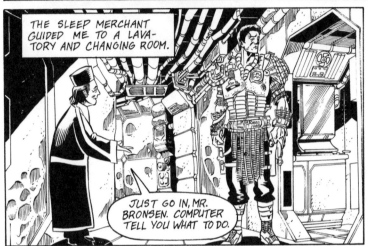

THE SLEEP MERCHANT GUIDED ME TO A LAVATORY AND CHANGING ROOM.

JUST GO IN, MR. BRONSEN. COMPUTER TELL YOU WHAT TO DO.

THERE WAS A LOCKER FOR ME TO PUT MY GEAR IN.

A HOT SHOWER. A BAR OF PERFUMED SOAP. A LIGHT, ODORLESS DECONTAMINANT SPRAY. THE SLEEP MERCHANT HAD MADE NO MENTION OF THESE LUXURIES.

I FELT GUILTY FOR HAVING BUCKLED AT THE PRICE.

NEXT CAME A WHITE TUNIC AND PANTS, OF VERY SOFT MATERIAL.

THERE WERE TINY HOLES IN THE RIGHT SHOULDER.

FINALLY I EMERGED INTO THE HALLWAY. I COULDN'T SEE THE SLEEP MERCHANT, BUT I COULD HEAR HIM IN ONE OF THE SLEEP CHAMBERS. HE WAS SPEAKING CHINESE -- SOFT, COOING SOUNDS, AS IF TO A CHILD, FOLLOWED BY HARSHER BUT STILL LOVING COMMANDS.

THEN HE CAME OUT.

16

SPLENDID!

HIS TRANSFORMATION FROM AVUNCULAR FRIEND TO THREATENING THUG AND BACK AGAIN WAS DIZZYING. I FELT NUMB FROM THE NECK UP. I WANTED TO BACK OUT, TO RUN, BUT SOMETHING IN THE BACK OF MY MIND SAID: *VERY BAD IDEA.*

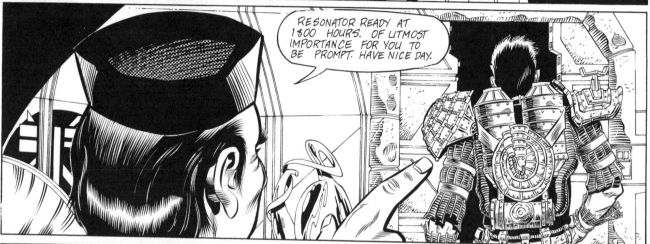

RESONATOR READY AT 1800 HOURS. OF UTMOST IMPORTANCE FOR YOU TO BE PROMPT. HAVE NICE DAY.

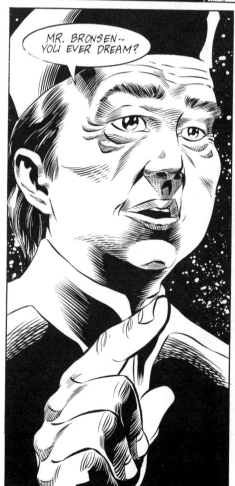

MR. BRONSEN-- YOU EVER DREAM?

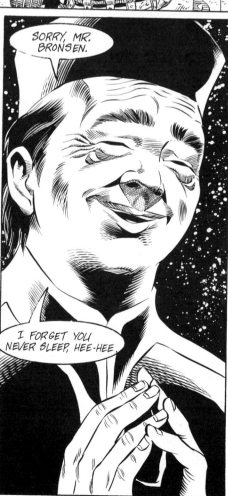

SORRY, MR. BRONSEN.

I FORGET YOU NEVER SLEEP, HEE-HEE.

15

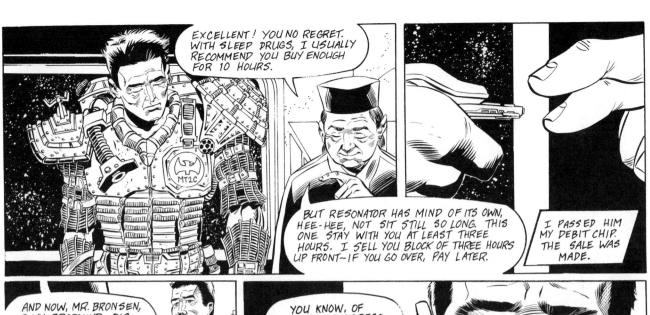

EXCELLENT! YOU NO REGRET. WITH SLEEP DRUGS, I USUALLY RECOMMEND YOU BUY ENOUGH FOR 10 HOURS.

BUT RESONATOR HAS MIND OF ITS OWN, HEE-HEE, NOT SIT STILL SO LONG. THIS ONE STAY WITH YOU AT LEAST THREE HOURS. I SELL YOU BLOCK OF THREE HOURS UP FRONT--IF YOU GO OVER, PAY LATER.

I PASSED HIM MY DEBIT CHIP. THE SALE WAS MADE.

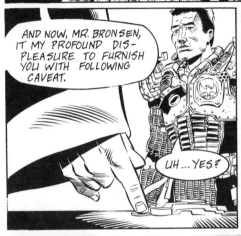

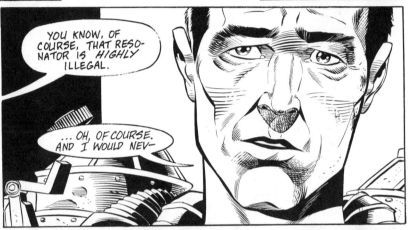

AND NOW, MR. BRONSEN, IT MY PROFOUND DIS-PLEASURE TO FURNISH YOU WITH FOLLOWING CAVEAT.

UH...YES?

YOU KNOW, OF COURSE, THAT RESO-NATOR IS HIGHLY ILLEGAL.

...OH, OF COURSE. AND I WOULD NEV-

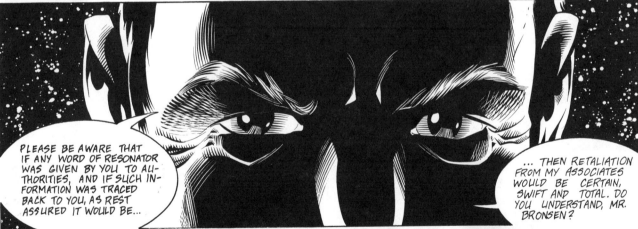

PLEASE BE AWARE THAT IF ANY WORD OF RESONATOR WAS GIVEN BY YOU TO AU-THORITIES, AND IF SUCH IN-FORMATION WAS TRACED BACK TO YOU, AS REST ASSURED IT WOULD BE...

...THEN RETALIATION FROM MY ASSOCIATES WOULD BE CERTAIN, SWIFT AND TOTAL. DO YOU UNDERSTAND, MR. BRONSEN?

...OF COURSE...

14

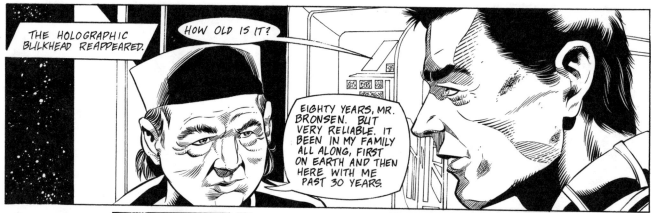

THE HOLOGRAPHIC BULKHEAD REAPPEARED.

HOW OLD IS IT?

EIGHTY YEARS, MR. BRONSEN. BUT VERY RELIABLE. IT BEEN IN MY FAMILY ALL ALONG, FIRST ON EARTH AND THEN HERE WITH ME PAST 30 YEARS.

DO A LOT OF YOUR CUSTOMERS USE IT?

BUT HUGGERT VOUCHED FOR YOU, I LIKE YOU ALREADY.

HOW MUCH TO RENT IT?

VERY FEW, MR. BRONSEN. HARD TO KNOW WHO TO TRUST. MOST PREFER DRUGS ANYWAY. BLUNTED PALATES, HEE-HEE.

450 AN HOUR. MORE THAN DRUGS, BUT RESONATOR EXCEEDINGLY RARE, EXCEEDINGLY DELICATE.

I'D BEEN COUNTING ON 150 AN HOUR, TOPS. I SUDDENLY WONDERED IF THIS WAS SOME SCAM ALL SLEEP STATION VIRGINS WERE SUCKERED INTO.

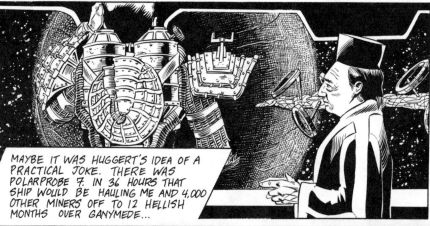

MAYBE IT WAS HUGGERT'S IDEA OF A PRACTICAL JOKE. THERE WAS POLARPROBE 7. IN 36 HOURS THAT SHIP WOULD BE HAULING ME AND 4,000 OTHER MINERS OFF TO 12 HELLISH MONTHS OVER GANYMEDE...

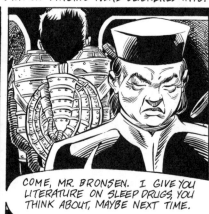

COME, MR. BRONSEN. I GIVE YOU LITERATURE ON SLEEP DRUGS, YOU THINK ABOUT, MAYBE NEXT TIME.

I'LL TRY IT.

THE RESONATOR.

HAIL MARY.

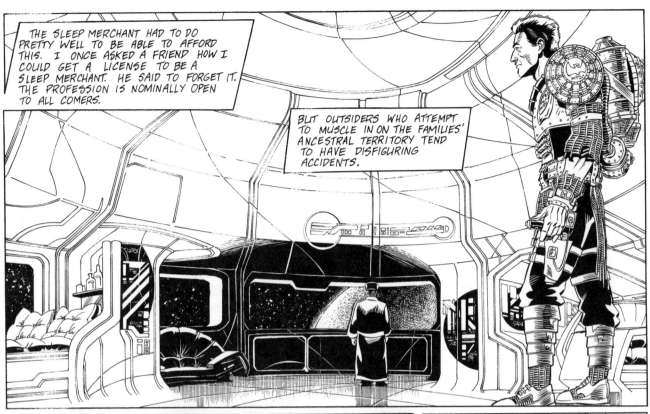

THE SLEEP MERCHANT HAD TO DO PRETTY WELL TO BE ABLE TO AFFORD THIS. I ONCE ASKED A FRIEND HOW I COULD GET A LICENSE TO BE A SLEEP MERCHANT. HE SAID TO FORGET IT. THE PROFESSION IS NOMINALLY OPEN TO ALL COMERS.

BUT OUTSIDERS WHO ATTEMPT TO MUSCLE IN ON THE FAMILIES' ANCESTRAL TERRITORY TEND TO HAVE DISFIGURING ACCIDENTS.

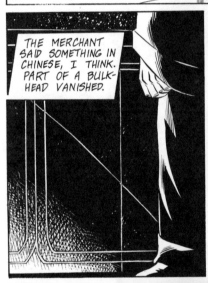

THE MERCHANT SAID SOMETHING IN CHINESE, I THINK. PART OF A BULK-HEAD VANISHED.

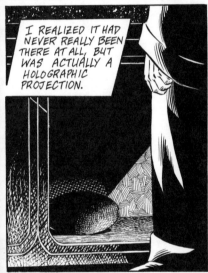

I REALIZED IT HAD NEVER REALLY BEEN THERE AT ALL, BUT WAS ACTUALLY A HOLOGRAPHIC PROJECTION.

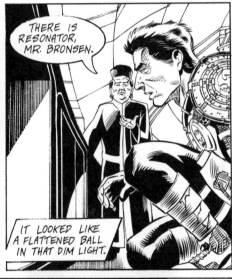

THERE IS RESONATOR, MR. BRONSEN.

IT LOOKED LIKE A FLATTENED BALL IN THAT DIM LIGHT.

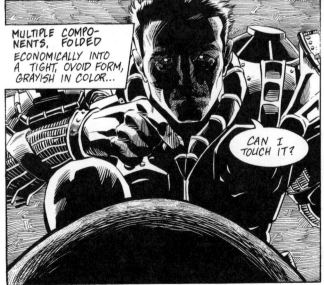

MULTIPLE COMPO-NENTS, FOLDED ECONOMICALLY INTO A TIGHT, OVOID FORM, GRAYISH IN COLOR...

CAN I TOUCH IT?

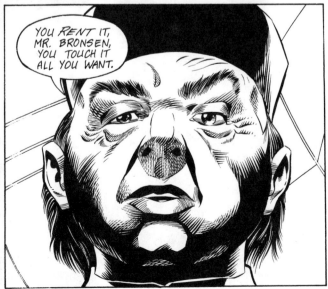

YOU RENT IT, MR. BRONSEN, YOU TOUCH IT ALL YOU WANT.

12

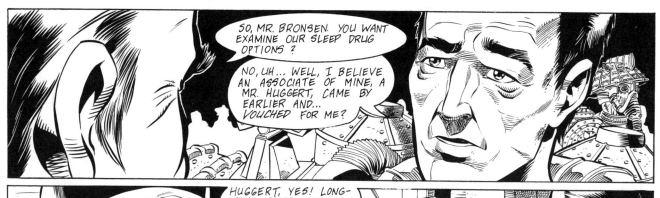

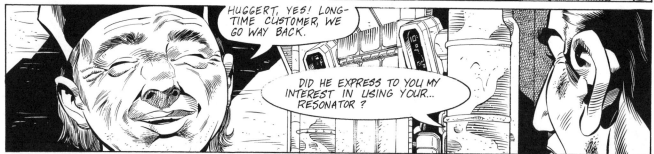

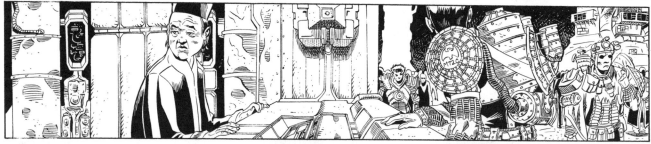

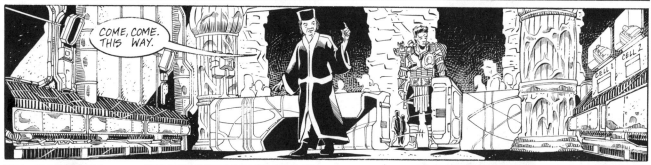

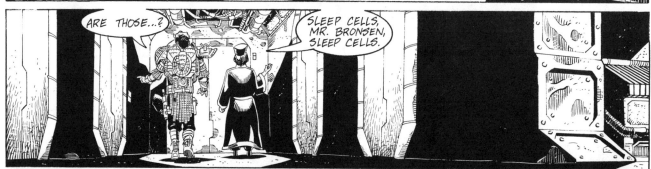

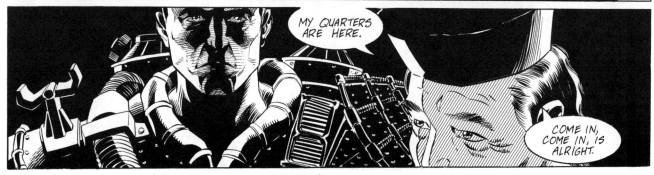

11

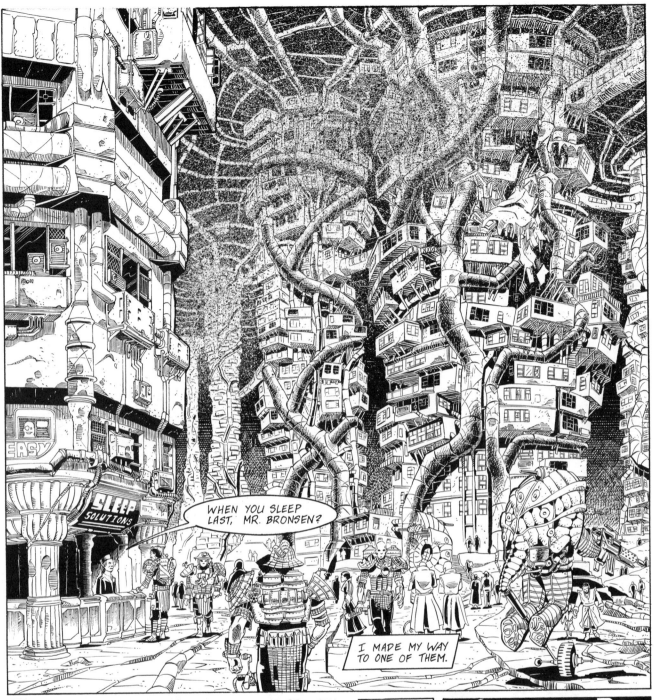

WHEN YOU SLEEP LAST, MR. BRONSEN?

I MADE MY WAY TO ONE OF THEM.

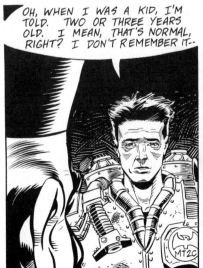

OH, WHEN I WAS A KID, I'M TOLD. TWO OR THREE YEARS OLD. I MEAN, THAT'S NORMAL, RIGHT? I DON'T REMEMBER IT--

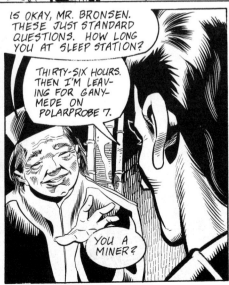

IS OKAY, MR. BRONSEN. THESE JUST STANDARD QUESTIONS. HOW LONG YOU AT SLEEP STATION?

THIRTY-SIX HOURS. THEN I'M LEAVING FOR GANYMEDE ON POLARPROBE 7.

YOU A MINER?

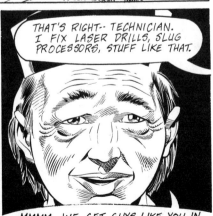

THAT'S RIGHT-- TECHNICIAN. I FIX LASER DRILLS, SLUG PROCESSORS, STUFF LIKE THAT.

MMMM. WE GET GUYS LIKE YOU IN HERE ALL THE TIME, GOING BETWEEN MARS AND GANYMEDE, LOOKING FOR NEW KICKS, HEE-HEE. NO OFFENSE, YOU GUYS MY BREAD AND BUTTER.

10

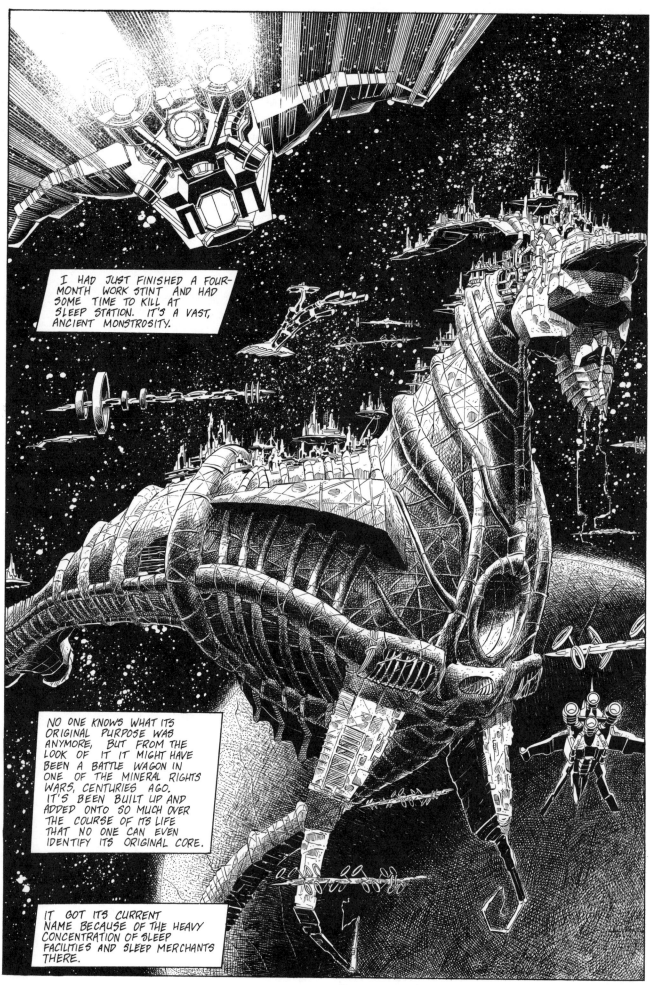

I HAD JUST FINISHED A FOUR-MONTH WORK STINT AND HAD SOME TIME TO KILL AT SLEEP STATION. IT'S A VAST, ANCIENT MONSTROSITY.

NO ONE KNOWS WHAT ITS ORIGINAL PURPOSE WAS ANYMORE, BUT FROM THE LOOK OF IT IT MIGHT HAVE BEEN A BATTLE WAGON IN ONE OF THE MINERAL RIGHTS WARS, CENTURIES AGO. IT'S BEEN BUILT UP AND ADDED ONTO SO MUCH OVER THE COURSE OF ITS LIFE THAT NO ONE CAN EVEN IDENTIFY ITS ORIGINAL CORE.

IT GOT ITS CURRENT NAME BECAUSE OF THE HEAVY CONCENTRATION OF SLEEP FACILITIES AND SLEEP MERCHANTS THERE.

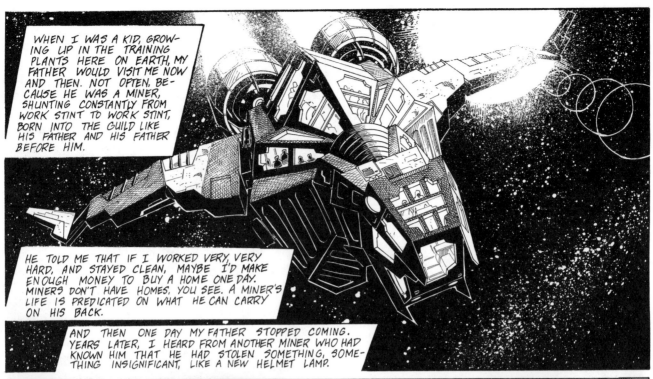

WHEN I WAS A KID, GROW-
ING UP IN THE TRAINING
PLANTS HERE ON EARTH, MY
FATHER WOULD VISIT ME NOW
AND THEN. NOT OFTEN, BE-
CAUSE HE WAS A MINER,
SHUNTING CONSTANTLY FROM
WORK STINT TO WORK STINT,
BORN INTO THE GUILD LIKE
HIS FATHER AND HIS FATHER
BEFORE HIM.

HE TOLD ME THAT IF I WORKED VERY, VERY
HARD, AND STAYED CLEAN, MAYBE I'D MAKE
ENOUGH MONEY TO BUY A HOME ONE DAY.
MINERS DON'T HAVE HOMES, YOU SEE. A MINER'S
LIFE IS PREDICATED ON WHAT HE CAN CARRY
ON HIS BACK.

AND THEN ONE DAY MY FATHER STOPPED COMING.
YEARS LATER, I HEARD FROM ANOTHER MINER WHO HAD
KNOWN HIM THAT HE HAD STOLEN SOMETHING, SOME-
THING INSIGNIFICANT, LIKE A NEW HELMET LAMP.

BUT THEY CAUGHT HIM, AND THEY
SENT HIM TO A LABOR CAMP ON
MARS, OR KILLED HIM.

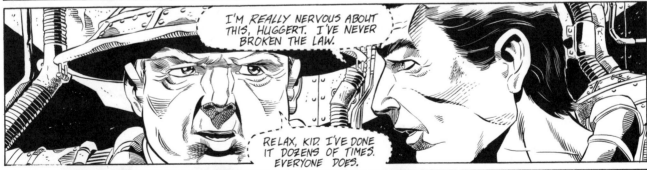

I'M REALLY NERVOUS ABOUT
THIS, HUGGERT. I'VE NEVER
BROKEN THE LAW.

RELAX, KID. I'VE DONE
IT DOZENS OF TIMES.
EVERYONE DOES.

PROBABLY
KILLED HIM.

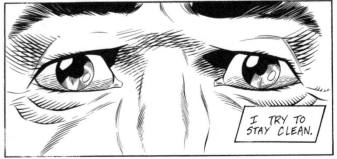

I TRY TO
STAY CLEAN.

DO YOU REALIZE THAT BY QUESTIONING YOU IN MY ABSENCE HE IS IN VIOLATION OF BPD PROTOCOL 5010-721-B?

HE HASN'T ASKED ME ANYTHING. HE JUST WATCHES ME. I DON'T MIND, HE SAVED MY LIFE, AFTER ALL.

YOU HEARD THE MAN, COUNSELOR. I'VE SIMPLY BEEN OBSERVING THE PRISONER.

BUT I DO REALIZE THAT MY CONTINUED PRESENCE HERE COULD HINDER THE EFFECTIVE PERFORMANCE OF YOUR DUTIES, SO I'LL EXCUSE MYSELF.

OPEN.

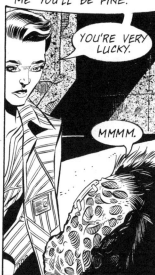

THE INJURIES YOU SUSTAINED IN THE SHUTTLE CRASH WERE EXTENSIVE. BUT THE DOCTORS TELL ME YOU'LL BE FINE.

YOU'RE VERY LUCKY.

MMMM.

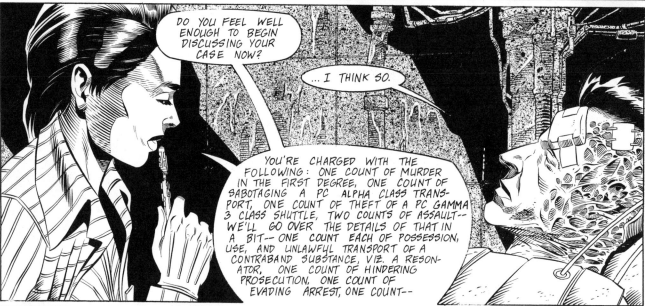

DO YOU FEEL WELL ENOUGH TO BEGIN DISCUSSING YOUR CASE NOW?

... I THINK SO.

YOU'RE CHARGED WITH THE FOLLOWING: ONE COUNT OF MURDER IN THE FIRST DEGREE, ONE COUNT OF SABOTAGING A PC ALPHA CLASS TRANSPORT, ONE COUNT OF THEFT OF A PC GAMMA 3 CLASS SHUTTLE, TWO COUNTS OF ASSAULT-- WE'LL GO OVER THE DETAILS OF THAT IN A BIT-- ONE COUNT EACH OF POSSESSION, USE, AND UNLAWFUL TRANSPORT OF A CONTRABAND SUBSTANCE, VIZ. A RESONATOR, ONE COUNT OF HINDERING PROSECUTION, ONE COUNT OF EVADING ARREST, ONE COUNT--

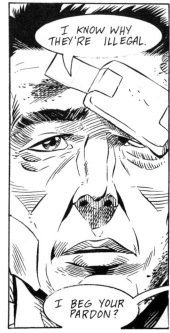

I KNOW WHY THEY'RE ILLEGAL.

I BEG YOUR PARDON?

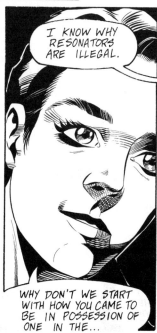

I KNOW WHY RESONATORS ARE ILLEGAL.

WHY DON'T WE START WITH HOW YOU CAME TO BE IN POSSESSION OF ONE IN THE...

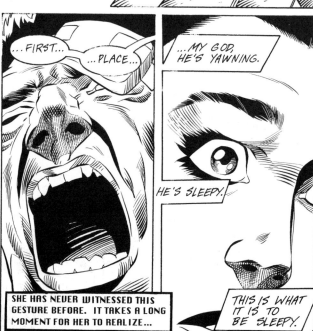

...FIRST... ...PLACE...

SHE HAS NEVER WITNESSED THIS GESTURE BEFORE. IT TAKES A LONG MOMENT FOR HER TO REALIZE...

...MY GOD, HE'S YAWNING.

HE'S SLEEPY.

THIS IS WHAT IT IS TO BE SLEEPY.

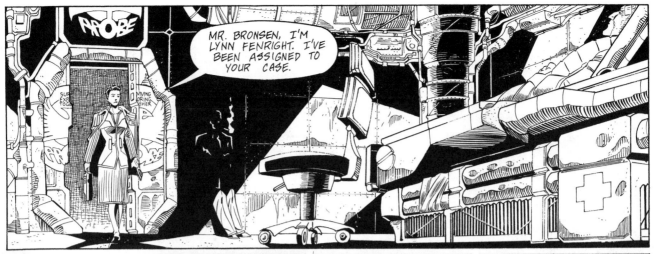

MR. BRONSEN, I'M LYNN FENRIGHT. I'VE BEEN ASSIGNED TO YOUR CASE.

ENDICOTT STANDER, PROBE SECURITY AND PROTOCOL ENFORCEMENT.

SORRY. DIDN'T MEAN TO CATCH YOU OFF GUARD.

SHE HADN'T EXPECTED THIS. SHE HAD BEEN TOLD THAT BRONSEN WOULD BE ALONE. SHE'S BEEN AWARE OF THIS MAN FOR ALL OF FIVE SECONDS--AND ALREADY SHE FEELS VIOLATED BY HIM.

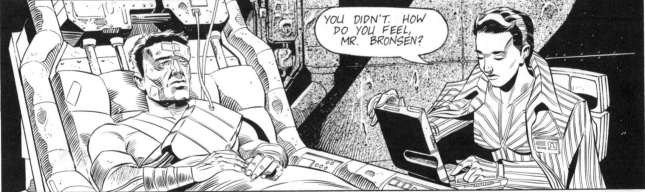

YOU DIDN'T. HOW DO YOU FEEL, MR. BRONSEN?

...TIRED.

HAVE YOU BEEN GIVEN ANY SLEEP DRUGS?

NO. I MEAN, NOT THAT I'M AWARE OF.

HE HASN'T. AND HE'S STILL SLEEPY. NOW WHAT THE HELL DO YOU MAKE OF THAT, COUNSELOR?

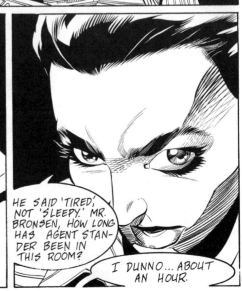

HE SAID 'TIRED,' NOT 'SLEEPY.' MR. BRONSEN, HOW LONG HAS AGENT STANDER BEEN IN THIS ROOM?

I DUNNO... ABOUT AN HOUR.

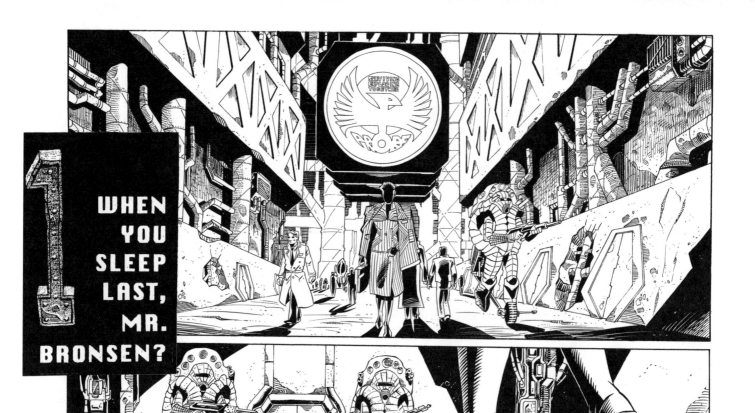

1 WHEN YOU SLEEP LAST, MR. BRONSEN?

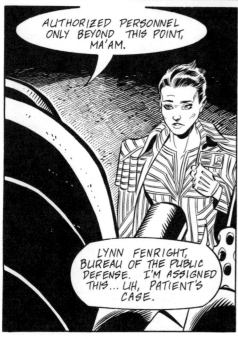

AUTHORIZED PERSONNEL ONLY BEYOND THIS POINT, MA'AM.

LYNN FENRIGHT, BUREAU OF THE PUBLIC DEFENSE. I'M ASSIGNED THIS... UH, PATIENT'S CASE.

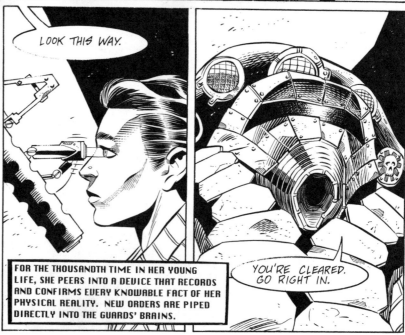

LOOK THIS WAY.

YOU'RE CLEARED. GO RIGHT IN.

FOR THE THOUSANDTH TIME IN HER YOUNG LIFE, SHE PEERS INTO A DEVICE THAT RECORDS AND CONFIRMS EVERY KNOWABLE FACT OF HER PHYSICAL REALITY. NEW ORDERS ARE PIPED DIRECTLY INTO THE GUARDS' BRAINS.

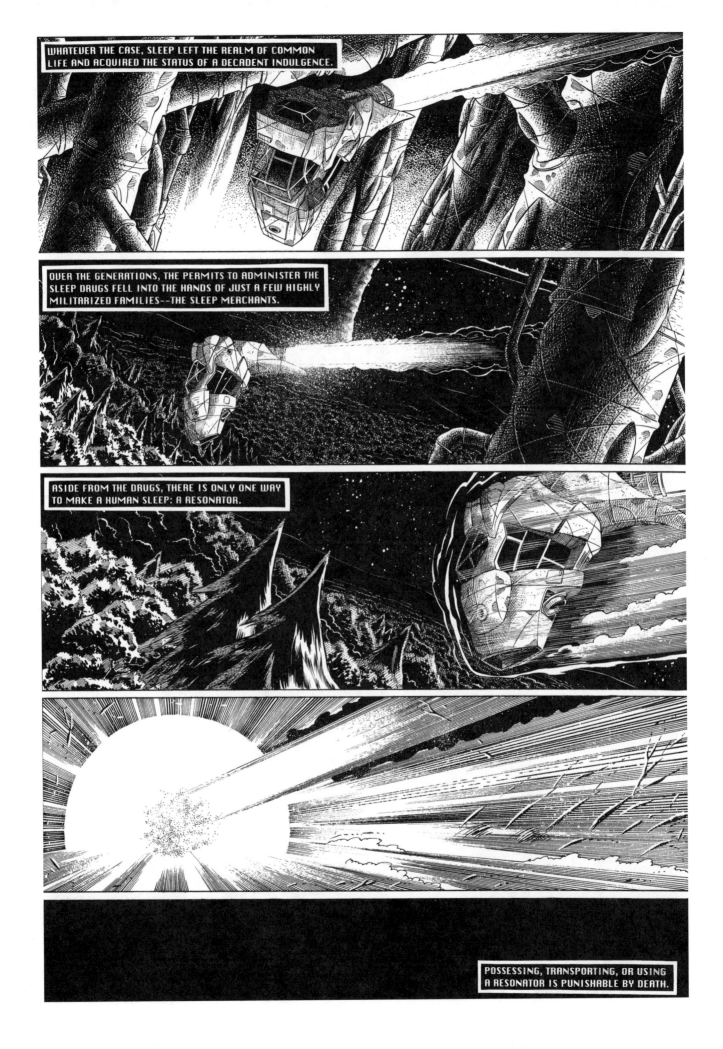

WHATEVER THE CASE, SLEEP LEFT THE REALM OF COMMON LIFE AND ACQUIRED THE STATUS OF A DECADENT INDULGENCE.

OVER THE GENERATIONS, THE PERMITS TO ADMINISTER THE SLEEP DRUGS FELL INTO THE HANDS OF JUST A FEW HIGHLY MILITARIZED FAMILIES--THE SLEEP MERCHANTS.

ASIDE FROM THE DRUGS, THERE IS ONLY ONE WAY TO MAKE A HUMAN SLEEP: A RESONATOR.

POSSESSING, TRANSPORTING, OR USING A RESONATOR IS PUNISHABLE BY DEATH.

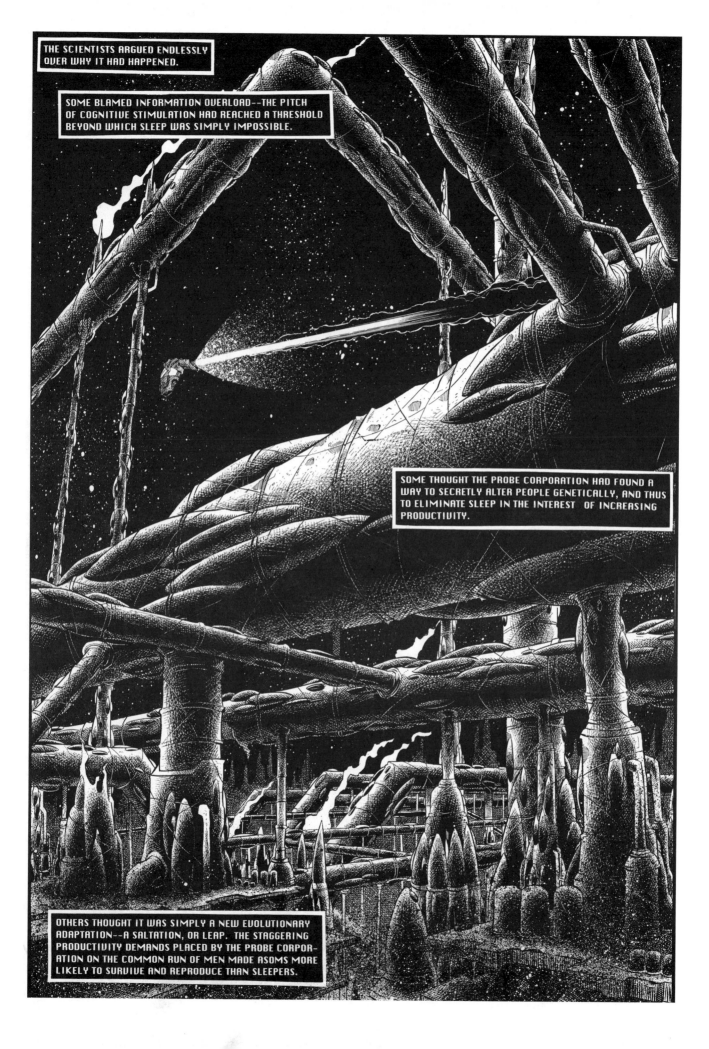

"...HUMANS STOPPED SLEEPING."

AFTER THE SURVIVING WAR VESSELS WERE CONVERTED
TO COMMERCIAL USE AND THE SCOURING OF THE SOLAR
SYSTEM FOR THE RAW MATERIALS TO KEEP THEM
FLYING BEGAN...

AFTER THE PROBE CORPORATION SEIZED
TOTAL POLITICAL POWER...

AFTER THE FAMINES...

AFTER THE WARS...